Outlaw Culture

'The reader discovers ... that bell hooks is a joy to read, her work a nimbly written hybrid form of social commentary, by turns personal, political, and in-your-face.'

San Francisco Chronicle Examiner

'*Outlaw Culture* should be read, regardless of whether one agrees with feminism as presented by hooks. hooks raises critical issues that all should find engaging as well as challenging!'

Real African World

'She brings to the task of cultural criticism an astute eye and a courageous spirit ... Hers is a voice that forces us to confront the political undercurrents of life in America.'

New York Times Book Review

'hooks's style is refreshingly brash and accessible and often inflected by personal experience. Readers may contest her politics, yet few will be unmoved by the spirit that animates these essays; a desire to rethink cultural institutions that sustain racism, sexism, and other systems of political oppression.'

Publishers Weekly

Routledge Classics contains the very best of Routledge
publishing over the past century or so, books that have,
by popular consent, become established as classics in
their field. Drawing on a fantastic heritage of innovative
writing published by Routledge and its associated
imprints, this series makes available in attractive,
affordable form some of the most important works of
modern times.

For a complete list of titles visit
www.routledge.com/classics

bell
hooks

Outlaw Culture

Resisting representations

Routledge
Taylor & Francis Group
LONDON AND NEW YORK

First published 1994 by Routledge

First published in Routledge Classics 2006 by Routledge
2 Park Square, Milton Park, Abingdon, Oxon OX14 4RN
52 Vanderbilt Avenue, New York, NY 10017

Routledge is an imprint of the Taylor & Francis Group, an informa business

© 1994 Gloria Watkins

Typeset in Joanna by RefineCatch Limited, Bungay, Suffolk

Library of Congress Cataloging in Publication Data
A catalog record for this book has been requested

British Library Cataloguing in Publication Data
A catalogue record for this book is available from the British Library

ISBN 13: 978-0-415-38958-7 (pbk)
ISBN 13: 978-1-138-12758-6 (hbk)

for John Amarh—stepping out on faith

CONTENTS

INTRODUCTION

The heartbeat of cultural revolution

From the moment I returned to living in a small town, children reentered my daily life. Before I left the racially segregated Southern town where I was born and raised, it would have been impossible for me to imagine a life that did not include the constant presence of children. In that world, being single and childless would not have deprived me of their company. Living in poor and working-class black culture, among extended family and community, it would have been seen as strange not to talk to, know, and love children. When I left that world to attend predominantly white universities for undergraduate and graduate study, each step I made on the ladder leading me to tenure and the distinguished professorship I hold today took me further away from the lives of children.

In the predominantly white world of bourgeois academic social relations, where children tend to be seen as "private

property," it is rare to have the opportunity to form close, pas-
sionate, cross-generational, non-family-based friendships. Yet
when I moved to a small town six years ago and rented a large old
house with plenty of bats and a tiny bathroom (off the kitchen,
with no door), children just walked back into my life. Somehow
word spread around the neighborhood that I had built this bright
red door leading into a tiny room with low ceilings, a perfect
room for small people. Children climbed the steps up to my porch
and asked to see the red door. And that is how I came to be sitting
in my living room one day with two little black girls, talking
about teaching and writing, telling them about cultural criticism.

At first it was hard to explain the meaning of cultural studies,
the practice of cultural criticism. But then a print of Jacob
Lawrence's painting "The Lovers" beckoned to me. We were all
sitting facing the wall where it hung in front of a red rocking
chair. My new little girlfriends have already let me know they
thought I "have a thing about the color red.' In Trinh T. Minh-ha's
exciting book on representation, *When the Moon Waxes Red*, she
explains red's lure: "At once an unlimited and profoundly sub-
jective color, red can physio- or psychologically close in as well
as open up. It points to both a person's boundless inner voyage,
and the indeterminate outer burning of the worlds of war.
Through centuries, it remains the badge of revolution." And
indeed I tell the girls, "I'm into red 'cause it's so revolutionary,"
a comment that sparks intense giggles.

We begin our talk about cultural studies with the color red,
with its meaning in black life. Already they know that red is a
color for seduction and desire. We talk about the Lawrence paint-
ing, what they see when they really look at it—hard—hard. We
talk about everything we see that we like, the way the lovers are
sitting on the couch with the record player beside them, looking
like they are dancing, only they are sitting down. We try and
imitate them. We talk about the jet black color of their bodies
and the bright red of the table next to them. Already they know

about color caste, about the way dark black color makes one less desirable. Connecting all these pieces, we find a way to understand Jacob Lawrence, desire and passion in black life. We practice culture criticism and feel the fun and excitement of learning in relation to living regular life, of using everything we already know to know more.

Merging critical thinking in everyday life with knowledge learned in books and through study has been the union of theory and practice that has informed my intellectual cultural work. Passionately concerned with education for critical consciousness, I continually search for ways to think, teach, and write that excite and liberate the mind, that passion to live and act in a way that challenges systems of domination: racism, sexism, class elitism. When I first begin working as an Assistant Professor of English and Black Studies at Yale University, I felt so limited by conventional pedagogy, by the emphasis on specialization and periodization. Doing interdisciplinary work in graduate school, I found this made me suspect—less legitimate. It threatened folks that I could be busy writing books on black women and feminism while studying medieval literature. Crossing boundaries seemed even harder as I moved up the academic hierarchy. Everyone in authority seemed to want us to stay in one place. When that crossing was coupled with progressive commitment to Left politics and a desire to write in a manner that would make my ideas accessible to a world beyond the academy, it made me feel all the more like a radical outsider, someone who only felt at home in the margins—in women's studies and black studies where interdisciplinary work was encouraged and affirmed.

Everything changed when white male academics in the United States "discovered" cultural studies. Suddenly, much that had once been illegitimate became the rage. The work that I did— eclectic, interdisciplinary, inspired by revolutionary political visions—had an acceptable place, another home. It could fit with the cultural studies framework black British critic Stuart Hall

evoked when he declared that: "The work that cultural studies has to do is to mobilize everything that it can find in terms of intellectual resources in order to understand what keeps making the lives we live, and the societies we live in, profoundly and deeply antihumane." Not only did I find in cultural studies a site where I could freely transgress boundaries, it was a location that enabled students to enter passionately a pedagogical process firmly rooted in education for critical consciousness, a place where they felt recognized and included, where they could unite knowledge learned in classrooms with life outside.

Combining theory and practice was the pedagogical strategy I had always used, that had inspired and motivated my teaching. It was great to have an acceptable framework to share knowledge that came from pushing against boundaries, moving out of one's place. In their introduction to *Between Borders: Pedagogy and the Politics of Cultural Studies*, Henry Giroux and Peter McLaren emphasize the way "cultural studies combines theory and practice in order to affirm and demonstrate pedagogical practices engaged in creating a new language, rupturing disciplinary boundaries, decentering authority, and rewriting the institutional and discursive border-lands in which politics becomes a condition for reasserting the relationship between agency, power, and struggle." In the class-room, cultural criticism was the approach to learning that excited students, connecting them across race, class, gender, sex-ual practices, and a host of other "differences." This excitement was intensified when the focus of critique turned to popular culture. Using this same pedagogical strategy outside the acad-emy, I found that everyday folks from all walks of life were eager to share thoughts and talk critically about popular culture. Cul-tural studies was similar to Black Studies and Women's Studies in the way it affirmed interdisciplinary work, in its acknowledg-ment that education is not politically neutral. But it was different in that it affirmed our right and responsibility as academics to study and write about popular culture seriously. Talking critically

about popular culture was a powerful way to share knowledge, in and outside the academy, across differences, in an oppositional and subversive way.

Even though cultural studies that looks at popular culture has the power to move intellectuals both out of the academy and into the streets where our work can be shared with a larger audience, many critical thinkers who do cultural criticism are afraid to make that move. They prefer to score points by remaining in the academic world and representing radical chic there. This is especially the case when academics feel they are less cool if they attempt to link cultural studies's intellectual practice with radical politicization. The desire to "appear cool" or "down" has led to the production of a body of cultural studies work in the United States that appropriates and rewrites the scripts and meanings of popular culture in ways that attribute to diverse cultural practices subversive, radical transgressive intent and power even when there is little evidence to suggest this is the case. This has been especially true of the academic work produced about popular icons (Madonna, for example). Voyeuristic cannibalization of popular culture by cultural critics is definitely dangerous when the intent is purely opportunistic. However, when we desire to decolonize minds and imaginations, cultural studies' focus on popular culture can be and is a powerful site for intervention, challenge, and change.

All the essays and dialogues in Outlaw Culture: Resisting Representations emerge from a practical engagement with cultural practices and cultural icons who are defined as on the edge, as pushing the limits, disturbing the conventional, acceptable politics of representation. Starting from the standpoint that it is not the work of cultural critics merely to affirm passively cultural practices already defined as radical or transgressive, I cross boundaries to take another look, to contest, to interrogate, and in some cases to recover and redeem. These essays reflect the desire to construct frameworks where border crossing will not be evoked simply as

a masturbatory mental exercise that condones the movement of the insurgent intellectual mind across new frontiers (another version of the jungle safari), or become the justification for movements from the center into the margin that merely mimic in a new way old patterns of cultural imperialism and colonialism. Working with students and families from diverse class backgrounds, I am constantly amazed at how difficult it is to cross boundaries in this white supremacist, capitalist, patriarchal society. And it is obviously most difficult for individuals who lack material privilege or higher levels of education to make the elaborate shifts in location, thought, and life experience cultural critics talk and write about as though it is only a matter of individual will. To claim border crossing, the mixing of high and low, cultural hybridity, as the deepest expression of a desired cultural practice within multicultural democracy means that we must dare to envision ways such freedom of movement can be experienced by everyone. Since the disruption of the colonized/ colonizer mind-set is necessary for border crossings to not simply reinscribe old patterns, we need strategies for decolonization that aim to change the minds and habits of everyone involved in cultural criticism. In these essays, I call attention to class and the myriad ways in which structures of class privilege prevent those who are not materially privileged from having access to those forms of education for critical consciousness, that are essential to the decolonization process. What does it mean for us to educate young, privileged, predominantly white students to divest of white supremacy if that work is not coupled with work that seeks to intervene in and change internalized racism that assaults people of color; to share feminist thinking and practice if that work is not coupled with fierce action; to share feminist thought and change sexism in all walks of life? To create a culture where those who could occupy the colonizing location have the freedom to self-interrogate, challenge, and change while the vast majority of the colonized lack such freedom is merely to keep in place

existing structures of domination. Politically, we do not live in a postcolonial world, because the mind-set of neo-colonialism shapes the underlying metaphysics of white supremacist capitalist patriarchy. Cultural criticism can be an agent for change, educating for critical consciousness in liberatory ways, only if we start with a mind-set and a progressive politics that is fundamentally anticolonialist, that negates cultural imperialism in all its manifestations.

Crossing borders within the academic world, moving in and out of Black Studies, Women's Studies, traditional English departments, and cultural studies, I am continually distressed by the willingness of one group to repudiate domination in one form while supporting it in another—white men who take sexism seriously but are not concerned with racism or vice versa, black men who are concerned with ending racism but do not want to challenge sexism, white women who want to challenge sexism but cling to racism, black women who want to challenge racism and sexism but claim class hierarchy. To arrive at the just, more humane world Stuart Hall envisions cultural studies as having the power to help create, we must be willing to courageously surrender participation in whatever sphere of coercive hierarchical domination we enjoy individual and group privilege. Given that cultural fascism is on the rise, that there is such open demand for separatist politics, embracing notions of inclusion and exclusion, whether based on shared gender, race, or nationality, seriously impedes all progressive effort to create a culture where border crossing enables both the sharing of resources and the production of a culture of communalism and mutuality. The fierce willingness to repudiate domination in a holistic manner is the starting point for progressive cultural revolution. Cultural criticism can be and is a vital location for the exchange of knowledge, or the formation of new epistemologies.

As I pondered the fascination those children of diverse gender, race/ethnicity, nationality, class, and as yet undeclared sexual

practice expressed about the red door, I began to think about the politics of space. This door led into a room designed for small bodies: everything in reach, nothing placed to intimidate or threaten. Although I was unable to conjure clear memories, I tried to remember my relationship to space as a child, the ways the break with dependency on grown-ups or older, bigger siblings and the assertion of one's own agency was a declaration of freedom and power. I remember thinking—and, like all cultural critics who are children, sharing my observation with the world around me—that if I had the power, I would make everything in the world be the right size for children, and grown-ups would have to learn how to do everything differently. In many ways progressive cultural revolution can happen only as we learn to do everything differently. Decolonizing our minds and imaginations, we learn to think differently, to see everything with "the new eyes" Malcolm X told us we needed if we were to enter the struggle as subjects and not objects. These essays and dialogues represent my ongoing growth as artist, cultural critic, feminist theorist, writer, seeker on the path. Contrary to convention, I almost always first imagine a collection of essays I want to write and then produce them as cultural events excite my imagination. Some of my essays appear first in magazines, because I am eager to spread the message, get critical feedback, and to speak to and with diverse audiences; publishing work in multiple locations makes that possible. The work in Outlaw Culture often begins where earlier published work stopped; at times it may repeat for emphasis and remembrance. Though I see it as all connected, each piece has a different take on culture and reality. Polyphonic, it combines the many voices I speak—academic talk, standard English, vernacular patois, the language of the street. Celebrating and affirming insurgent intellectual cultural practice, it is symbolically a red door—an invitation to enter a space of changing thought, the open mind that is the heartbeat of cultural revolution.

1

POWER TO THE PUSSY

We don't wannabe dicks in drag

I believe in the power of Madonna, that she has the balls to be the patron saint of new feminism.
—Kate Tentler, *The Village Voice*

In my twenties, I made my first pilgrimage to Europe. Journeying there was a necessary initiation for any young artist in the United States destined to lead a Bohemian life of intensity, a life on the edge, full of adventure. Nothing about being black, female, working class, growing up in a racially segregated Southern town, where the closest I ever came to ecstasy was during Sunday morning church service, made me think that the doors of avant-garde radical cool would be closed to me. Confined and restrained by family, region, and religion, I was inwardly homeless, suffering, I believed, from a heartbreaking estrangement from a divine community of radical artistic visionaries whom I imagined were longing for me to join them.

In much pain, I spent my childhood years dreaming of the moment when I would find my way home. In my imagination, home was a place of radical openness, of recognition and reconciliation, where one could create freely.

Europe was a necessary starting place for this search. I believed I would not find there the dehumanizing racism so pervasive here that it crippled black creativity. The Europe of my imagination was a place of artistic and cultural freedom, where there were no limits or boundaries. I had learned about this Europe in books, in the writings of black expatriates. Yet this was not the Europe I discovered. The Europe I journeyed to was a place where racism was ever present, only it took the form of a passion for the "primitive," the "exotic." When a friend and I arrived in Paris, a taxi driver took us to a hotel where pictures of nude black females adorned the walls. Everywhere, I encountered the acceptance and celebration of blackness as long as it remained within the confines of primitivism.

Ironically, white Europeans were constantly urging me to join them in their affirmation of Europe as a more free, less racist, more culturally open place than the United States. At some point I was told that Europeans, unlike white Americans, had no trouble worshipping a black Madonna; this was proof that their culture was able to move beyond race and racism. Indeed, European friends insisted that I make a pilgrimage to Montserrat to see for myself. At the shrine of the Black Madonna I saw long lines of adoring white worshippers offering homage. They were praying, crying, longing to caress and touch, to be blessed by this mysterious black woman saint. In their imaginations her presence was the perfect embodiment of the miraculous. To be with her was to be in the place of ecstasy. Indeed, momentarily in this sanctuary, race, class, gender, and nationality had fallen away. In their place was a vision of hope and possibility. Yet this moment in no way altered the politics of domination outside, in that space of the real. Only in the realm of the sacred imaginary was

there the possibility of transcendence. None of us could remain there.

My journey ended. I did not return home to become a Bohemian artist. My creative work, painting and writing, was pushed to the background as I worked hard to succeed in the academy, to become something I had never wanted to be. To this day I feel as imprisoned in the academic world as I felt in the world of my growing up. And I still cling to the dream of a radical visionary artistic community that can sustain and nurture creativity.

I share these memories and reflections as a preface to talking about Madonna as a cultural icon, to contextualize what she has represented for me. Early on, I was enamored of her not so much because I was "into" her music—I was into her presence. Her image, like that of the Black Madonna, evoked a sense of promise and possibility, a vision of freedom; feminist in that she was daring to transgress sexist boundaries; Bohemian in that she was an adventurer, a risk taker; daring in that she presented a complex, non-static ever-changing subjectivity. She was intense, into pleasure, yet disciplined. For me and many other young "hip" feminist women confined in the academy, Madonna was a symbol of unrepressed female creativity and power—sexy, seductive, serious, and strong. She was the embodiment of that radical risk-taking part of my/our female self that had to be repressed daily for us to make it in the institutionalized world of the mainstream, in the academy. For a long while, her transgressive presence was a beacon, a guiding light, charting the journey of female "feminist" artists coming to power—coming to cultural fulfillment.

These days, watching Madonna publicly redefine her persona away from this early politicized image of transgressive female artistry necessarily engenders in diverse feminist admirers feelings of betrayal and loss. We longed to witness the material girl enter mature womanhood still embodying a subversive feminist

spirit. We longed for this, in part, to see serious radical female cultural icons manifesting the feminist promise that sexism would not always limit, inform, and shape our cultural identities and destiny. Deep down, many feminist Madonna admirers, ourselves entering mature womanhood, fear that this transition will signal the end of all forms of radicalism—social, sexual, cultural. We have so needed her transgressions. Women struggling to maintain fierce commitment to radical feminist womanhood in the face of a culture that rewards betrayal want to have a feminist icon who stands against the patriarchy, who "fights the power." For a long time, Madonna appeared to be that icon. Since feminist thinking and the feminist movement are currently undermined by intense backlash, we long for female icons who show everyone that we can triumph despite fierce antifeminism. Ultimately, we know that feminist transformation of culture and society is even more directly threatened when those who were once advocates, supporters of feminist demands for an end to sexism and sexist oppression, act as though this is no longer a necessary and crucial agenda. Hence, our collective lament when it appears that Madonna will not fulfill that earlier sense of feminist promise and power.

Currently, Madonna is redefining her public persona in a manner that negates and erases her earlier support for feminist issues. The first hint of this major about-face was made public in the October 1992 issue of *Vanity Fair* with its display of Madonna as little-girl sex kitten. A frightening gap separated the radical vision of active female sexuality Madonna projects in the *Vanity Fair* interview with Maureen Orth (evocatively titled "The Material Girl's Sexual (R)Evolution") and the boring, conventional kiddie-porn type photographs accompanying the text. The image of a grown, over thirty, Madonna recreating herself as a little-girl sex kitten, presumably for the thrill of gaining and holding onto the sustained mass patriarchal pornographic gaze for as long as she can keep the public's attention, exposes the

way female aging in a sexist society can undermine any woman's allegiance to radical politics, to feminism. What is the "material girl" to do when she has fast become a grown woman in an economy of cultural images where so much of her mass appeal was deeply rooted in the romance of rebellious youth? The re-creation of herself as little girl comes across primarily as an opportunistic attempt to sustain the image that she can be forever young. Starting over again as little-girl-on-the-playground sex symbol, Madonna abandons and betrays her earlier radical questioning of sexist objectifications of female sexuality, announcing via these photos that she consents to being represented within a field of image production that is over-determined by patriarchy and the needs of a heterosexist pornographic gaze.

Gone is the "hot" Madonna who dares to challenge the status quo. There is nothing "fierce" or even interesting about the *Vanity Fair* photographs. And they do not evoke in me fierce response. Looking at them I just simply felt sad. After all her daring, her courageous challenging of sexist constructions of female sexuality, Madonna at the peak of her power has stopped pushing against the system. Her new image has no radical edge. The loss of that subversive style is all the more evident in *Sex*. Suddenly, nothing about Madonna's image is politicized. Instead, with the publication of *Sex*, she assumes the role of high priestess of a cultural hedonism that seeks to substitute unlimited production and pursuit of sexual pleasure for a radical, liberating political practice, one that would free our minds and our bodies.

Sex pushes pervasive hedonism as an alternative to resistance. The shifting radical subjectivity that was the quintessential trademark of Madonna's earlier opposition to conformist fixed identity was a daring to be different that was not expressive of shallow exhibitionism but of a will to confront, challenge, and change the status quo. I remember Madonna flaunting sexual assertiveness in early videos like "Material Girl," telling *Nightline*

that she drew the line at violence, humiliation, and degradation of women. It is this subject position that has disappeared. As Susan Bordo reminds us in her essay "Material Girl: The Effacements of Postmodern Culture," that will to be different "is won through ongoing political struggle rather than through the act of creative interpretation." Ironically, it is precisely at this cultural moment when Madonna allies herself with the status quo that she insists on identifying herself as radical, declaring, "I see myself as a revolutionary at this point." She asserts her belief that *Sex* will function politically, that it will "open some people's minds," presumably that it will lead viewers to accept and condone various sexual practices. The irony is, of course, that for those viewers who have always consumed a range of patriarchal pornographic material and/or progressive erotica, *Sex* offers no new images. Every time I open *Sex* I am reminded of a high school yearbook. The layout and design appear amateurish. The constant changing of typeface and style evoke memories of meetings about my high school yearbook where we agreed that anything goes and to let everyone's desires be represented. This casual effect seems highly intentional in *Sex*. Where the faces of graduating seniors and their classmates might be, Madonna gives us diverse sexual images, many of which look as though they have been appropriated from *Players, Playboy, On Our Backs*, and so on, with of course one special difference—they all feature Madonna.

While this in-your-face collection of porn and erotica may seduce a mass public (particularly an audience of teenaged consumers) that might never have gone seeking these images in the many other places where they could be found, it is doubtful that it will change anyone's view about sexual practices. Despite Madonna's hype that would have the public believe she is the radical visionary introducing transgressive subject matter to a mass audience, the reality is that advertisements, videos, movies, and television were already exploiting these images. Madonna is

really only a link in the marketing chain that exploits representations of sexuality and the body for profit, a chain which focuses on images that were once deemed "taboo." Not wanting to undermine her own hype, the material girl must argue that her images are different—original. The major difference, of course, is that the space she occupies as cultural entertainer and icon enables her to reach a much larger audience than traditional consumers of pornographic images or progressive erotica. Despite her hopes of radical intervention, the vast majority of readers seem to approach Sex like conventional consumers of pornography. The book is used to sexually excite, provoke, or stimulate voyeuristic masturbatory pleasure. Nothing radical about that.

The most radical aspect of Sex is its appropriation and use of homoerotic imagery. This use is not unique. Commenting on the way these acts of appropriation have become a new trend, Newsweek's review of Sex asserted:

> As gay-bashing has become one of the most common hate-crimes in America, gay iconography is bubbling up defiantly in mainstream media. Since Madonna first cast herself as Marilyn Monroe, she has played out the role of drag queen, using identity as a form of self-defense. In exchange for her genuine affection, she's raided gay sub-culture's closet for the best of her ideas ... she isn't just taking explicit sex mainstream; she is taking explicit homosex mainstream. In this she is a pioneer. Hard as it is to imagine a major celebrity of another era making a book as graphic as Sex, and surviving—it's impossible to imagine anyone making one as gay.

In other words, within today's cannibalistic market economy the willingness to consume homoerotic and/or homosexual images does not correspond to a cultural willingness to stand against homophobia or challenge heterosexism.

Patriarchal pornography has always appropriated and exploited homoeroticism. Within the larger context of pornographic sexual hedonism anything goes, and all taboos become part of the pleasure mix. This experience does not mean that the individuals consuming these images are not fiercely committed to maintaining heterosexism and perpetuating homophobia. Voyeuristic desire to look at, or experience through fantasy, sexual practices that in one's everyday life might be perceived as taboo does not signal a rupture in the sexual status quo. That is why simply portraying these images, mass marketing them to a larger public, is in and of itself not a subversive intervention, though in some instances it may have a disruptive challenging impact.

Throughout Madonna's career she has appropriated fascinating aspects of gay subcultures even as she has often framed gay experience in a stereotypically heterosexist and homophobic manner. (An example of this tendency is her insistence in the film *Truth or Dare* that her dancers, most of whom are gay and nonwhite, are "emotional cripples" who need her to "play mother," guiding and disciplining them.) This kind of maternal/paternalism fits with a history of so-called sympathetic heterosexual framing of homosexual experience in popular culture which represents it as deviant, subversive, wild, a "horror" that is both fascinating and fun but always fundamentally a "horror."

This unsubversive manner of representation jumps out from the pages of *Sex*. The initial pictures of Madonna with two lesbian sex radicals portrays them in scenarios that visually construct them as freaks. In various shots Madonna is positioned in relation to them in a manner that insists on the primacy of her image as the embodiment of a heterosexual norm, "the ideal feminine." Visually placed in several photographs as voyeur and/or victim, she is at the center and the lesbian couple always marginalized. Homophobic constructions of gay sexual practice in mass media consistently reinforce the stereotypical notion that gay folks are predators, eager to feast upon the innocent.

Madonna is the symbol of innocence; the two lesbian women represent experience. Unlike her, they do not have firm, hard bodies, or wear on their faces the freshly made-up, well-fed, all-American look. One of the most powerful nonerotic or pornographic images in this sequence shows Madonna at a distance from the two women, looking anguished, as though she does not belong, as though being in their presence hurts. A study in contrast, Madonna consistently appears in these images as though she is with them but not of them. Posed in this way, her presence invites status quo readers to imagine that they too can consume images of difference, participate in the sexual practices depicted, and yet remain untouched—unchanged.

Embodying the highest expression of capitalist patriarchal pornographic power, Madonna emerges in *Sex* as the penultimate sexual voyeur. She looks, then asks that we look at her looking. Since all the while the reader of her opening remarks knows that we are not really seeing documentary photos but a carefully constructed sexual stage, we can never forget that our gaze is directed, controlled. We have paid for our right to look, just as Madonna has paid the two women to appear with her. Our gaze must always and only be directed at what she wants us to see. And this means that what appears to be a portrait of homoeroticism/homosexuality is merely a reflection of her voyeuristic perspective. It is that overdetermining perspective that shapes and informs the image of gay sexual practice we are allowed to see.

Within the sphere of Madonna's pornographic gaze, gayness is reinscribed as a trope within the cultural narrative of patriarchal pornographic sexual hedonism. The gayness presented throughout *Sex* does not call for a recognition and acceptance of difference. It is instead a demand that difference be appropriated in a manner that diffuses its power. Hence, the consuming voyeuristic pornographic gaze violates the gay body and being by suggesting, via the mode of appropriation, that the site of

interrogation must always rest not with the homoerotic/homosexual presence but with a heterosexual center. Gayness then appears as merely an extension of heterosexual pleasure, part of that practice and not an alternative or fundamentally different expression of sexual desire.

Ultimately, images of homosexuality in Sex, though presented as never before to a mainstream audience, are not depicted in a manner that requires viewers to show any allegiance to, or understanding of, the context from which they emerge. Indeed, they are presented as though they come into being through the heterosexual imagination, thereby enabling heterosexual and/or homophobic audiences to share in Madonna's voyeuristic relations, looking into and at "gayness," without connecting that pleasure to any resistance struggle for gay rights, to any demand that they relinquish heterosexist power. As with the opening pages, the image of Madonna in a gay club surrounded by men evokes a will to violate—to enter a space that is at the very least symbolically, if not actually, closed—off limits. Even in the realm of male homoeroticism/homosexuality, Madonna's image usurps, takes over, subordinates. Coded always in Sex as heterosexual, her image is the dominant expression of heterosexism. Mirroring the role of a plantation overseer in a slave-based economy, Madonna surveys the landscape of sexual hedonism, her "gay" freedom, her territory of the other, her jungle. No break with stereotypes here. And more importantly, no critical interrogation of the way in which these images perpetuate and maintain institutionalized homophobic domination. In the context of Sex, gay culture remains irrevocably linked to a system of patriarchal control framed by a heterosexist pornographic gaze.

Just as representations of gayness are not problematized in Sex neither is S/M. No longer an underground happening, S/M scenarios are among the sexual taboos exploited for profit. Such scenarios are now commonly enacted on prime time television

shows and in movies. Yet none of what we see in mainstream media (*Sex* is no exception) shows images of sex radicals who are committed to a vision of sexual pleasure that rests on mutual consent. Consent comes through communication. Yet the S/M we see both in mainstream media and in *Sex* is not about consent. It is the subject-to-subject dimension of S/M that is lost when symbols of these sexual practices are appropriated to shock or titillate. None of Madonna's fictive S/M monologues foreground issues of agreement and consent. In both images and written text, S/M is represented solely as being about punishment. Narrow notions of sexual sadomasochism fail to characterize it as a sexual ritual that "works" issues of pain and power. Whatever the degree of punishment present, the point is ultimately pleasure.

In her all-knowing rap on S/M, Madonna assumes the role of teacher/authority, giving us truth learned from an authentic source: "I talked to a dominatrix once and she said the definition of S/M was that you let someone hurt you who you know would never hurt you. It's always a mutual choice. You have an unstated agreement between you." Yet in Madonna's mind the choice is always to hurt or be hurt. It is this perversion of sex-radical practice that informs her assertion: "I don't even think S/M is about sex. I think it's about power, the struggle for power." While S/M is about power, it's about negotiation—the antithesis of competitive struggle.

By placing herself in the role of instructor and selling *Sex* as a how-to manual, Madonna dangerously usurps the progressive voices and bodies of diverse individuals engaged in S/M sexual practice. Her most reactionary take on S/M connotes heterosexual male violence against women with consensual sado-masochism. Prefacing her brief discussion of S/M, Madonna asserts:

> I think for the most part if women are in an abusive relationship and they know it and they stay in it, they must be digging it. I

suppose some people might think that's an irresponsible statement. I'm sure there are a lot of women in abusive relationships who don't want to be, who are trapped economically; they have all these kids and they have to deal with it. But I have friends who have money and are educated and they stay in abusive relationships, so they must be getting something out of it.

Revealing that she is no expert on domestic violence, Madonna flaunts her ignorance with the same seductive arrogance of sexist men who have used the same faulty logic to condone, support, and perpetuate violence against women.

More than any visual image in *Sex*, these remarks signal Madonna's break with feminist thinking. Reflecting a patriarchal standpoint, these statements are more than just irresponsible; they are dangerous. Madonna uses her position as cultural icon to sanction violence against women. And the tragedy of it all is that these statements are inserted in an utterly gratuitous manner. They are in no way connected to the visual images of heterosexual S/M. By making them, Madonna uses *Sex* as a platform to express right-wing antifeminist sentiments that, if uttered in another context, might have provoked public protest and outrage.

Concluding her declaration with the insistence that "the difference between abuse and S/M is the issue of responsibility," Madonna neatly deflects attention away from the real issue of "choice." To focus on choice rather than responsibility she would have had to acknowledge that within patriarchal culture, where male domination of women is promoted and male physical and sexual abuse of women is socially sanctioned, no open cultural climate exists to promote consensual heterosexual power play in any arena, including the sexual. Few women have the freedom to choose an S/M sexual practice in a heterosexual relationship. Contrary to Madonna's assertions, female class

power rarely mediates male violence, even though it may offer a means of escape. No doubt Madonna knows this, but she is more concerned with courting and seducing an antifeminist public, a misogynist sexist audience that makes exactly the same pronouncements about women and abuse. A similar critique could be made of Madonna's comments on pornography.

Madonna's appropriation of gayness as the sign of transgression, as well as her preoccupation with S/M, usually deflects attention away from her use of racially charged imagery. Critics who applaud the way she draws mainstream attention to gay sexuality say nothing about the issue of race. Yet the cultural narrative of white supremacy is woven throughout the visual and written text of *Sex*. Despite her personal history as a dark ethnic from an immigrant background, Madonna's mega-success is tied to her representation as a blond. By assuming the mantle of Marilyn Monroe, she publicly revealed her longing to leave behind the experience of her ethnic and bodily history to inhabit the cultural space of the white feminine ideal. In his essay "White," film critic Richard Dyer describes the way Hollywood's idealization of white femininity converges with aesthetic standards informed by white supremacy. Emphasizing that the image of Monroe "is an inescapably and necessarily white one," Dyer calls attention to the fact that "the codes of glamour lighting in Hollywood were developed in relation to white women, to endow them with a glow and radiance that has correspondence with the transcendental rhetoric of popular Christianity." Significantly, only "white"-skinned females could be imagined as innocent, virtuous, transcendent. This fact affirms my white European friends' assertion that there is no cultural space within the United States that would allow white folks to deify black femaleness, to worship a black Madonna. Racism and sexism combine to make it impossible for white folks, and even some black folks, to imagine a black Madonna, since such figures are representations of purity and innocence.

Within racist and sexist iconography the black female is stereo-typically portrayed as experienced and impure. Hence, she can never embody that Birth-of-a-Nation fragile womanhood that is the essence of a Madonna figure.

Within white supremacist culture, a female must be white to occupy the space of sacred femininity, and she must also be blond. Prior to the shooting of images in Sex, Madonna had returned to her natural dark hair color. Yet workers helping to construct her public persona insisted that she bleach her hair blond. Entertainment Weekly reported that Madonna was reluctant, but was told by her make-up artist: "This is your book. If you want to be a brunette, fine. But in black and white, blond magnifies better. Blond says more!" Blond speaks, says more, when it both mirrors and embodies the white supremacist aesthetics that inform the popular imagination of our culture. Concurrently, Madonna's appropriation of the identity of the European actress Dita and of her Germanic couture is an obvious gesture connecting her to a culture of fascism, Nazism, and white supremacy, particularly as it is linked to sexual hedonism.

Madonna embodies a social construction of "whiteness" that emphasizes purity, pure form. Indeed, her willingness to assume the Marilyn Monroe persona affirms her investment in a cultural vision of white that is tied to imperialism and colonial domin-ation. The conquest of light over dark replays the drama of white supremacist domination of the Native American, African, and so on. In that representation of whiteness, Dyer asserts, "being white is coterminous with the endless plenitude of human diversity." He explains: "If we are to see the historical, cultural, and political implications (to put it mildly) of white world domi-nation, it is important to see similarities, typicalities within the seemingly infinite variety of white representation." At the start of her career, the "whiteness" that Madonna flaunted was repre-sented as other than, different from the mainstream, more con-nected to the reality of folks marginalized by race or sexual

practice. For a time, Madonna seemed to desire to occupy both that space of whiteness that is different and the space that is familiar. Different, she is the young Italian white girl wanting to be black. Familiar, she is Marilyn Monroe, the ultimate cultural icon of white female beauty, purity, and sensuality.

Increasingly, Madonna occupies the space of the white cultural imperialist, talking on the mantle of the white colonial adventurer moving into the wilderness of black culture (gay and straight), of white gay subculture. Within these new and different realms of experience she never divests herself of white privilege. She maintains both the purity of her representation and her dominance. This is especially evident in *Sex*. In stories of sexual adventures told in *Sex*, people of color appear as primary protagonists. In one, the young Puerto Rican boy virgin is the "object" of the fictive Dita/Madonna's lust. We are told: "He was fearless. He would do anything . . . I was so turned on; it was probably the most erotic sex I ever had. But he gave me crabs." The stereotypes here are obvious, a fact which makes them no less damaging. Madonna's text constructs a narrative of pure white womanhood contaminated by contact with the colored "other." It would be easy to dismiss this construction as merely playful if it were not so consistent throughout *Sex*. In another adventure story, an apparently well-off white male enters a fancy department store where he is seduced by a Cuban salesgirl. She is, of course, as stereotype would have it, hot and whorish, ready to cheat on her boyfriend when any anonymous "desiring" white man looks her way. The structure of this narrative suggests that it, like the previous one, appeals directly to white supremacist sexual fantasies.

Though *Sex* appears to be culturally diverse, people of color are strategically located, always and only in a subordinate position. Our images and culture appear always in a context that mirrors racist hierarchies. We are always present to serve white desire. And while *Sex* exploits the myth of jungle fever, Madonna

is carefully positioned within a visual framework where the big black man and the black woman appear as a couple who are her sexual servants; no readers could imagine that Madonna is partnering herself with a black male. No, all her images of conventional heterosexual coupling are with "nice" white boys. Black female sexuality is stereotypically represented as degraded. In the much-remarked and visually powerful come shot, Madonna stands over the prostrate naked body of black female model Naomi Campbell (not an anonymous fantasy image) and mimics a golden shower, by squirting lotion on the reclining figure. This image conveys a serious visual message about race, gender, and nationality. Madonna can be seen here as representing the imperialism of the United States, its triumph over Britain (Campbell is British Caribbean) as well as the conquest of "exotic" black cultures. Campbell has been called by the white-dominated fashion media the new Josephine Baker, a persona which directly contrasts that of idealized white womanhood. As the celebrated "primitive" icon, she must learn her place in relation to the white mistress and master. To conquer and subordinate this representation of "wild black sexuality," Madonna must occupy a phallic position. In keeping with sexist/racist iconography, the black female is symbolically subordinated by white male power; in this case it is Madonna assuming the white supremacist patriarchal role.

Throughout *Sex*, Madonna appears as the white imperialist wielding patriarchal power to assert control over the realm of sexual difference. None of this is mitigated by the recognition—emphasized by Madonna herself—that gender is an act of social construction. Nor can Madonna's disguises, however richly layered, ultimately mask her violence and cruelty towards women. Discussing gender parity, Carol-Anne Tyler ("Boys Will Be Girls: The Politics of Gay Drag") suggests that the male drag queen's femininity is "a put on, not the real thing, signalling he has what women like, the phallus." Though Madonna, of course,

cannot do male drag, she does appropriate a drag queen look or style. Tyler identifies this female impersonator of the male impersonator as a phallic mother, insisting that "when the active desiring woman still reflects man's desires, the mirrors of the patriarchal imagination cannot have been shattered." In Madonna's latest persona as phallic mother she lets us know that she has no desire to shatter patriarchy. She can occupy the space of phallocentrism, be the patriarch, even as she appears to be the embodiment of idealized femininity.

She claims not to envy men, asserting: "I wouldn't want a penis. It would be like having a third leg. It would seem like a contraption that would get in the way. I think I have a dick in my brain. I don't need to have one between my legs." No doubt that "dick" in her brain accounts for Madonna's inability to grasp that feminism, or for that matter, women's liberation, was never about trying to gain the right to be dicks in drag. But wait a minute, I seem to recall that the men I knew back when the contemporary feminist movement was "hot" all believed that us little women didn't really want our freedom, we just wanted to be one of the boys. And in fact those same men, no doubt thinking through the dicks in their brains, told us that if we "women libbers" just had a good fuck, we would all come to our senses and forget all about liberation. We would in fact learn to find pleasure in being dominated. And when feminists did not fall for this dick rap, men tried to seduce us into believing with our brains and our bodies that the ultimate power was to be found in being able to choose to dominate or be dominated. Well, many of us said "thanks but no thanks." And some of us, well, some of us were tempted and began to think that if we could not really have our freedom, then the next best thing would be to have the right to be dicks in drag, phallocentric girls doing everything the boys do—only better.

This message has so seduced Madonna that now she can share the same phallic rap with her feminist sisters and all her other

fans. Most of the recent images she projects in videos, films, and photographs tell women and everyone that the thrill, the big orgasm, the real freedom is having the power to choose to dominate or be dominated. This is the message of *Sex*.

Madonna's feminist fans, once so adoring, are on the positive tip when we insist that we want an end to domination, when we resist her allure by saying no—no more seduction and betrayal. We long for the return of the feminist Madonna, the kind of cultural icon Susan Griffin celebrates in *Women and Nature* when she writes:

> We heard of this woman who was out of control. We heard that she was led by her feelings. That her emotions were violent. That she was impetuous. That she violated tradition and overrode convention . . . We say we have listened to her voice asking, "Of what materials can that heart be composed which can melt when insulted and instead of revolting at injustice, kiss the rod? . . . And from what is dark and deep within us, we say, tyranny revolts us; we will not kiss the rod.

2

ALTARS OF SACRIFICE

Re-membering Basquiat

Is your all on the altar of sacrifice laid?
—Black church song

At the opening of the 1992 Jean-Michel Basquiat exhibition at the Whitney Museum last fall, I wandered through the crowd talking to the folks about the art. I had just one question. It was about emotional responses to the work. I asked, what did people feel looking at Basquiat's paintings? No one I talked with answered the question. They went off on tangents, said what they liked about him, recalled meetings, generally talked about the show, but something seemed to stand in the way, preventing them from spontaneously articulating feelings the work evoked. If art moves us, touches our spirit, it is not easily forgotten. Images will reappear in our heads against our will. I often think that many of the works that are canonically labeled "great" are

simply those that lingered longest in individual memory. And that they lingered because while looking at them someone was moved, touched, taken to another place, momentarily born again.

Those folks who are not moved by Basquiat's work are usually unable to think of it as "great" or even "good" art. Certainly this response seems to characterize much of what mainstream art critics think about Basquiat. Unmoved, they are unable to speak meaningfully about the work. Often with no subtlety or tact, they "diss" the work by obsessively focusing on Basquiat's life or the development of his career, all the while insisting that they are in the best possible position to judge its value and significance. (A stellar example of this tendency is Adam Gopnik's 1992 piece in the New Yorker). Undoubtedly it is a difficult task to determine the worth and value of a painter's life and work if one cannot get close enough to feel anything, if indeed one can only stand at a distance.

Ironically, though Basquiat spent much of his short adult life trying to get close to significant white folks in the established art world, he consciously produced art that was a barrier, a wall between him and that world. Like a secret chamber that can only be opened and entered by those who can decipher hidden codes, Basquiat's painting challenges folks who think that by merely looking they can see. Calling attention to this aspect of Basquiat's style, Robert Storr has written, "Everything about his work is knowing and much is about knowing." Yet the work resists "knowing," offers none of the loose and generous hospitality Basquiat was willing to give freely as a person.

Designed to be a closed door, Basquiat's work holds no warm welcome for those who approach it with a narrow Eurocentric gaze. That gaze which can only recognize Basquiat if he is in the company of Warhol or some other highly visible figure. That gaze which can value him only if he can be seen as part of a continuum of contemporary American art with a genealogy traced through white males; Pollock, de Kooning, Rauschenberg,

Twombly, and on to Andy. Rarely does anyone connect Basqui-
at's work to traditions in African American art history. While it
is obvious that he was influenced and inspired by the work of
established white male artists, the content of his work does not
neatly converge with theirs. Even when Basquiat can be placed
stylistically in the exclusive, white male art club that denies entry
to most black artists, his subject matter—his content—always
separates him once again, and defamiliarizes him.

It is the content of his work that serves as a barrier, chal-
lenging the Eurocentric gaze that commodifies, appropriates and
celebrates. In keeping with the codes of that street culture he
loved so much, Basquiat's work is *in your face*. It confronts differ-
ent eyes in different ways. Looking at the work from a Eurocen-
tric perspective, one sees and values only those aspects that
mimic familiar white Western artistic traditions. Looking at the
work from a more inclusive standpoint, we are all better able to
see the dynamism springing from the convergence, contact, and
conflict of varied traditions. Many artistic black folks I know,
including myself, celebrate this inclusive dimension emphasized
in an insightful discussion of his life and work by his close
friend, the artist and rapper Fred Braithwaite (a.k.a. Fab 5
Freddy). In *Interview*, Braithwaite acknowledges the sweetness of
their artistic bonding and says that it had to do with their shared
openness to any influence, the pleasure they took in talking to
one another "about other painters as well as about the guys
painting on the trains."

Basquiat was in no way secretive about the fact that he was
influenced and inspired by the work of white artists. It is the
multiple other sources of inspiration and influence that are
submerged, lost, when critics are obsessed with seeing him as
connected solely to a white Western artistic continuum. These
other elements are lost precisely because they are often not
seen—or if seen, not understood. When art critic Thomas
McEvilley suggests in *Artforum* that "this black artist was doing

exactly what classical-Modernist white artists such as Picasso and Georges Braque had done: deliberately echoing a primitive style," he erases all of Basquiat's distinct connections to a cultural and ancestral memory that linked him directly to "primitive" traditions. This then allows McEvilley to make the absurd suggestion that Basquiat was "behaving like white men who think they are behaving like black men," rather than understand that Basquiat was grappling with both the pull of a genealogy that is fundamentally "black" (rooted in African diasporic "primitive" and "high art" traditions) and a fascination with white Western traditions. Articulating the distance separating traditional Eurocentric art from his own history and destiny and from the collective fate of diasporic black artists and black people, Basquiat's paintings testify.

To bear witness in his work, Basquiat struggled to utter the unspeakable. Prophetically called, he engaged in an extended artistic elaboration of a politics of dehumanization. In his work, colonization of the black body and mind is marked by the anguish of abandonment, estrangement, dismemberment, and death. Red paint drips like blood on his untitled painting of a black female, identified by a sign that reads "Detail of Maid from Olympia." A dual critique is occurring here. First, the critique of Western imperialism and then the critique of the way in which imperialism makes itself heard, the way it is reproduced in culture and art. This image is ugly and grotesque. That is exactly how it should be. For what Basquiat unmasks is the ugliness of those traditions. He takes the Eurocentric valuation of the great and beautiful and demands that we acknowledge the brutal reality it masks.

The "ugliness" conveyed in Basquiat paintings is not solely the horror of colonizing whiteness; it is the tragedy of black complicity and betrayal. Works like "Irony of a Negro Policeman" (1981) and "Quality Meats for the Public" (1982) document this stance. The images are nakedly violent. They speak of dread

and terror, of being torn apart and ravished. Commodified, appropriated, made to "serve" the interests of white masters, the black body as Basquiat shows it is incomplete, never fulfilled. And even when he is "calling out" the work of black stars— sports figures, entertainers—there is still the portrayal of incompleteness and the message that complicity negates. These works suggest that assimilation and participation in a bourgeois white paradigm can lead to a process of self-objectification that is just as dehumanizing as any racist assault by white culture. Content to be only what the oppressors want, this black image can never be fully self-actualized. It must always be represented as fragmented. Expressing a firsthand knowledge of the way assimilation and objectification lead to isolation, Basquiat's black male figures stand alone and apart; they are not whole people.

It is much too simplistic a reading to see works like "Jack Johnson" (1982) and "Untitled (Sugar Ray Robinson)" (1982) as solely celebrating black culture. Appearing always in these paintings as half-formed or somehow mutilated, the black male body becomes iconographically a sign of lack and absence. This image of incompleteness mirrors those in works that more explicitly critique white imperialism. The painting "Native Carrying Some Guns, Bibles, Amorites on Safari" (1982) graphically evokes images of incomplete blackness. With wicked wit, Basquiat states in the lower right-hand corner of the work, "I wont even mention gold (oro)," as though he needed to remind onlookers of a conscious interrogating strategy behind the skeletal, cartoonlike images.

In Basquiat's work, flesh on the black body is almost always falling away. Like skeletal figures in the Australian aboriginal bark painting described by Robert Edward (X-ray paintings, in which the artist depicts external features as well as the internal organs of animals, humans, and spirits in order to emphasize "that there is more to a living thing than external appearances"), these figures have been worked down to the bone. To do justice

to this work, then, our gaze must do more than reflect surface appearances. Daring us to probe the heart of darkness, to move our eyes beyond the colonizing gaze, the paintings ask that we hold in our memory the bones of the dead while we consider the world of the black immediate, the familiar.

To see and understand these paintings, one must be willing to accept the tragic dimensions of black life. In *The Fire Next Time*, James Baldwin declared that "for the horrors" of black life "there has been almost no language." He insisted that it was the privacy of black experience that needed "to be recognized in language." Basquiat's work gives that private anguish artistic expression.

Stripping away surfaces, Basquiat confronts us with the naked black image. There is no "fleshy" black body to exploit in his work, for that body is diminished, vanishing. Those who long to be seduced by that black body must look elsewhere. It is fitting that the skeletal figures displayed again and again in Basquiat's work resemble those depicted in Gillies Turle's book *The Art of the Maasai*. Both Maasai art and Basquiat's work delineate the violent erasure of a people, their culture and traditions. This erasure is rendered all the more problematic when artifacts of that "vanishing culture" are commodified to enhance the aesthetics of those perpetuating the erasure.

The world of Maasai art is a world of bones. Choosing not to work with pigments when making paintings or decorative art, the Maasai use bones from hunting animals in their art to give expression to their relationship with nature and with their ancestors. Maasai artists believe that bones speak, tell all the necessary cultural information, take the place of history books. Bones become the repository of personal and political history. Maasai art survives as a living memory of the distinctiveness of a black culture that flourished most vigorously when it was undiscovered by the white man. It is this privacy that white imperialism violates and destroys. Turle emphasizes that while the bones are "intense focus points to prime minds into a deeper

receptive state," this communicative power is lost on those who are unable to hear bones speak.

Even though socially Basquiat did not "diss" those white folks who could not move beyond surface appearances (stereotypes of entertaining darkies, pet Negroes and the like), in his work he serves notice on that liberal white public. Calling out their inability to let the notion of racial superiority go, even though it limits and restricts their vision, he mockingly deconstructs their investment in traditions and canons, exposing a collective gaze that is wedded to an aesthetic of white supremacy. The painting "Obnoxious Liberals" (1982) shows us a ruptured history by depicting a mutilated black Samson in chains and then a more contemporary black figure, no longer naked but fully clothed in formal attire, who wears on his body a sign that boldly states, "Not For Sale." That sign is worn to ward off the overture of the large, almost overbearing white figure in the painting. Despite the incredible energy Basquiat displayed playing the how-to-be-a-famous-artist-in-the-shortest-amount-of-time game— courting the right crowd, making connections, networking his way into high, "white" art places—he chose to make his work a space where that process of commodification is critiqued, particularly as it pertains to the black body and soul. Unimpressed by white exoticization of the "Negro," he mocks this process in works that announce an "undiscovered genius of the Mississippi delta," forcing us to question who makes such discoveries and for what reason.

Throughout his work, Basquiat links imperialism to patriarchy, to a phallocentric view of the universe where male egos become attached to a myth of heroism. The image of the crown, a recurring symbol in his work, calls to and mocks the Western obsession with being on top, the ruler. Art historian Robert Farris Thompson suggests that the icon of the crown reflects Basquiat's ongoing fascination with the subject matter of "royalty, heroism, and the streets." McEvilley interprets the

crown similarly, seeing it as representative of a "sense of double identity, a royal selfhood somehow lost but dimly remembered." He explains that "in Basquiat's oeuvre, the theme of divine or royal exile was brought down to earth or historicized by the concrete reality of the African diaspora. The king that he once was in another world (and that he would be again when he returned there) could be imagined concretely as a Watusi warrior or Egyptian pharaoh."

There is no doubt that Basquiat was personally obsessed with the idea of glory and fame, but this obsession is also the subject of intense self-interrogation in his paintings. Both Thompson and McEvilley fail to recognize Basquiat's mocking, bitter critique of his own longing for fame. In Basquiat's work the crown is not an unambiguous image; while it may positively speak of the longing for glory and power, it connects that desire to dehumanization, to the general willingness on the part of males globally to commit any unjust act that will lead them to the top. In the painting "Crowns (Peso Neto)" (1981), black figures wear crowns but are sharply contrasted with the lone white figure wearing a crown, for it is that figure that looms large, overseeing a shadowy world, as well as the world of black glory.

In much of Basquiat's work the struggle for cultural hegemony in the West is depicted as a struggle between men. Racialized, it is a struggle between black men and white men over who will dominate. In "Charles the First" (1982), we are told "Most Young Kings Get Thier [sic] Head Cut Off." Evoking a political and sexual metaphor that fuses the fear of castration with the longing to assert dominance, Basquiat makes it clear that black masculinity is irrevocably linked to white masculinity by virtue of a shared obsession with conquest, both sexual and political.

Historically, competition between black and white males has been highlighted in the sports arena. Basquiat extends that field of competition into the realm of the cultural (the poster of him

and Andy Warhol duking it out in boxing attire and gloves is not as innocent and playful as it appears to be), and the territory is music, jazz in particular. Basquiat's work calls attention to the innovative power of black male jazz musicians, whom he reveres as creative father figures. Their presence and work embody for him a spirit of triumph. He sees their creativity exceeding that of their white counterparts. They enable him not only to give birth to himself as a black genius but also to accept the wisdom of an inclusive standpoint.

Braithwaite affirms that Basquiat felt there was a cultural fusion and synthesis in the work of black male jazz musicians that mirrored his own aspirations. This connection is misunderstood and belittled by Gopnik in his essay "Madison Avenue Primitive" (note the derision the title conveys) when he arrogantly voices his indignation at Basquiat's work being linked with that of great black jazz musicians. With the graciousness and high-handedness of an old-world paternalistic colonizer, Gopnik declares that he can accept that the curator of the Basquiat show attempted to place him in a high-art tradition: "No harm, perhaps, is done by this, or by the endless comparisons in the catalogue of Basquiat to Goya, Picasso, and other big names." But, Gopnik fumes, "What is unforgivable is the endless comparisons in the catalogue essays of Basquiat to the masters of American jazz."

Gopnik speaks about Basquiat's own attempts to play jazz and then proceeds to tell us what a lousy musician Basquiat really was. He misses the point. Basquiat never assumed that his musical talent was the same as that of jazz greats. His attempt to link his work to black jazz musicians was not an assertion of his own musical or artistic ability. It was a declaration of respect for the creative genius of jazz. He was awed by all the avant-garde dimensions of the music that affirm fusion, mixing, improvisation. And he felt a strong affinity with jazz artists in the shared will to push against the boundaries of conventional (white)

artistic tastes. Celebrating that sense of connection in his work, Basquiat creates a black artistic community that can include him. In reality, he did not live long enough to search out such a community and claim a space of belonging. The only space he could claim was that of shared fame.

Fame, symbolized by the crown, is offered as the only possible path to subjectivity for the black male artist. To be un-famous is to be rendered invisible. Therefore, one is without choice. You either enter the phallocentric battlefield of representation and play the game or you are doomed to exist outside history. Basquiat wanted a place in history, and he played the game. In trying to make a place for himself—for blackness—in the established art world, he assumed the role of explorer/colonizer. Wanting to make an intervention with his life and work, he inverted the image of the white colonizer.

Basquiat journeyed into the heart of whiteness. White territory he named as a savage and brutal place. The journey is embarked upon with no certainty of return. Nor is there any way to know what you will find or who you will be at journey's end. Braithwaite declares: "The unfortunate thing was, once one did figure out how to get into the art world, it was like, well, shit, where am I? You've pulled off this amazing feat, you've waltzed your way right into the thick of it, and probably faster than anybody in history, but once you got in you were standing around wondering where you were. And then, Who's here with me?" Recognizing art world fame to be a male game, one that he could play, working the stereotypical darky image, playing the trickster, Basquiat understood that he was risking his life—that this journey was all about sacrifice.

What must be sacrificed in relation to oneself is that which has no place in whiteness. To be seen by the white art world, to be known, Basquiat had to remake himself, to create from the perspective of the white imagination. He had to become both native and nonnative at the same time—to assume the blackness

defined by the white imagination and the blackness that is not unlike whiteness. As anthropologist A. David Napier explains in his book Foreign Bodies: "Strangers within our midst are indeed the strangest of all—not because they are so alien, but because they are so close to us. As so many legends of 'wildmen,' wandering Jews, and feral children remind us, strangers must be like us but different. They cannot be completely exotic, for, were they so, we could not recognize them."

For the white art world to recognize Basquiat, he had to sacrifice those parts of himself they would not be interested in or fascinated by. Black but assimilated, Basquiat claimed the space of the exotic as though it were a new frontier, waiting only to be colonized. He made of that cultural space within whiteness (the land of the exotic) a location where he would be re-membered in history even as he simultaneously created art that unsparingly interrogates such mutilation and self-distortion. As cultural critic Greg Tate asserts in "Nobody Loves a Genius Child," for Basquiat "making it . . . meant going down in history, ranked beside the Great White Fathers of Western painting in the eyes of the major critics, museum curators and art historians who ultimately determine such things."

Willingly making the sacrifice in no way freed Basquiat from the pain of that sacrifice. The pain erupts in the private space of his work. It is amazing that so few critics discuss configurations of pain in Basquiat's work, emphasizing instead its playfulness, its celebratory qualities. This reduces his painting to spectacle, making the work a mere extension of the minstrel show that Basquiat frequently turned his life into. Private pain could be explored in art because he knew that a certain world "caught" looking would not see it, would not even expect to find it there. Francesco Penizzi begins to speak about this pain in his essay, "Black and White All Over: Poetry and Desolation Painting," when he identifies Basquiat's offerings as "self-immolations, Sacrifices of the Self" which do not emerge from desire, but

from the desert of hope." Rituals of sacrifice stem from the inner workings of spirit that inform the outer manifestation.

Basquiat's paintings bear witness, mirror this almost spiritual understanding. They expose and speak the anguish of sacrifice. A text of absence and loss, they echo the sorrow of what has been given over and given up. McEvilley's insight that "in its spiritual aspect, [Basquiat's] subject matter is orphic—that is, related to the ancient myth of the soul as a deity lost, wandering from its true home, and temporarily imprisoned in a degradingly limited body" appropriately characterizes that anguish. What limits the body in Basquiat's work is the construction of maleness as lack. To be male, caught up in the endless cycle of conquest, is to lose out in the realm of fulfillment.

Significantly, there are few references in Basquiat's work that connect him with a world of blackness that is female or to a world of influences and inspirations that are female. That Basquiat, for the most part, disavows a connection to the female in his work is a profound and revealing gap that illuminates and expands our vision of him and his work. Simplistic pseudo-psychoanalytic readings of his life and work lead critics to suggest that Basquiat was a perpetual boy always in search of the father. In his essay for the Whitney catalogue, critic René Ricard insists: "Andy represented to Jean the 'Good White Father' Jean had been searching for since his teenage years. Jean's mother has always been a mystery to me. I never met her. She lives in a hospital, emerging infrequently, to my knowledge. Andy did her portrait. She and Andy were the most important people in Jean's life."

Since Basquiat was attached to his natural father, Gerard, as well as surrounded by other male mentor figures, it seems unlikely that the significant "lack" in his life was an absent father. Perhaps it was the presence of too many fathers—paternalistic cannibals who overshadowed and demanded repression of attention for and memory of the mother or any feminine/female

principle—that led Basquiat to be seduced by the metaphoric ritual sacrifice of his fathers, a sort of phallic murder that led to a death of the soul.

The loss of his mother, a shadowy figure trapped in a world of madness that caused her to be shut away, symbolically abandoned and abandoning, may have been the psychic trauma that shaped Basquiat's work. Andy Warhol's portrait of Matilde Basquiat shows us the smiling image of a black Puerto Rican woman. It was this individual, playfully identified by her son as "bruja" (witch), who first saw in Jean-Michel the workings of artistic genius and possibility. His father remembers, "His mother got him started and she pushed him. She was actually a very good artist." Jean-Michel also gave testimony, "I'd say my mother gave me all the primary things. The art came from her." Yet this individual who gave him the lived texts of ancestral knowledge as well as that of the white West is an absent figure in the personal scrapbook of Basquiat as successful artist. It is as if his inability to reconcile the force and power of femaleness with phallocentrism led to the erasure of female presence in his work.

Conflicted in his own sexuality, Basquiat is nevertheless represented in the Whitney catalogue and elsewhere as the stereotypical black stud randomly fucking white women. No importance is attached by critics to the sexual ambiguity that was so central to the Basquiat diva persona. Even while struggling to come to grips with himself as a subject rather than an object, he consistently relied on old patriarchal notions of male identity despite the fact that he critically associated maleness with imperialism, conquest, greed, endless appetite and, ultimately, death.

To be in touch with senses and emotions beyond conquest is to enter the realm of the mysterious. This is the oppositional location Basquiat longed for yet could not reach. This is the feared location, associated not with meaningful resistance but with madness, loss, and invisibility. Basquiat's paintings evoke a

sense of dread. But the terror there is not for the world as it is, the decentered, disintegrating West, that familiar terrain of death. No, the dread is for that unimagined space, that location where one can live without the "same old shit."

Confined within a process of naming, of documenting violence against the black male self, Basquiat was not able to chart the journey of escape. Napier asserts that "in naming, we relieve ourselves of the burden of actually considering the implication of how a different way of thinking can completely transform the conditions that make for meaningful social relations." A master deconstructivist, Basquiat was not then able to imagine a concrete world of collective solidarities that could alter in any way the status quo. McEvilley sees Basquiat's work as an "iconographic celebration of the idea of the end of the world, or of a certain paradigm of it." While the work clearly calls out this disintegration, the mood of celebration is never sustained. Although Basquiat graphically portrays the disintegration of the West, he mourns the impact of this collapse when it signals doom in black life. Carnivalesque, humorous, playful representations of death and decay merely mask the tragic, cover it with a thin veneer of celebration. Clinging to this veneer, folks deny that a reality exists beyond and beneath the mask.

Black gay filmmaker Marlon Riggs recently suggested that many black folks "have striven to maintain secret enclosed spaces within our histories, within our lives, within our psyches about those things which disrupt our sense of self." Despite an addiction to masking/masquerading in his personal life, Basquiat used painting to disintegrate the public image of himself that he created and helped sustain. It is no wonder then that this work is subjected to an ongoing critique that questions its "authenticity and value." Failing to represent Basquiat accurately to that white art world that remains confident it "knew" him, critics claim and colonize the work within a theoretical apparatus of appropriation that can diffuse its power by making it always and only

spectacle. That sense of "horrific" spectacle is advertised by the paintings chosen to don the covers of every publication on his work, including the Whitney catalogue.

In the conclusion to The Art of the Maasai, Turle asserts: "When a continent has had its people enslaved, its resources removed, and its lands colonized, the perpetrators of these actions can never agree with contemporary criticism or they would have to condemn themselves." Refusal to confront the necessity of potential self-condemnation makes those who are least moved by Basquiat's work insist on knowing it best. Understanding this, Braithwaite articulates the hope that Basquiat's work will be critically reconsidered, that the exhibition at the Whitney will finally compel people to "look at what he did."

But before this can happen, Braithwaite cautions, the established white art world (and I would add the Eurocentric, multi-ethnic viewing public) must first "look at themselves." With insight he insists: "They have to try to erase, if possible, all the racism from their hearts and minds. And then when they look at the paintings they can see the art." Calling for a process of decolonization that is certainly not happening (judging from the growing mass of negative responses to the show), Braithwaite articulates the only possible cultural shift in perspective that can lay the groundwork for a comprehensive critical appreciation of Basquiat's work.

The work by Basquiat that haunts my imagination, that lingers in my memory, is "Riding with Death" (1988). Evoking images of possession, of riding and being ridden in the Haitian voudoun sense—as a process of exorcism, one that makes revelation, renewal and transformation possible—I feel the subversion of the sense of dread provoked by so much of Basquiat's work. In its place is the possibility that the black-and-brown figure riding the skeletal white bones is indeed "possessed." Napier invites us to consider possession as "truly an avant-garde activity, in that those in trance are empowered to go to the periphery of what is

and can be known, to explore the boundaries, and to return unharmed." No such spirit of possession guarded Jean-Michel Basquiat in his life. Napier reports that "people in trance do not—as performance artists in the West sometimes do—leave wounded bodies in the human world." Basquiat must go down in history as one of the wounded. Yet his art will stand as the testimony that declares with a vengeance: we are more than our pain. That is why I am most moved by the one Basquiat painting that juxtaposes the paradigm of ritual sacrifice with that of ritual recovery and return.

3

WHAT'S PASSION GOT TO DO WITH IT?

An interview with Marie-France Alderman

All of bell hooks's essays include an unforgettable testimony, a personal story told with trust. Why people tend to remember hooks's words has to do with that trust—which is a leap of faith and which, in the face of what she chooses to talk about, remember and imagine, makes her much more than "one of the foremost black intellectuals in America today." bell hooks has a way of offering herself up on the sacrificial altar of critical inquiry that involves my heart and mind: I am always left with the exhilarating insights only seasoned raconteurs can inspire, hooks is *the personal is political* thirty years later, flagrant proof that feminism engenders pleasure and hope and the renewed lives that come with them.

bell hooks's Black Looks established her reputation as an important film critic. Relentless in her conviction that "many audiences in the United States resist the idea that images

have an ideological content," hooks goes about piercing "the wall of denial" with some of the fiercest and sexiest film analyses ever published. An essay hooks wrote for *Visions* about *The Crying Game* and *The Bodyguard* and an interview that took place in New York in September give us a glimpse into a mind for which intellectual pleasure, art, and political intervention are one and the same.

—Marie-France Alderman

bell hooks: A friend from Ireland once said to me, "You know, you'll never make it in the United States because there's no place for passion"—not to mention for being a passionate woman. That's probably what feminism was initially about: How do we make room for self-determining, passionate women who will be able to just be? I am passionate about everything in my life—first and foremost, passionate about ideas. And that's a dangerous person to be in this society, not just because I'm a woman, but because it's such a fundamentally anti-intellectual, anti-critical thinking society. I don't think we can act like it's so great for men to be critical thinkers either. This society doesn't want anybody to be a critical thinker. What we as women need to ask ourselves is: "In what context within patriarchy do women create space where we can protect our genius?" It's a very, very difficult question. I think I most cultivated myself in the home space, yet that's the space that is most threatening: it is much harder to resist a mother who loves you and then shames you than it is an outside world that does the same. It's easier to say "no" to the outside world. When a lover tells you—as I've been told—"My next girlfriend will be dumb," I think, "What is that message about?" Female creativity will have difficulty making itself seen. And when you add to that being a black female or a colored female, it becomes even more difficult.

Marie-France Alderman: What about the representation of black female creativity in recent films?

bh: *What's Love Got to Do With It, The Bodyguard,* and *Poetic Justice* involve passionate black women characters, but they all rely on this packaging of black women musical icons— Janet Jackson, Tina Turner, and Whitney Houston. No one says you have to see *The Bodyguard* because Whitney Houston is such a great actress, because we know she's not a great actress at all. We're going to see what this musical icon does in this movie. Is this Hollywood saying we still can't take black women seriously as actresses?

MFA: Perhaps only as entertainers—

bh: Why does the real Tina Turner have to come in at the end of *What's Love Got to Do With It*? It's like saying that Angela Bassett isn't a good enough actress—which I didn't think she was—by the way, and that's part of why, in a sense, it becomes Larry Fishburne's narrative of Ike, more so than the narrative of Tina Turner. It's a very tragic film, because you sit in the theater and you see people really identify with the character of Ike, not with the character of Tina Turner. In my essay "Selling Hot Pussy," in *Black Looks,* I talked about how Ike constructed the whole idea of Tina Turner's character from those television movies of *Sheena, Queen of the Jungle.*

MFA: And you talk about how she was, in fact, anything but a wild woman.

bh: *I, Tina,* Tina Turner's autobiography, is so much about her tragedy—the tragedy of being this incredibly talented woman in a family that didn't care for you. Then you meet this man who appears to really care for you, who exploits you, but at the same time, you're deeply tied to

him. One of the things in the film that was so upsetting was when Tina Turner lost her hair. The filmmakers make that a funny moment. But can we really say that any woman losing her hair in this culture could be a funny moment? No one ever speculates that maybe Tina stayed with Ike because as a woman with no hair in this culture, she had no real value. That no amount of wigs . . .

MFA: or great legs . . .

bh: . . . no amount of being this incredible star could make up for the fact that she had bald spots. I mean, think about the whole relationship—not only of women in general in this culture to hair, but of black women to hair. *What's Love* takes that incredibly tragic moment in a young female's life and turns it into laughter, into farce. What I kept thinking about was why this culture can't see a serious film that's not just about a black female tragedy, but about a black female triumph. It's so interesting how the film stops with Ike's brutality, as though it is Tina Turner's life ending. Why is it that her success is less interesting than the period of her life when she's a victim?

MFA: Tina Turner lost control of her own story somewhere along the line.

bh: Part of what remains tragic about a figure like Tina Turner is that she's still a person who has to work through that image of her that Ike created. I don't know if this is true but I heard that she sold her story to Hollywood but didn't ask to go over the script or for rights of approval. Obviously, she didn't. Otherwise how could it have become cinematically Ike's story? And why do we have to hear about Larry Fishburne not wanting to do this film unless there can be changes in Ike's character; unless that character can be softened, made to feel more human?

I mean, Fuck Ike! That's how I feel. You know, all these black people—particularly black men—have been saying to me, "Ike couldn't have treated her that bad." Why don't they say, "Isn't it tragic that he did treat her so bad?" This just goes to show you how we, as black people in this country, remain sexist in our thinking of men and women. The farcical element of this film has to do not just with the producers thinking that white people won't take seriously a film about a black woman who's battered and abused but that black people won't either. So you have to make it funny. I was very frightened by the extent to which laughter circulated in that theater over stuff that wasn't funny. That scene with her hair is so utterly farcical. The fact is that no fucking woman—including Tina Turner—is beautiful in her body when she's being battered. The real Tina Turner was sick a lot. She had all kinds of health problems during her life with Ike. Yet the film shows us this person who is so incredibly beautiful and incredibly sexual. We don't see the kind of contrast Tina Turner actually sets up in her autobiography between, "I looked like a wreck one minute, and then, I went on that stage and projected all this energy." The film should have given us the pathos of that, but it did not at all because farce can't give you the pathos of that.

MFA: When you talk about Tina Turner going from a victimized, overworked woman, who is always sick, to an entertainer who jumps to the stage—that's consistent with a conception of black life that goes from the cotton field to tap dancing.

bh: Absolutely.

MFA: Maybe we can't imagine anything about black lives beyond that.

bh: We can't imagine anything else as long as Hollywood and the structures of filmmaking keep these very "either/or" categories. The Bodyguard makes a significant break with Hollywood construction of black female characters—not because Whitney Houston has sex with this white man, but because the white man, Frank Farmer, says that her life is valuable, that her life is worth saving. Traditionally, Hollywood has said, "Black women are backdrops; they're dixie cups. You can use them and dispense them." Now, here's a whole film that's saying just the opposite. Whether it's a bad film is beside the point. The fact is, millions and millions of people around the world are looking at this film which, at its core, challenges all our perceptions of the value of not only black life but of black female life. To say that a black, single mother's life is valuable, is really a very revolutionary thing in a society where black women who are single parents are always constructed in the public imagination as unbeautiful, unsexy, unintelligent, deranged, what have you. At the same time, the film's overall message is paternalistic. I found it fascinating that we see Kevin Costner's character related to God, Nation, and country.

MFA: The same thing happened in *Dances with Wolves*.

bh: And in *The Crying Game*, where you have white men struggling with their identity. In *The Bodyguard*, we're dealing with a white boy who is the right, for God, for country but who somehow finds himself at a moment of crisis in his life—having sex, falling in love with this black woman. That's what he needs to get himself together but once he's together, he has to go back. So, we have the final shots in the film where he's back with God and Nation. It's all white. It's all male, and of course, the film makes us feel that he's made the right choice.

He didn't allow himself to be swept away by otherness and difference, yet the very reason this film can gross $138 million is that people are fascinated right now with questions of otherness and difference. Both Kevin Costner and Neil Jordan repeatedly said that their films had nothing to do with race. Kevin Costner said that "it would be a pity if people went to see *The Bodyguard* and thought it was about race." Well, why the fuck does he think millions of people want to see it? Nobody cares about white men fucking black women. People care about the idea of a rich white man—the fictional man, Frank Farmer, but also the real Kevin Costner—being fascinated by Whitney Houston. They went to see a film about love, not about fucking, because we can see any number of porno films where white men are fucking black women. *The Bodyguard* is about a love so powerful that it makes people transgress certain values. Think again about how it compares with *The Crying Game*, where once again, we have this theme of desire and love so powerful that it allows one to transcend national identity, racial identity, and finally, sexual identity. I find that to be the ultimate reactionary message in both of these films: We don't need politics. We don't need struggle. All we need is desire. It is desire that becomes the place of connection. This is a very postmodern vision of desire, as the new place of transgression that eliminates the need for radical politics.

MFA: In their introduction to *Angry Women*, Andrea Juno and V. Vale explained the current fascination with gender bending and sexual transgression as a reaction to overpopulation. In other words humans know they've outgrown a certain system and "are starting to exercise their option to reinvent their biological destinies." Could that be why desire has become so important?

bh: That's a mythopoetic reading that I don't have problems with, but I think the interesting thing about it is that it returns us to a dream that I think is very deep in this society right now, which is a dream of transformation—of transforming a society—that doesn't have to engage in any kind of unpleasant, sacrificial, political action. You know a film I saw recently that was very moving to me—and I kept contrasting it to *Menace II Society*—was the film *Falling Down*. There is a way to talk about *Falling Down* as describing the end of Western civilization. Black philosopher Cornel West talks about the fact that part of the crisis we're in has to do with Western patriarchal biases no longer functioning, and there is a way in which *Falling Down* is about a white man who's saying, I trusted in this system. I did exactly what the system told me to and it's not working for me. It's lied to me." That doesn't mean you have the right to be so angry that you can attack people of color or attack other marginal groups. In so many ways, though, that's exactly how a lot of white people feel. There's this sense that if this white supremacist capitalist patriarchy isn't working for white people —most especially for working-class white men, or middle-class white men—it's the fault of some others out there. It's in this way that the structure has fed on itself. The fact is when you have something that gets as fierce as the kind of greed we have right now, then white men are going to have to suffer the fallout of that greed as well. That's one of the scary things about Bosnia and Croatia: we're not seeing the fallout played out on the field of the bodies of people of color—which is what America is used to seeing on its television. The dead bodies of color around the world symbolize a crisis in imperialism and the whole freaky thing of white supremacy. It's interesting that people don't talk about ethnic cleansing as tied to

mythic notions of race purity and white supremacy which are so much a part of what this country is struggling with. What South Africa is struggling with—that myth of white supremacy—is also being played out by black Americans when we overvalue those who are light-skinned and have straight hair, while ignoring other black people. It all shows how deeply that myth has inserted itself in all our imaginations. *Falling Down* captures not only the horror of that but also the role that the mass media has played in that. In the one scene where the white man is trying to use that major weapon and the little black boy shows him how to, the man says to this little boy, "Well, how do you know how to use it?" The boy says, "I've seen it in movies."

Menace II Society, which I thought was really just a reactionary film on so many levels, offers itself to us as "black culture," yet what the film actually interrogates within its own narrative is that these black boys have learned how to do this shit not from black culture but from watching white gangster movies. The film points out that the whole myth of the gangster—as it is being played out in rap and in movies—is not some Afrocentric or black-defined myth, it's the public myth that's in all our imaginations from movies and television. There was the scene in *Menace II Society*, where we see them watching those white gangster movies and wanting to be like that, and that is the tragedy of white supremacy and colonization. It's delivered to us in the whole package of the film, as being about blackness, as being a statement about black young people and where they are, but it is, in truth, a statement about how white supremacy has shaped and perverted the imagination of young black people. What the film says is that these people have difficulty imagining any way out of their lives and the film doesn't really

subvert that. It says to you: When you finally decide to imagine a way out, that's when you get blown away. The deeper message of the film is: Don't imagine a way out, because the person who's still standing at the end of the film has been the most brutal. But in *Falling Down* the white man is not still standing. He hasn't conquered the turf. There's this whole sense of, "Yeah, you now see what everyone else has been seeing, which is that the planet has been fucked up and you're going to be a victim of it too," as opposed to the way in which *Menace II Society* suggests—mythically almost—that the genocide we are being entertained by is not going to be complete, that there are going to be the unique and special individuals who will survive the genocide but they're not the individuals who were dreaming of a way out. That's why these films are anti-utopian. They're antirevolution because they shut down the imagination, and it's very, very frightening. In the same way, I was disturbed lately by the film, *Just Another Girl on the I.R.T.* Subtextually, its a fucking antiabortion film. This woman who is portrayed as so powerful and thoughtful yet she can't make a decision about what to do with her body. I teach young women at a city college: these women would not be so confused when it came to their bodies, but that's how people imagine lower-class black women. I teach single mothers who have had the will and the power to go forward with their lives while this society says to them, "How dare you think you can go forward with your life and fulfill your dreams?'

MFA: Camille Billops's film *Finding Christa* addresses that. Talk about revolutionary. A woman—Billops herself—does something for the sake of her art very few of us would ever think of doing: give her young daughter up for

adoption. And then, twenty years later, far from denying anything, instead celebrates it all over again through the making of the film. *Finding Christa* is a very troubling and interesting film.

bh: I think it was disturbing on a number of levels. It's interesting that we can read about men who have turned their back on parenting to cultivate their creativity and their projects and no one ever thinks it's horrific, but a lot of us, including myself, were troubled by what we saw in Camille Billops's film. This woman went to such measures to ensure that she had the space to continue being who she wanted to be, and at the same time, it felt very violent and very violating of the daughter. I've always liked Camille Billops's films. *Suzanne Suzanne* is one of my favorite films because more than any other films by independent black filmmakers, she really compels people to think about the contradictions and complexities that beset people. We're not used to women artists of any race exerting that kind of relationship to art.

MFA: Billops did what *she* thought she had to do. You know, "A woman's gotta do what a woman's gotta do."

bh: It's funny. I was reading this interview with Susan Sarandon about *Thelma and Louise*, another very powerful film that turns into a farce.

MFA: *Thelma and Louise* is a reactionary film. The women might be feisty for a while but at the end they've got to off themselves. These women would have been heroic if they'd *refused* to disappear. Imagine the story of two male outlaws who, when the going gets tough decide to hold each other's hand and dive into oblivion. How cool is that? But somehow it is cool to think of women

disappearing, killing themselves. Maybe it's a collective unconscious wish.

bh: But there is this one scene at the beginning. When Susan Sarandon's character says, "When a woman is crying, she's not having a good time." There is that sense that she doesn't shoot him because of the attempted rape, she shoots him because of his complete and utter fucking indifference. In that moment, a lot of men saw how this indifference fucking hurts, but then, it's all undermined by everything that happens after that scene. That's the tragedy of *Thelma and Louise*: it doesn't offer empowerment by the end, it's made feminism a joke, it's made rebellion a joke, and in the traditional patriarchal manner, it's made death the punishment.

MFA: Yet many feminists—lesbian and straight—stood up and cheered when the two protagonists decide to commit suicide.

bh: Filmmaker Monika Treut said something similar to what I'm about to say, which is that if people are starving and you give them a cracker they're not going to say, "Gee, this cracker is limited. It's not what I deserve. I deserve a full meal." As a feminist, I think it's pathetic that people want to cheer *Thelma and Louise*, a film so narrow in its vision, so limited. But I hear that from black people about black films that I critique: This is all we have. So, we've got to celebrate something magical and transformative in a film and at the same time discuss it critically.

MFA: Artist Lawrence Weiner calls that flirting with madness.

bh: A lot of women have found themselves falling into madness when the world does not recognize them and they cannot recognize themselves in the world. This is

exemplified in the lives of people like Sylvia Plath, Anne Sexton, Virginia Woolf, and Zora Neale Hurston. That's because there's a lot that happens to women of all races —and black women in particular—who become stars. There's envy. I was just home recently at a family reunion, and people said such mean and brutal things to me that I started to think, "What's going on here?" And my brother said that a lot of what's going on here is envy. There's a part of me that says, "I don't want to go further with my life, further with my creativity, because if people envy me, they'll torture me." It's not so much a sense of not being able to handle anything; it's a sense of not being able to handle torture. We hear all these statistics about how many women are raped and beaten every so many seconds yet when we talk about having fear in patriarchy, we're made to feel that that's crazy. What incredible women today—especially those who are feminists—aren't talked about in many contexts as mad? We fall into periods of critical breakdown, because we often feel there is no world that will embrace us.

MFA: When I think about madness, I am reminded of R. D. Laing who said that one's self is an illusion; that we hallucinate the abyss, but that we can also make this leap of faith that the abyss is perfect freedom—that it won't lead to self-annihilation or destruction but the exact opposite.

bh: I think the reality is that the world exists only inasmuch as people like us make it. So, I don't want to suggest that we can't have it. We have to make it. However, if I am lured into thinking that because everyone's bought my books and I've got these reviews, there's already a place—that's where I could get really screwed. You can go crazy looking for these people who bought your books, wrote reviews and said you were a great thinker,

or da-da-da-da-da. I think that's where envy comes in. That's why the movie *Amadeus* was so fascinating because it says that sometimes people try to destroy you, precisely because they recognize your power—not because they don't see it, but because they see it and they don't want it to exist. That's why Madonna, who is one of the most powerful, creative women in the United States today, has reinvented her public image to be that of the subordinate, victimized woman. In a sense, it allows her to exist without horror. What would really be going on for Madonna if she was putting forth an image that said: "I'm so powerful, I'm going to recover myself. I'm going to deal with the childhood abuse that happened in my life, and I'm going to continue to creatively imagine ways for women to be sexually free"? I think she would be a much more threatening image than she is in some little-girl pornographic shoot in *Vanity Fair*. Such images allow her to be bought and dismissed.

MFA: Perhaps it's a conscious strategy on her part: One soothing little girl photo session, then bam—she breaks or at least confronts a new taboo.

bh: Sandra Bernhard is another creative woman who has struggled with questions of transgression and has broken new ground. I just finished reading her book, *Love, Love, Love*. There's something particularly exciting in the way she toys with notion of difference, the way she problematizes black female and white female relations, and the way she talks about traditional seduction and gaslighting sexuality—capturing and conquest.

MFA: Which is a concept—to seduce and betray—that comes back a lot in your own work.

bh: I used to have this friend, we always wrote about movies

in our journals—discussions of different movies. One of the things we wrote about was a discussion about gaslighting and how in the great gaslighting films of Hitchcock there was always some attempt at reconciliation, whereas now we get gaslighting films like *Jagged Edge* where no order is restored by the end of the film. There is not restoration of harmony that involves a union of male and female—some reconciliation of the act of betrayal. In real life—with friends, with lovers, with parents—we're always having to struggle to reconcile betrayal. We don't just drop everyone who betrays us and move on to better love. We are called upon by life to work through certain forms of betrayal.

MFA: To get to better love.

bh: Absolutely. Grappling with betrayal leads to an understanding of compassion, forgiveness, and acceptance that makes for a certain kind of powerful love. People get annoyed at me for this, but I liked Streisand's *Prince of Tides*. I thought that *Prince of Tides* was two films. One is about the issues of self-restoration in order to love, which is what the Nick Nolte character is all about. Then there's the bullshit film of Barbra Streisand wanting to seduce the WASP man. I recently looked at *Prince of Tides* fast-forwarding all the scenes of her sexual relationship with him and it became a very poignant film about male return to the possibility of love. The film does suggest to men the they're not going to be able to love and experience any kind of mature relationship and sustain a relationship of joy without some self-interrogation. A lot of white male recovery films—*The Fisher King* and others— are trying to say just that: "White man, you're going to have to look at yourself with some degree of critical thought, if you are to experience any love at all." But

there don't seem to be any films that suggest to the black man that he needs to look at himself critically in order to know love.

MFA: What about Burnett's *To Sleep with Anger*?

bh: Charles Burnett is a powerful filmmaker, yet here's his weakest film and that's the one that gets the most attention. The Danny Glover character is so powerful, yet we don't know why. Is he a symbol of creativity gone amok?

MFA: He's like the rainmaker—you know, Burt Lancaster's *Rainmaker*.

bh: Oh, absolutely. When he lies down on that kitchen floor, there's no capacity to utilize his magic and his creativity. He's just gone in terms of images of black men, I would just say that John Sayles's portrait of the black male character *Brother from Another Planet* is a transgressive moment. The love scene between that character and the women in *City of Hope* is an interesting representation of what allows males to enter the space of heterosexual intercourse in a way that is evocative of tenderness and mutual pleasure. However, I do think that John Sayles has a strange relationship with black women because he always portrays us with these weird wigs—like the woman in *Brother from Another Planet* and the black woman in *Passion Fish*.

MFA: Let's talk about love and fear.

bh: *Sleepless in Seattle* is a very interesting movie about passion and love and fear. In both *Truly, Madly, Deeply* and *Sleepless in Seattle*, the fear is that you've lost a grand love and you'll never be able to experience it again. Passion and desire about love do have the potential to destroy people. It's like losing your sense of smell or taste. There is that intensity of passion in films like *Red Sorghum* and *Ju Dou*—that sense

of being so deeply, spiritually, emotionally connected to another person. Tragically, there's so much weird focus on codependency in this culture—especially where women are concerned—that it has become very hard for women to articulate what it means to have that kind of life-transforming passion. I think that our culture doesn't recognize passion because real passion has the power to disrupt boundaries. I want there to be a place in the world where people can engage in one another's differences in a way that is redemptive, full of hope and possibility. Not this "In order to love you, I must make you something else." That's what domination is all about: that in order to be close to you, I must possess you, remake and recast you. Redemptive love is what's hinted at in The Bodyguard and in The Crying Game. Then it goes away and we don't know where it's gone. Why did it go away?

MFA: For the same reason Thelma and Louise have to die.

bh: Absolutely. We have to go to films outside America to find any vision of redemptive love—whether it be heterosexual love or love in different sexual practices—because America is a culture of domination. Love mitigates against violation yet our construction of desire is the context of domination is always, always about violation. There must be a tremendous hunger for this kind of hopeful love in our culture right now because people are so drawn to films like Raise the Red Lantern, Red Sorghum, and Like Water for Chocolate. Pedro Almodóvar almost always explores this tension between our desire for recognition and love and our complete fear of abandonment. In Tie Me Up! Tie Me Down! we don't have this perfect middle-class vision of recovery. Many feminists hate it because the woman falls in love with her kidnapper yet the fact is that in our real lives there are always contradictory circumstances that

confront us. Out of that mess, we create possibilities of transcendence. I do feel that a certain kind of feminist discourse came to a complete and utter halt around the question of sexuality and power because people cannot reconcile the way in which desire can intervene in our political belief structure, our value systems, our claims of racial, ethnic, or even sexual purity. I don't think the average person in this culture knows what passion is, because daily TV and the mass media are saying, "It's best to live your life in certain forms of estrangement and addiction." We're seeing too many films that don't deliver the goods, that don't give us any world that calls us to feel again, and if we can't feel, then we don't have any hope of knowing love.

4

SEDUCTION AND BETRAYAL

The Crying Game meets *The Bodyguard*

Hollywood's traditional message about interracial sex has been that it is tragic, that it will not work. Until Spike Lee made *Jungle Fever*, that xenophobic, racist message had been primarily brought to us courtesy of white filmmakers. That message has not changed. When Hollywood sought to do its own version of Coline Serreau's 1989 film, *Mama, There's a Man in Your Bed*, a film about interracial desire where the relationship between a working-class black woman and a privileged white man works, no big white male stars wanted to play the leading role. Though this fact was presented in the news, the reasons were not. No doubt these white men were afraid that they would lose status, invite the wrath of white female moviegoers who do not want to see "their" heroes making it with black girls, or, God forbid, risk being seen as "nigger lovers" in real life. After all, white females constitute a viewing audience that could write thousands of

letters protesting love between a white man and a black woman on daytime soaps, letting the networks know that they do not want to see this on little or big screens.

Mama, There's a Man in Your Bed is unique in that it represents interracial love in a complex manner. It raises challenging questions about the difficulties of having a partner who is of a different race and class. It insists that love alone would not enable one to transcend difference if the person in power—in this case the wealthy white man—does not shift his ways of thinking, reconceptualize power, divest of bourgeois attitudes, and so on. As their love develops, the white man is called to interrogate his location, how he thinks about folks who are different, and most importantly how he treats them in everyday life. Since the black woman he loves has children, relatives, and other relationships, he must also learn to engage himself fully with her community. Having worked as a cleaner in his office, she knows his world and how it works. He must learn to understand, appreciate, and value her world. Mutual give-and-take enables their relationship to work—not the stuff of romantic fantasy.

Unlike Hollywood's traditional yet "rare" black female heroine, the black woman in *Mama, There's a Man in Your Bed*, is not an exotic sex kitten, is not a "tragic mulatto." In the French film she is stocky, dressed mostly in everyday working clothes—in no way a "femme fatale." And this fact alone may have made it impossible for any white male "star" to feel comfortable appearing as her partner. By Hollywood standards (and this includes films by black directors), a full-figured, plump, black woman can only play the role of mammy/matron; she can never be the object of desire. Ever willing to cater to the needs of the marketplace, Hollywood may yet do its own version of *Mama, There's a Man in Your Bed* but it is unlikely that it will retain the original's seriousness and complexity of perspective. No doubt it will be another *Sister Act*, where viewers are made to consider just a bit "ridiculous" any black female whose looks

do not conform to traditional representations of beauty yet who is or becomes the object of white male desire. The audience must be made to think it is improbable that such a black woman would really be the chosen companion of any desirable white man.

Audiences may ultimately see an American version of *Mama, There's a Man in Your Bed*, as Hollywood has recently discovered once again (as it did during the period when films like *Imitation of Life* and *Pinkie* were big draws) that films which focus on interracial relationships can attract huge audiences and make big bucks. White supremacist attitudes and prejudicial feelings, which have traditionally shaped the desires of white moviegoers, can be exploited by clever marketing; what was once deemed unworthy can become the "hot ticket." Right now, race is the hot issue. In my recent book on race and representation, *Black Looks*, I emphasize that blackness as commodity exploits the taboo subject of race; that this is a cultural moment where white people and the rest of us are being asked by the marketplace to let our prejudices and xenophobia (fear of difference) go, and happily "eat the other."

Two fine examples of this "eating" are the Hollywood film *The Bodyguard* and the independent film *The Crying Game*. Both films highlight relationships that cross boundaries. *The Crying Game* is concerned with exploring the boundaries of race, gender, and nationality, *The Bodyguard* with boundaries of race and class. Within their particular genres, both films have been major box office successes. Yet *The Crying Game* received critical acclaim while *The Bodyguard* was overwhelmingly trashed by critics. Magazines such as *Entertainment Weekly* gave grades of "A" to the first film and "D" to the latter. Though it is certainly a better film by artistic standards (superior acting, more complex plot, good screen writing) the elements of *The Crying Game* that make it work for audiences are more similar to than different from those that make *The Bodyguard* work. The two films are both romances. They

both look at "desire" deemed taboo and exploit the theme of love on the edge.

At a time when critical theory and cultural criticism calls us to interrogate politics of locations and issues of race, nationality, and gender, these films usurp this crucial challenge with the message that desire, and not the realm of politics, is the location of reconciliation and redemption. And while both films exploit racialized subject matter, the directors deny the significance of race. Until *The Bodyguard*, American audiences had never seen a Hollywood film where a major white male star chooses a black female lover, yet the publicity for the film insisted that race was not important. Interviewed in an issue of the black magazine *Ebony*, Kevin Costner protested, "I don't think race is an issue here. The film is about a relationship between two people, and it would have been a failure if it became a film about interracial relationships." Similarly, in interviews where Neil Jordan talks about *The Crying Game* he does not racially identify the black female character. She is always "the woman." For example, in an interview with Lawrence Chua in *Bomb* magazine, Jordan says, "Fergus thinks the woman is one thing and he finds out she is something different." Both these assertions expose the extent to which these white males have not interrogated their location or standpoint. Progressive feminist thinkers and cultural critics have continually called attention to the fact that white supremacy allows those who exercise white privilege not to acknowledge the power of race, to behave as though race does not matter, even as they help put in place and maintain spheres of power where racial hierarchies are fixed and absolute.

In both *The Crying Game* and *The Bodyguard* it is the racial identity of the black "female" heroines that gives each movie its radical edge. Long before any viewers of *The Crying Game* know that Dil is a transvestite, they are intrigued by her exoticism, which is marked by racial difference. She/he is not just any old black woman; she embodies the "tragic mulatto" persona that has

always been the slot for sexually desirable black female characters of mixed race in Hollywood films. Since most viewers do not know Dil's sexual identity before seeing the film, they are most likely drawn to the movie because of its exploration of race and nationality as the locations of difference. Kevin Costner's insistence that The Bodyguard is not about an interracial relationship seems ludicrously arrogant in light of the fact that masses of viewers flocked to see this film because it depicted a relationship between a black woman and a white man, characters portrayed by big stars, Costner and Whitney Houston. Black female spectators (along with many other groups) flocked to see The Bodyguard because we were so conscious of the way in which the politics of racism and white supremacy in Hollywood has always blocked the representation of black women as chosen partners for white men. And if this cannot happen, then black females are rarely able to play the female lead in a movie as so often that role means that one will be involved with the male lead.

The characters of Dil (Jaye Davidson) in The Crying Game and Rachel Marron (Whitney Houston) in The Bodyguard were portrayed unconventionally in that they were the love objects of white men, but they were stereotypically oversexed, sexual initiators, women of experience. Dil is a singer/'ho (the film never really resolves just what the nature of her role as a sex worker is) and Rachel Marron is also a singer/'ho. Traditionally, Hollywood's sexual black women are whores or prostitutes, and these two movies don't break with the tradition. Even though Dil works as a hairdresser and Marron makes her money as an entertainer, their lure is in the realm of the sexual. As white racist/sexist stereotypes in mass media representations teach us, scratch the surface of any black woman's sexuality and you find a 'ho—someone who is sexually available, apparently indiscriminate, who is incapable of commitment, someone who is likely to seduce and betray. Neither Dil nor Marron bothers to get to know the white male each falls in love with. In both cases, it is

love—or should I say "lust"—at first sight. Both films suggest the feeling of taboo caused by unknowing that actual knowledge of the "other" would destroy sexual mystery, the feeling of taboo caused by unknowing, by the presence of pleasure and danger. Even though Fergus (Stephen Rea) has searched for Dil, she quickly becomes the sexual initiator, servicing him. Similarly, Marron seduces Frank Farmer (Kevin Costner), the bodyguard she has hired. Both films suggest that the sexual allure of these two black females is so intense, that these vulnerable white males lose all will to resist (even when Fergus must face the fact that Dil is not biologically female). During slavery in the United States, white men in government who supported the idea of sending black folks back to Africa gathered petitions warning of the danger of sexual relations between decent white men and licentious black females, asking specifically that the government "remove this temptation from us." They wanted the State to check their lust, lest it get out of hand. Uncontrollable lust between white men and black women is not taboo. It becomes taboo only to the extent that such lust leads to the development of a committed relationship.

The Bodyguard assures its audiences that no matter how magical, sexy, or thrilling the love between Rachel Marron and Frank Farmer is, it will not work. And if we dare to imagine that it can, there is always the powerful theme song to remind us that it will not. Even though the song's primary refrain declares "I will always love you," other lyrics suggest that this relationship has been doomed from the start. The parting lover speaks of "bittersweet memories, that is all I am taking with me," then declares, "We both know I am not what you need." Since no explanation is given, audiences can only presume that the unspoken denied subject of race and interracial romance makes this love impossible. Conventionally, then, The Bodyguard seduces audiences with the promises of a fulfilling romance between a white male and a black female only then to gaslight us by telling

us that relationship is doomed. Such a message can satisfy xenophobic or racist moviegoers who want to be titillated by taboo even as they are comforted by a restoration of the status quo when the film ends. White supremacist viewers can find their own insistence on the danger of racial pollution and race-mixing confirmed by the film, and nationalist black folks who condemn interracial relationships can also be satisfied. The rest of us are left simply wondering why this love cannot be realized.

When we leave the realm of cinema, it is obvious that the dynamics of white supremacist capitalist patriarchy—which has historically represented black females as "undesirable mates" even if they are desirable sex objects, and so rendered it socially unacceptable for powerful white males to seek committed relationships with black women—continue to inform the nature of romantic partnership in our society. What would happen to the future of white supremacist patriarchy if heterosexual white males were choosing to form serious relationships with black females? Clearly, this structure would be undermined. Significantly, The Bodyguard reaffirms this message. Frank Farmer is portrayed as a conservative Republican patriarch, a defender of the nation. Once he leaves the black woman "she-devil" who has seduced and enthralled him, he returns to his rightful place as keeper of the nation's patriarchal legacy. In the film, we see him protecting the white male officers of state. These last scenes suggest that loving a black woman would keep him from honoring and protecting the nation.

Ironically, even though The Crying Game interrogates the notion of a pure nation by showing that Europe is no longer white, that European citizens are multicultural as well as multicolored, it too suggests via its characterization of Fergus that a white Irishman can sever his ties to nation and his commitment to fighting for national liberation by becoming romantically involved with a black woman. Though Neil Jordan's film, unlike The Bodyguard, suggests that this break with national identity can be positive, he

does so by suggesting that the national identity one wants to give up is one in which freedom must still be struggle. National identity in England, his film suggests, is not fluid, not static, not so important. In this way, his film deflects the imperialist racism and colonialism of Britain and makes it appear to be the location where everyone can be free, no longer confined to categories. In this mythic universe, fulfillment of desire is presented as the ultimate expression of freedom.

In keeping with a colonizing mind set, with racial stereotypes, the bodies of black men and women become the location, the playing field, where white men work out their conflicts around freedom, their longing for transcendence. In Fergus's eyes, the black male prisoner Jody (Forest Whitaker) embodies the humanity his white comrades have lost. Though a grown man, Jody is childlike, innocent, a neoprimitive. In the interview with Chua, Jordan confirms that he wanted to represent Jody as child-like when he says that in this relationship Fergus "was like the mother." Jody alters the power relationship between himself and Fergus by emotionally seducing him. He represents emotionality and, like Dil (another primitive), is not cut off from his relation to feeling or sensuality. The film highlights the depiction of black males and females as childlike and in need of white parents/ protectors. And even though Rea attempts to reverse this representation as the film ends by turning Dil into the caretaker, the one who will nurture Fergus, he reinscribes racial stereotypes through both representations.

Fergus "eats the other" when he consumes Jody's life story, including the mythic narrative that shapes the black man's worldview, and then usurps his place in the affections of Dil. As the film ends, Fergus as white male hero has not only cannibal-ized Jody, he appropriates Jody's narrative and uses it to declare his possession of Dil. Jordan asserts that "his obsession with the man leads him to reshape her in the image of the guy he's lost." Black bodies, then, are like clay—there to be shaped so that they

become anything that the white man wants them to be. They become the embodiment of his desires. This paradigm mirrors that of colonialism. It offers a romanticized image of the white colonizer moving into black territory, occupying it, possessing it in a way that affirms his identity. Fergus never fully acknowledges Dil's race or sex. Like the real-life Costner and Rea, he can make black bodies the site of his political and cultural "radicalism" without having to respect those bodies.

Most critical reviews of The Crying Game did not discuss race, and those that did suggested that the power of this film lies in its willingness to insist that race and gender finally do not matter: it's what's inside that counts. Yet this message is undermined by the fact that all the people who are subordinated to white power are black. Even though this film (like The Bodyguard) seduces by suggesting that it can be pleasurable to cross boundaries, to accept difference, it does not disrupt conventional representations of power, of subordination and domination. Black people allow white men to remake them in the film. And Dil's transvestism appears to be less radical when she eagerly offers her womanly identity in order to satisfy Fergus without asking him for an explanation. Fergus's actions are clearly paternalistic and patriarchal. Dil gives that Billie Holiday "hush now, don't explain" kind of love that misogynist, sexist men have always longed for. She acts in complicity with Fergus's appropriation of Jody.

Those of us who are charmed by her defiant, bold manner throughout the film are amazed when she suddenly turns into the traditional "little woman," eager to do anything for her man. She is even willing to kill. Her aggression is conveniently targeted at the only "real" woman in the film, Jude, who happens to be white. When Dil assumes a maternal role with Fergus she shifts from the role of 'ho to that of mammy. But when Dil is lured to believe Fergus will be her caretaker, the roles are suddenly reversed. There is nothing radical about Dil's positionality at the film's end. As "black female" taking care of her white

man, she embodies a racist/sexist stereotype. As "little woman" nurturing and waiting for her man (let's remember that girlfriend did not faithfully wait for Jody), she embodies a sexist stereotype.

Throughout much of *The Crying Game*, audiences have the opportunity to watch a film that disrupts many of our conventional notions about identity. The British soldier is black. His girlfriend turns out to be a transvestite. Fergus readily abandons his role as IRA freedom fighter (a group that is simplistically portrayed as only terrorist) to become your average working man. In the best sense, much of this film invites us to interrogate the limits of identity politics, showing us the way desire and feelings can disrupt fixed notions of who we are and what we stand for. Yet in the final scenes of the film, Fergus and Dil seem to be primarily concerned with inhabiting sexist gender roles. He reverts to the passive, silent, unemotional, "rational" white man, an identity he sought to escape in the film. And Dil, no longer bold or defiant, is black woman as sex object and nurturer. Suddenly heterosexism and the Dick-and-Jane lifestyle are evoked as ideals—so much for difference and ambiguity. Complex readings of identity are abandoned and everything is back in its place. No wonder, then, that mainstream viewers find this film so acceptable.

In a culture that systematically devalues black womanhood, that sees our presence as meaningful only to the extent that we serve others, it does not seem surprising that audiences would love a film that reinscribes us symbolically in this role. (I say symbolically because the fact that Dil is really a black man suggests that in the best of white supremacist, capitalist patriarchal, imperialist worlds the female presence is not needed.) It can be erased (no need for real black women to exist) or annihilated (let's have the black man brutally murder the white woman, not because she is a fascist terrorist but because she is biologically woman). Because I considered Jude to be first and foremost a

fascist, I did not initially see her death as misogynist slaughter. Critically reconsidering the scene in which Jude is murdered, I realized that Dil's rage is directed against her because Jude is biologically female. It cannot be solely that she used the appearance of femininity to entrap Jody, for Dil uses that same means of entrapment. Ultimately, despite magical transgressive moments, there is much in this film that is conservative, even reactionary. Crudely put, it suggests that transvestites hate and want to destroy "real" women; that straight white men want black mammies so badly they invent them; that white men are even willing to vomit up their homophobia and enter a relationship with a black man to get that down-home service only a black female can give; that real homosexual men are brutes who batter; and ultimately that the world would be a better, more peaceful place if we would all forget about articulating race, gender and sexual practice and just become white heterosexual couples who do not play around with changing roles or shifting identity. These reactionary messages correspond with all the conservative messages regarding difference in The Bodyguard.

Significantly, the similarities between the two films go unnoticed by those critics who rave about The Crying Game and who either trash or ignore The Bodyguard. Yet somehow it seems fitting that The Bodyguard would be critically rejected in white supremacist capitalist patriarchy. For despite its conventional plot, the representation of blackness in general, and black femaleness in particular, are far more radical than any image in The Crying Game. The conventional Hollywood placement of black females in the role of servants is disrupted. In fact, Rachel Marron is wealthy, and Frank Farmer is hired to serve her. However utopian this inversion, it does challenge stereotypical assumptions about race, class, and gender hierarchies. When Frank Farmer acts to fully protect the life of Marron (how many films do we see in the United States where black female life is deemed valuable, worth protecting?) he takes her home to his

white father who embraces her with patriarchal care. Again, this representation is a radical break with stereotypical racist norms. It cannot be mere coincidence that a film that makes significant breaks with racist and sexist norms via its representation of black womanhood should be trashed by critics even as another film which reinscribes racist and sexist representations should be extolled as more meaningful. Even though The Bodyguard conservatively suggests that interracial relationships are doomed, it remains a film that offers concrete meaningful interventions in the area of race and representation.

People who flocked to see The Bodyguard, some of whom saw it many times, cannot simply assume that all the individuals writing reviews were unaware of these interventions. Given the way black life and black womanhood are devalued, the critics may simply have felt that the radical moments in this film should be ignored lest they signal that Hollywood can change—that individuals can create important interventions. The mega-economic success of The Bodyguard called attention to the reality that producers, directors, and stars can use their power to make progressive changes in the area of representation, even if, as in the case of Costner, they do not acknowledge the value of these changes.

Despite flaws, both The Crying Game and The Bodyguard are daring works that evoke much about issues of race and gender, about difference and identity. Unfortunately, both films resolve the tensions of difference, of shifting roles and identity, by affirming the status quo. Both suggest that otherness can be the place where white folks—in both cases white men—work through their troubled identity, their longings for transcendence. In this way they perpetuate white cultural imperialism and colonialism. Though compelling in those moments when they celebrate the possibility of accepting difference, learning from and growing through shifting locations, perspectives, and identities, these films ultimately seduce and betray.

5

CENSORSHIP FROM LEFT AND RIGHT

Recently, the Canadian government refused to allow my book *Black Looks: Race and Representation* into Canada. Copies were being shipped to a radical bookstore. They were held as "hate" literature. It seemed ironic that this book, which opens with a chapter urging everyone to learn to "love blackness," would be accused of encouraging racial hatred. I doubt that anyone at the Canadian border read this book: the target for repression and censorship was the radical bookstore, not me. After a barrage of protests, the government released the books suggesting that they were held simply because there had been a misunderstanding about their content. Despite the fact that the books were released, it was another message sent to remind radical bookstores—particularly those that sell feminist, lesbian, and/or overtly sexual literature—that the state is watching them and ready to censor.

Canadian readers of all races and ethnicities were horrified by the seizure of *Black Looks*. Politically, censorship has been a major location where those with radical politics are attacked both in

Canada and the United States. All around the United States books by African American authors have been among those selected for censorship in grade schools and public libraries. These cases often go unnoticed by a larger public and by African Americans in general. To many folks, they seem like isolated incidents instigated by the Far Right.

More than the censoring of books, the issue of whether the work of individual African American rap musicians should be censored has been the catalyst compelling many black folks to consider issues of censorship. Conservatives in black communities are as motivated to censor as are their counterparts in other communities. Support for censorship in black communities is rarely noticed when mass media highlights this issue. The lack of coverage does not mean that support for censorship is not growing among black people. Yet few, if any, black leaders call attention to the dangers to progressive political work when censorship is condoned.

Black academics and intellectuals have not made many public statements about censorship, with the exception of the testimony of Professor Henry Louis Gates, Jr., in the court case involving the black male musicians 2 Live Crew. His support of their right to free speech was viewed by many black folks less as a radical stance on the issue of censorship and more as a case of patriarchal black male bonding. This was a pity, since the uproar over this case presented an opportunity for diverse black communities to engage in public debate about censorship.

Censorship is a troubled issue for black folks. Bourgeois class values often shape overall public opinion across class in black life, so that almost everyone is taught to value discretion and secret-keeping. When those values are coupled with diverse expressions of religious conservatism, a cultural environment that embraces censorship can thrive. Black support of censorship seems strongest when the issue is public exposure of flaws, wrongdoing, or mistakes by black political figures. Ralph

Abernathy's choice to offer information about Martin Luther King that might have altered public perception of King's life, information concerning sexuality, was viewed by most black folks across class as a breach of etiquette, an invasion of the private by the public. Ultimately, it was seen solely as an act of aggression and not as useful information that offers a more complex portrait of King's identity. A similar response greeted Bruce Perry's biography of Malcolm X. Ironically, the publishers feared that there would be major backlash against the book when in fact, it was disregarded, for the most part not read, seen as another attempt to discredit a powerful black male leader. In both these cases, had many black folks the power to censor these works, to keep them from seeing the light of day, these books would not be in existence.

Active in black liberation struggle and in feminist movement, I am disturbed by the willingness of more conservative thinkers in these two movements to embrace censorship as an acceptable means of social control. The political core of any movement for freedom in the society has to have the political imperative to protect free speech. Time and again, radicals have seen that censorship is used to silence progressive voices rather than those who take the conservative stand that free speech must be suppressed in specific instances. Progressive activists must work politically to protect free speech, to oppose censorship. These issues are most publicly highlighted in black civil rights struggle and feminist movement, in struggles over representations of vulgarity, sexuality, and pornography. Yet some of the reticence on the part of individuals in both groups to the vehement opposition of censorship reflects the deep investment in regulatory silencing that has, dangerously, come to be an accepted aspect of both black liberation struggle and feminist movement. This covert silencing of dissenting voices and opinions undermines free speech and strengthens the forces of censorship within and outside radical movements.

In the early years of contemporary feminist movement, solidarity between women was often equated with the formation of "safe" spaces where groups of presumably like-minded women could come together, sharing ideas and experiences without fear of silencing or rigorous challenges. Groups sometimes disintegrated when the speaking of diverse opinions led to contestation, confrontation, and out-and-out conflict. It was common for individual dissenting voices to be silenced by the collective demand for harmony. Those voices were at times punished by exclusion and ostracization. Before it became politically acceptable to discuss issues of race and racism within feminist circles, I was one of those "undesirable" dissenting voices. Always a devout advocate of feminist politics, I was, and am, also constantly interrogating, and if need be, harsh in my critique. I learned powerful lessons from hanging in there, continuing to engage in feminist movement even when that involvement was not welcomed. Significantly, I learned that any progressive political movement grows and matures only to the degree that it passionately welcomes and encourages, in theory and practice, diversity of opinion, new ideas, critical exchange, and dissent.

This remains true for feminist movement; it is not less true for black liberation struggle. In the heyday of civil rights struggle, black power movement folks were often "excommunicated" if they did not simply support the party line. This was also the case in white male-dominated "left" political circles. Censorship of dissenting voices in progressive circles often goes unnoticed. Radical groups are often so small that it is easy to punish folks using tactics that may not be apparent to those outside the group. Usually, repression is enforced by powerful members of the group threatening punishment, the most common being some form of ostracization or excommunication. This may take the form of no longer including an individual's thoughts or writing in relevant discussions, especially publication, or excluding individuals from important meetings and conferences. And in some

cases it may take the form of a consistent, behind-the-scenes effort to cast doubt verbally on their credibility.

Marginalized groups often fear that dissent, especially if it is expressed in public critique, will play into the hands of dominating forces and undermine support for progressive causes. Throughout the history of black struggle against racism there has been, and continues to be, major disagreement over whether or not we should rigorously critique one another publicly, especially in racially integrated contexts. Efforts to censor surface whenever marginalized groups are overly concerned with presenting a "positive" image to the dominant group. Most recently, the outcome of the Clarence Thomas hearings and his subsequent appointment to the Supreme Court shows how misguided, narrow notions of racial solidarity that suppress dissent and critique can lead black folks to support individuals who will not protect their rights. As Clarence Thomas uses the power invested in him as a member of the Supreme Court to curtail human rights, to stand in the way of racial justice and the struggle against sexism, those who felt it was more important to support the "brother" because white folks were out to get him, must if they are at all aware see the error of their ways. We will never know what the outcome of the Thomas hearings might have been had powerful black leaders around the United States collectively called for mass support to resist this appointment.

Even though the Thomas hearings forced the American public to consider issues of race and gender, issues they ignore daily, many blacks (especially men) closed ranks to support Thomas uncritically, just as many feminists (especially white women and black women professionals) closed ranks to support Anita Hill. The essay I wrote on the hearings which suggested that the public needed to look critically at both individuals and their political allegiances led many of my feminist comrades (especially black women) to tell me that the piece should not have been written. A long-time black feminist comrade accused me of

having temporarily "lost my mind" as she felt my critique of Hill's performance was a betrayal of feminist solidarity. Again and again, I have to insist that feminist solidarity rooted in a commitment to progressive politics must include a space for rigorous critique, for dissent, or we are doomed to reproduce in progressive communities the very forms of domination we seek to oppose.

The negative responses I received about the essay on the Thomas hearings (now published in *Black Looks*) called to mind other incidents where friends and comrades have attempted to censor my viewpoint. A couple of years back, I wrote a critical piece on the work of a major black woman writer. Talking about this piece while it was still in process with prominent black women scholars and comrades, I was taken aback when I was told that it was not a good idea for me to complete it, that the writer would be disappointed and "hurt". When the piece was published, I received word that the writer was not only hurt but that she no longer considered me an ally. The fact that the piece does not trash her work did not matter. My insistence that criticizing one piece did not mean that I do not admire and appreciate other writing by this same author fell on deaf ears. I was simply told that writing and publishing this piece would be an "act of betrayal."

These responses compelled me to reevaluate the purpose of my piece—to search my conscience to see if there was any will to harm the writer in question. After this process, I remained convinced that it was an important piece to write. After it was written and published, I suddenly lost contact with a circle of black women with whom I had once considered myself close. I began to hear through gossip that I could not be counted on to "keep confidences." The evocation of "confidence" has no direct relation to the integrity of one's word or the pursuit of truth. Revolutionary feminist and black liberation movements have always insisted there be recognition of the way in which the

separation between public and private maintains and perpetuates structures of domination. Often the idea of privacy is evoked as a way to suppress dissent by falsely suggesting that there is or should be neutral, protected ground. Agreed upon confidences between individuals—promises—should be honored, and a distinction must be made between those consensual agreements and the sharing of information that is only later, and in the interest of protecting individuals, deemed private. Discussions of ideas, issues that take place in offices, homes, and hallways are certainly less public than lectures and published work, but they do not constitute neutral, protected space.

Fundamentally, many folks evoke keeping confidence as another way of talking about secret-keeping. Suppressing critical comments or making them in private one-on-one settings where there are no witnesses are deemed more appropriate ways to handle dissent. Bourgeois decorum upholds this means of dealing with conflict. Lying is often more acceptable than speaking truth. The equation of truth-telling with betrayal is one of the more powerful ways to promote silence. No one wants to be regarded as a traitor. Issues of regard are invariably linked to the desire to shape and construct images. Many individuals in the public eye want to determine and control their representation. When the notion of solidarity or allegiance is reduced solely to the issue of secret-keeping in the interest of both making and sustaining images, we lose our ability to form communities based on respect and mutual commitment to the free expression of ideas.

Among black intellectuals, critical thinkers, writers, and academics there is clearly an elite group. This group tends not to be appointed by black followers but are accorded status by the degree to which an individual garners the regard and recognition of a powerful white public. Running interference between the black community and mainstream white culture, these folks often assume the role of mediator, or what I euphemistically call

the "secret police," regulating ideas, determining who should speak where and when, what needs to be written when and by whom, and of course meting out rewards and punishment. This group is not all-powerful, but it does seek to censor voices not saying that which is deemed acceptable. The folks at the top of these hierarchies are usually black men. Though they may not choose to repress and censor, they may be feared, and individuals will attempt to please them by not saying what they think these "leaders" do not want to hear. Fear of alienating black thinkers who appear to be power brokers leads to the suppression of black critical thinking.

Black scholar Henry Louis Gates, Jr., a major mover and shaker in intellectual and academic circles, published an essay focusing on "black anti-Semitism" on the Op-Ed pages of the New York Times. I found this essay very problematic. Although it contained a useful and necessary critique of black anti-Semitism, particularly in regard to certain narrow-minded nationalist strains of Afrocentric thinking and scholarship, there was no careful attempt in the writing to contextualize the relationship between black folks and white Jews in a manner that would oppose any monolithic construction of black people as anti-Semitic. Disturbed by this piece, I worried that the gaps in this essay would serve to legitimate further silencing of black voices who are in any way critical of white Jews, and that the essay would create further unnecessary divisions and conflicts.

Though compelled by serious political concerns to respond to this essay, I hesitated. Initially, I suppressed the impulse to write a response because I feared negative repercussions from black and white readers. Interrogating this fear, I saw it is as rooted in my desire to belong, to experience myself as part of a collective of black critical thinkers and not as estranged or different. And frankly, I feared punishment (i.e., not being offered desired jobs, grants, etc.). Even though I felt these fears were not rational—since I made peace long ago with the reality that dissenting

opinions often make one an outsider—these fears not only made me pause; for a time they acted as censors. It troubled me that as "established" as I am, and by that I mean being a full professor with tenure, I could fear speaking my mind. I wondered how someone less established could dare to speak freely if those of us who have the least to lose are afraid to make our voices heard.

Before I began writing my response to the Gates essay, I spoke with black colleagues, many of whom also disagreed with the perspectives in the piece. Some of them openly acknowledged that they had checked their impulses to respond critically for fear of reprisals. Whether the threat of negative reprisal is real or not, black critical thinking will never openly flourish if individuals are constantly self-censoring. If black academics with greater access to mass media use their power to silence, then there is no space for the cultivation of free speech that welcomes and celebrates dissent.

Often, major black writers and academics feel that it is their responsibility to determine which voices from the margins strengthen the struggle for racial uplift and which impede the progress of the race. Comfortable with censorship when they can assert that it is in the collective interest, they do not see a connection between these actions and overall efforts to undermine free speech in this society. At a major conference focusing on the works of a prominent black woman writer, I gave a lecture espousing ideas she did not agree with. Rather than engage me in critical exchange, she "dissed" me at the end of the day. Later, she told folks that I was an "obstructionist," someone who went about things in the wrong way. To me, this was related to my greater willingness to engage in direct confrontation of issues and her more mediated approach. Yet I felt no need to trash her. I see a place for both approaches. Older black writers and thinkers often assume a traditional, parent-like hierarchical role in relation to younger thinkers. Then there are always those individuals who remain convinced that black folks must not air our dirty

laundry in public. Some of these individuals believe we must never appear to be criticizing blackness in front of white folks. While I can agree that there is always the risk that public disagreement and dissent may reinforce white racist assumptions about black identity, there are just too few all-black settings for us to maintain silence waiting for the best "politically correct" settings to speak freely and openly. Evoking "betrayal of the race" effectively acts to silence dissenting voices. Black critical thinkers, writers, academics, and intellectuals share a small universe, a world where opinions exchanged via gossip and small talk close doors, erect barriers, and exclude. The recent outraged and potentially censoring uproar over some individual black males' "negative" responses to Toni Morrison receiving the Nobel Prize is further indication that there is more collective zeal to silence, censor, or punish speech deemed unacceptable than for dissent, free expression of ideas, and the formation of public space where folks can disagree.

Black folks do not hold public forums where we talk about ways we might promote a climate of critical discourse that supports and highlights the primacy of free speech while simultaneously furthering our struggles for black self-determination. If we do not address the issue of censorship in a thoughtful and complex manner, then old unproductive, habitual responses will determine the scope of our discourse. What cultural conditions enable black male thinkers to be critical of black women without being seen as giving expression to sexist or misogynist opinions? And what critical climate will allow black women a space to critique one another without fear that all ties will be disrupted and severed?

Usually, critique causes some pain and discomfort. I know the feeling. I will never forget the day I went to my favorite bookstore hoping to rid myself of a serious case of the blues only to open the anthology Homegirls to a passage declaring that I was "so homophobic [I] could not even bring myself to use the word

lesbian"; this was part of a larger critique of my first book, *Ain't I a Woman: Black Women and Feminism*. I felt devastated—not because I could not receive fierce intellectual critiques of my work, but because this particular declaration was simply untrue, yet I knew it would influence folks' perceptions of me. I was deeply hurt. But it was up to me to cope with that hurt, put it in perspective, and respond to the issues and the individuals in an open-minded way. This is by no means an easy process. For those who are profoundly committed to free speech, to sustaining spaces for critical discourse where folks can speak their minds (hopefully constructively and in ways that do not threaten to malign and symbolically assassinate others), then there has to be a celebration of differing opinions even when there are conflicts, even when there are hurt feelings.

As a professor, I continually witness fear on the part of students to express themselves openly and freely. This fear is usually motivated by the concern that their peers will not like what they say, and that this will lead to some form of social punishment. Their willingness to self-censor in the interest of being liked, of being held in high regard by their peers, as well as their often profound fear of conflict, always indicts the notion that our classrooms are a place where the democratic assertion of free speech is possible. Professors will never create a learning community where students can understand the importance of free speech and exercise their rights to speak openly and freely if we lack the courage to fully embrace free speech. The same holds true for progressive political groups.

When repression via censorship becomes the norm in progressive political circles, we not only undermine our collective struggles to end domination, we act in complicity with that brand of contemporary, chic fascism that evokes romantic images of unity and solidarity, a return to traditional values, while working to deny free speech and suppress all forms of rebellious thought and action. In recent years, feminist thinkers have

fought long and hard to make feminist thinking, theorizing, and practice a radical space of openness where critical dialogue can take place. Much of that struggle has been waged by women of color, beginning with the conflict over whether or not to see issues of race and racism as feminist agendas.

Feminist movement, black liberation struggle, and all our progressive political movements to end domination must work to protect free speech. To maintain the space for constructive contestation and confrontation, we must oppose censorship. We remember the pain of silence and work to sustain our power to speak—freely, openly, provocatively.

6

TALKING SEX

Beyond the patriarchal phallic imaginary

Women who grew to womanhood at the peak of contemporary feminist movement know that at that moment in time, sexual liberation was on the feminist agenda. The right to make decisions about our bodies was primary, as were reproductive rights, particularly the right to abort an unplanned for unwanted fetus, and yet it was also important to claim the body as a site of pleasure. The feminist movement I embraced as a young coed at Stanford University highlighted the body. Refusing to shave, we let hair grow on our legs and under our armpits. We chose whether or not to wear panties. We gave up bras, girdles, and slips. We had all-girl parties, grown-up sleepovers. We slept together. We had sex. We did it with girls and boys. We did it across race, class, nationality. We did it in groups. We watched each other doing it. We did it with the men in our lives differently. We let them celebrate with us the discovery of female

sexual agency. We let them know the joys and ecstasy of mutual sexual choice. We embraced nakedness. We reclaimed the female body as a site of power and possibility.

We were the generation of the birth-control pill. We saw female freedom as intimately and always tied to the issue of body rights. We believed that women would never be free if we did not have the right to recover our bodies from sexual slavery, from the prison of patriarchy. We were not taking back the night; we were claiming it, claiming the dark in resistance to the bourgeois sexist world of repression, order, boredom, and fixed social roles. In the dark, we were finding new ways to see ourselves as women. We were charting a journey from slavery to freedom. We were making revolution. Our bodies were the occupied countries we liberated.

It was this vision of contemporary feminist movement I shared with *Esquire* magazine when interviewed by Tad Friend. Consistently, I shared with him the reality that many feminists have always been and are into sex. I emphatically stated that I repudiated the notion of a "new feminism" and saw it being created in the mass media mainly as a marketing ploy to advance the opportunistic concerns of individual women while simultaneously acting as an agent of antifeminist backlash by undermining feminism's radical/revolutionary gains. "New feminism" is being brought to us as a product that works effectively to set women against one another, to engage us in competition wars over which brand of feminism is more effect-ive. Large numbers of feminist thinkers and activists oppose the exploitative, hedonistic consumerism that is repackaging feminism as a commodity and selling it to us full of toxic components (a little bit of poisonous, patriarchal thinking sprinkled here and there), but we feel powerless to change this trend. Many of us feel we have never had a voice in the mainstream media, and that our counterhegemonic standpoints rarely gain a wider public hearing. For years, I was among those

feminist thinkers who felt reluctant to engage the mass media (by appearing on radio programs, television shows, or speaking with journalists) for fear of cooptation by editing processes which can be used to slant any message in the direction desired by the producers. That turning away from the mass media (to the degree that the mainstream media showed any interest in presenting our views) has been a gap that made it easier for reformists and liberal advocates for gender equality to assume the public spotlight and shape public opinion about feminist thinking.

The patriarchal-dominated mass media is far more interested in promoting the views of women who want both to claim feminism and repudiate it at the same time. Hence, the success of Camille Paglia, Katie Roiphe, and to some extent Naomi Wolf. Seen as the more liberal feminist voices countering those taken to embody strident, narrow anti-sex standpoints (e.g., Catharine MacKinnon, Andrea Dworkin), these women are offered up by the white male-dominated mass media as the hope of feminism. And they are the individuals that the mass media most often turns to when it desires to hear the feminist voice speak. These women are all white. For the most part, they come from privileged class backgrounds, were educated at elite institutions, and take conservative positions on most gender issues. They in no way represent radical or revolutionary feminist standpoints. And these standpoints are the ones the mass media rarely wants to call attention to. Feminist women of color must still struggle to break through the barriers of racism and white supremacy to make our voices heard. Some of us have been willing to engage the mass media, out of fear that this "new feminism" will erase our voices and our concerns by attempting to universalize the category "woman" while simultaneously deflecting attention away from the ways differences created by race and class hierarchies disrupt an unrealistic vision of commonality.

Strategic engagement with subversive politics of representation makes it necessary for us to intervene by actively participating in mainstream public dialogues about feminist movement. It was this standpoint that informed my decision to talk with *Esquire*. Even though the sexist perspectives commonly conveyed by articles in this magazine made me reluctant to speak with them, I had been assured by a feminist comrade—a black female—that the white male reporter could be trusted to represent our views fairly, that his intention was not to distort, pervert or mock. When I spoke with Tad Friend, I was told that he was doing a piece on different attitudes among feminists towards sexuality. It was my understanding that this was the primary focus of his discussion. When the article appeared in the February 1994 issue of *Esquire*, I found my comments had been distorted, perverted—that indeed the article intentionally mocks those presumably "old feminists" who are not "down" with the pro-sex "new feminists." Not having heard Friend use the phrase "do-me" (a bit of eating-the-other white cultural appropriation of funky black R&B I would have "dissed," had it been shared by Tad when he spoke with me), I could not object to his use of these phrases. During our phone interview he showed no knowledge of the contributions black women had made to feminist theory, even though he positively presented himself as striving to be inclusive, a stance I welcomed. Not being in any way a manhater or a believer in racial separatism, I was pleased to engage in a discussion about feminism and sexuality with a young white male from a privileged class background who seemed genuinely interested in learning. These dialogues across difference are important for education for critical consciousness. They are necessary if we are ever to change the structures of racism, sexism, and class elitism which exclude and do not promote solidarity across difference. With generosity and warmth, I engaged in a lively discussion with Friend about feminism and sexuality.

Over and over again in our conversation, I passionately addressed the dangers of a conservative politics of representation that eagerly exploits the idea of a "new feminism" that is more pro-sex and pro-male. My repudiation of the idea of "new feminism," as well as most of the ideas I discussed with Friend, were in no way conveyed in his article (which he never showed me before publishing). Reading the *Esquire* piece, I found myself and my ideas exploited in the conventional ways white supremacist, capitalist patriarchy consistently deploys to perpetuate the devaluation of feminism and black womanhood. Friend violated my confidence by doing exactly what I requested he not do, which is exploit my comments to reinforce the vision of "new feminism that is being pushed by privileged white girls." Acting in a similar manner to that of racist white women in feminist movement, he exploited my presence and my words to appear more inclusive and therefore more politically correct even as he discounted the meaning and substance of both. Although all the white women whose words and images are highlighted used sexually explicit street vernacular in their quotes, only mine are extracted and used to "represent" my major points—even though they were actually witty asides I made to explain a point Friend claimed not to understand, to want "broken down" to a more basic level.

By highlighting this quote, making the black female's voice and body exemplify rough, raw, vernacular speech, he continues the racist/sexist representation of black women as the oversexed "hot pussies" I critique in *Black Looks*, juxtaposing it, by way of contrast, with the racist/sexist image of white women as being less sexually raw, more repressed. Of course, all the white women quoted in the body of the article, speak in a graphic heterosexist vernacular. At this white male-dominated magazine, some individuals decided that it was acceptable to highlight a black female using sexually explicit speech while downplaying white women doing the same, a strategy that helps keep in place

neat little racist/sexist stereotypes about the differences between white and black women. My point here is not to suggest that women should not use sexually explicit street vernacular (that was certainly one of the freedoms feminists fought for at the onset of the movement), but to interrogate the way my use of this language was distorted by a process of decontextualization.

Friend attributes to me a quote which reads: "If all we have to choose from is the limp dick or the super hard dick we're in trouble. We need a versatile dick who admits that intercourse isn't all there is to sexuality, who can negotiate rough sex on Monday, eating pussy on Tuesday, and cuddling on Wednesday." Rewritten by Friend, my use of black street vernacular is turned into white parody. Never having thought that I myself "need a versatile dick," I shared with Friend my sense that heterosexual women want a man who can be versatile. To use the phrase "a versatile man" is to evoke a vision of action and agency, of male willingness to change and alter behavior. The phrase a "versatile dick" dehumanizes. Friend changed my words to make it appear that I support female objectification of men, denying their full personhood and reducing them to their anatomy. I am hard-pressed to understand how "dicks" negotiate anything, since the very word "negotiate" emphasizes communication and consent. Friend distorts this statement so as to make my words affirm identification with a phallic mindset, thereby evoking tired racist/sexist stereotypes of emasculating and castrating pseudo-masculine—and ultimately undesirable—hard, black females.

In like manner, I shared with him that "women can't just ask men to give up sexist objectification if we want a hard dick and a tight butt—and many of us do. We must change the way we desire. We must not objectify." Dropping the last two sentences without using punctuation to indicate that he has left something out, as well as changing my words and including his own, Friend toys with my ideas, reshaping them so that I am made to appear supportive of patriarchal notions of sexual pleasure and

sexist/heterosexist thinking that I in no way condone. Yet, despite Friend's deliberate distortion of my highlighted quote, its radical intentionality remains intact. It makes clear that sexist men must undergo a process of feminist revolution if they want to be capable of satisfying the needs of feminist women who experience our most intense sexual pleasure in an oppositional space outside the patriarchal phallic imaginary. It is this feminist vision of liberatory heterosexuality that seems to terrify men.

No wonder, then, that women who want to be sexual with men are perversely reinventing feminism so that it will satisfy patriarchal desires, so that it can be incorporated into a sexist phallic imaginary in such a way that male sexual agency as we now know it will never need to change. Representing a larger structure of white male power, Tad Friend, in conjunction with those who edited and published this piece, show contempt for any radical or revolutionary feminist practice that upholds dialogue and engagement with men, that sees men as comrades in struggle. Contrary to what this magazine and the mass media in general project in complicity with opportunistic white female allies (e.g., Camille Paglia, Naomi Wolf), older feminists like myself were supporting the inclusion of men in feminist movement (actually writing and publishing articles to push this point) years ago. Contrary to *Esquire*'s suggestion that there is "a new generation of women, who are embracing sex (and men!)," we are witnessing a new generation of women who, like their sexist male counterparts, are aggressively ahistorical and unaware of the long tradition of radical/revolutionary feminist thought that celebrates inclusiveness and liberatory sexuality. Both these groups prefer to seek out the most conservative, narrow-minded feminist thought on sex and men, then arrogantly use these images to represent the movement.

Their refusal even to acknowledge the existence of progressive

feminist thought about sex and sexuality allows them to sensationalize these issues even as they effectively use the image of the "do-me" feminists to assault the many women who stand against patriarchy and phallocentrism. Esquire magazine goes to great lengths to place me in the "do-me" category precisely because many sexist men remain unable to accept that women (and our male allies) who repudiate patriarchy assert sexual agency in new and exciting ways that are mutually humanizing and satisfying. It has always served the interest of the patriarchal status quo for men to represent the feminist woman as antisex and antimale. Even though the real lives of women active in feminist movement never conformed to this representation, it continues to prevail in the popular imagination because the subjugated knowledge that embracing feminism intensifies sexual pleasure for men and women in this society, no matter our sexual practice, is dangerous information. Too many folks might want to convert to feminist thought if they knew firsthand the powerful and passionate positive transformation it would create in every area of their sexual lives. It is better for patriarchy to try and make us believe that the only real sex available to feminist women who like men must be negotiated using the same old patriarchal modes of seduction that are perpetually unsatisfying to all women.

Patriarchal publications can successfully push this propagandistic message, as the Esquire issue does, precisely because powerful discussions of feminism and sexuality are not taking place continually, everywhere. Talking sex in meta-language and theoretical prose does not capture the imagination of masses of folks who are working daily to understand how their lives have been affected by shifting gender roles and expectations and how sexism fucks us all up, folks who just want to know what feminism is really all about and whether or not it can rescue us from the abyss of loneliness and sexual death. Living as we do in an antisex culture, with patriarchy as the most well organized and insti-

tutionalized attack on our sexual agency and imaginations, it is downright perverse and frightening that the mass media can convince anyone that feminism is the cause of women turning away from men or from heterosexual sex. Heterosexual women turned on by feminist movement learn how to move away from sexually dead encounters with patriarchal men who eroticize exploitative power and domination scenarios that in no way embrace female sexual agency, but these women do so not to give up sex but to make sex new, different, liberatory, and fun. Lack of critical vigilance within feminist movement made everyone unmindful of the ongoing need to document this shift positively. Were many more of us documenting our sex lives in art, literature, film and other media, there would be an abundance of counter-hegemonic evidence to disprove the popular sexist stereotype that women in feminist movement are antisex and antimen. By conceding the turf of sexuality to the phallocentric sexist media, feminists—whether liberal or radical—become complicit with conservative repression of public discourse of sexuality. If nothing else, articles such as the *Esquire* piece should serve as pointed reminders that radical/revolutionary feminists must always keep alive a dynamic public discussion of sexuality.

Collectively, many feminists stopped talking about sex publicly because such talk exposed not only our differences, our contradictions, it revealed that we had not yet produced visionary models of liberatory sexuality that fully reconciled issues of power and domination with our will to end systemic, sexist sexual exploitation and oppression. As the feminist pro-sex collective voice retreated into silence, sometimes pushed into the background by the puritanical violence of antisex conservative gender rights propaganda, the individual voices of narrowly focused thinkers like privileged white law professor Catharine MacKinnon, to give just one example, claimed to represent feminist perspectives on sexuality. Only folks outside feminist movement accept these voices as representative, yet these voices

continue to speak the feminist speech that the mass media most wants to hear. It delights in the sound of these voices because they are easier to belittle, make fun of, and finally dismiss. Obviously one-dimensional and often ruthlessly dogmatic, these voices are usually antisex, antipleasure, utterly lacking in humor. They deny the reality of contradictions and insist on an unattainable perfectionism in human behavior. It is no wonder, then, that the public voices of puritanical, reformist feminism turn most folks off. However, we do not effectively counter the negative impact of this message by embracing out-moded sexist visions of female sexual agency and pleasure.

I hear nothing sexually open or radical in the statement attributed to Lisa Palac in *Esquire*, who declares "I say to men, 'Okay, pretend you're a burglar and you've broken in here and you throw me down on the bed and make me suck your cock!' They're horrified—it goes against all they've been taught: No, no, it would degrade you! Exactly. Degrade me when I ask you to.' " The eroticization of sex as degradation, especially dick-sucking, and the equation of that chosen "degradation" with pleasure is merely an unimaginative reworking of stale patriarchal, pornographic fantasies that do not become more exciting or liberatory if women are the agents of their projection and realization. Most of the women quoted in *Esquire* display a lack of sexual imagination, since they primarily conceive of sexual agency only by inverting the patriarchal standpoint and claiming it as their own. Their comments were so pathetically male-identified that it was scary to think that readers might actually be convinced they were an expression of feminist, female, sexual agency. However, they were intended to excite the male imagination, and no doubt many men get off fantasizing that the feminist sexual revolution would not really change anything, just make it easier for everybody to occupy the space of the patriarchal phallic imaginary.

No doubt it was just such a moment of ecstatic masturbatory

reverie that led Tad Friend to declare: "The do-me feminists are choosing locker-room talk to shift discussion from the failures of men to the failures of feminism, from the paradigm of sexual abuse to the paradigm of sexual pleasure." This kind of either/or binary thinking mirrors the narrowminded dogmatic thinking it claims to critique. Revolutionary feminism does not focus on the failures of men, but rather on the violence of patriarchy and the pain of sexist exploitation and oppression. It calls out sexual abuse to transform the space of the erotic so that sexual pleasure can be sustained and ongoing, so that female agency can exist as an inalienable right. Revolutionary feminism embraces men who are able to change, who are capable of responding mutually in a subject-to-subject encounter where desire and fulfillment are in no way linked to coercive subjugation. This feminist vision of the sexual imaginary is the space few men seem able to enter.

7

CAMILLE PAGLIA

"Black" pagan or white colonizer?

An editor and reader of my work laments that not enough folks read me, know who I am. But she confesses, "It has to do in part with the academic way you write! Why, if you just let yourself go, you could be the black Camille Paglia!" This statement kept me laughing throughout the day. Though full of sass and wit, Paglia's *Sexual Personae* is tediously academic. (And no doubt as unread by mainstream readers as most other English department literary criticism). Many books bought nowadays remain unopened, bought not for their ideas but because the hype surrounding the author entices. That's why I give my own awards each year to "The Most Bought Least Read Books." So far, I know of no studies done to see how writers feel when they have a mega-financial success with a work that for the most part goes unread.

Who knows, then, what it means for me to strive to become

the "black Camille Paglia"? Maybe it would make me a more powerful voice in popular culture. Like RuPaul, I could come to fame "working" mainstream culture's hunger for representations of black folks that repudiate the notion "it's a white thing, you wouldn't understand." It's a deep thing to live in a culture where folks get off on the image of a big black man trying to look and act like a little white woman (a version of Dolly Parton's petite retrograde femininity complete with big blond hair). Or, for another take on the same phenomenon, there is the example of model Naomi Campbell being more than rewarded for giving up her naturally beautiful black looks for the joys of being a white woman wannabe. If only I could have long straight hair—blond, strawberry blond, red, light brown, any kind of dead, white-girl hair will do. If only. No doubt about it: in the marketplace of white supremacist capitalist patriarchy, the yellow brick road leading to black power in the mainstream can only be traveled by those who are throwing shade and shedding skin all the way—by those who are ready to be, as the novel put it, "black no more." This is a piece about why I ain't even interested in appearing as though I would even think about wanting to be "the black Camille Paglia."

To begin with, I need to make it clear to those who don't know that the throwing-shade, dissin', "reading" style that carried Miss Camille to fame was a persona she assembled after years of ethnographically studying the mannerisms of vernacular black culture, especially black gay sub-culture, and most especially the culture of the black queen. And girlfriend ain't even ashamed about this background, not at all embarrassed to say shit like:

> My mentors have always been Jews, Harold Bloom and so on, and they're the only ones who can tolerate my personality! But at any rate, when I got to Yale . . . whoa! Culture shock! Because I saw the way the WASP establishment had the Ivy League in a

death grip. In order to rise in academe, you have to adopt this WASP Style. It's very laid-back. Now, I really can't do it, but I call it "walking on eggs at a funeral home." Now I'm *loud*. Did you notice? I'm very loud. I've had a hell of a time in academe. This is why I usually get along with African Americans. I mean, when we're together, "Whooo!" It's like I feel totally *myself*—we just let everything go!

Naturally, all black Americans were more than pleased to have Miss Camille give us this vote of confidence, since we live to make it possible for white girls like herself to have a place where they can be "totally" themselves.

Throughout her work, Miss Camille unabashedly articulates white cultural imperialist representations of her beloved neo-primitive darkies, sharing profound tidbits such as "we don't need Derrida, we have Aretha." Or, "In my opinion, the most powerful energetic personalities in America are not WASPS but blacks, Jews, and gays, all of whom are in combat with larger, perhaps unconquerable historical forces." And she can even get downright Afrocentric when she wants to and just let it all hang. "The whole racial argument about the canon falls to nothing when it is seen that the origins of Greek Apollonianism were in Egypt, in Africa. Go down, Moses: even Judeo-Christianity sojourned in Egypt." Go, Miss Camille. Just appropriate that "difference" and go with it! Go, girl!

Come to think of it, not only is Miss Camille working the positive tip of transgressive black sub-culture, she really took some "how to get ahead and succeed on TV" lessons from Shahrazad Ali! The mix of sassy dissin' witty radical "reads" with straight-ahead conservative-speak spices things up in just the way that makes it the kind of border-crossing cultural criticism everybody can groove on. Even though it does seem that radical chic was absorbed by the rearticulation of mainstream, white supremacist capitalist patriarchal values. I mean girlfriend

bashed feminism left, right, and center telling us "current feminism" was "in a reactionary phase of hysterical moralism and prudery, like that of the Temperance movement a century ago." And when it came down to really talking about changing canons and curricula and divesting of some white supremacy, all Miss Camille could say was, "African Americans must study the language and structure of Western public power while still preserving their cultural identity, which has had world impact on the arts." Oh, we so hurt! Miss Camille, you mean all you think we can do is dance and sing? We read and write now, yes, ma'am.

Paglia never mentions the critical writing of any African American. And even her dissin' diatribe on Anita Hill never used that offensive word "black" since "What's race gotta do with it?" is top of the charts among the crowd that agrees with Miss Camille that the hearings were "one of the most powerful moments I have witnessed on television." In defense of a real life Mister—but certainly aping Alice Walker's color purple style—she proclaims, "Giving birth to himself, Thomas reenacted his own credo of the self-made man." When it came down to it, Miss Camille was not at all into changing or challenging the status quo. Girlfriend just wanted to be right there in the middle of that white supremacist capitalist patriarchal stage doing her thing. Go, girl! You got it! It's all yours!

The spotlight that the white male-dominated, racist, and sexist mass media turned on Camille Paglia has begun to dim. The lights are dimming not because she has ceased to be witty, stopped her sensational sound bites, or is any less stridently passionate in her trashing of feminism, but because the seductive young are on her turf, competing and claiming air time. Without Paglia as trailblazer and symbolic mentor, there would be no cultural limelight for white girls such as Katie Roiphe and Naomi Wolf. And no matter how hard they work to put that Oedipal distance between their writing and hers, they are singing the same tune on way too many things. And (dare I say it?)

that tune always seems to be a jazzed-up version of "The Way We Were"—you know, the good old days before feminism and multiculturalism and the unbiased curriculum fucked everything up. Come to think of it, Miss Camille was among the first white male-appointed female voices to proclaim that "we need a new kind of feminism, one that stresses personal responsibility and is open to art and sex in all their dark, unconsoling mysteries. The feminist of the *fin de siècle* will be bawdy, streetwise, and on-the-spot confrontational, in the prankish, sixties ways." Never mind that many living feminists personify all this. Our problem is that we are just fast, fresh girls that Paglia does not know—and if she did she would pretend not to, 'cause recognizing us would mean that much of what she has to say about feminism would be exposed for what it is: the stuff of sexist fantasy. This is not to say there is no basis in reality use for her critique, only that the basis is small and does not represent any feminist norm. Paglia, like those who come in her wake, chooses easy targets. She calls out the conservative crowd, the antimale, antisex, close-your-skirts-and-cross-your-legs, gender- equality-with-men-of-their-class, reformist, professional girls she knew up close and personal.

Sass and sarcasm aside, it has been tremendously difficult for radical/revolutionary feminist thinkers to intervene in the mass media's tendency to project conservative feminist thought as representative. At the same time, it has been all too easy for that same media to provide massive amounts of air time to self-proclaimed "feminist" spokespersons, such as Paglia, who not only confirm this representation but counter it with their own eclectic and sometimes even bizarre prescriptions for future feminist movement. Significantly, Paglia and her followers make feminism most palatable when they strip it of any radical political agenda that would include a critique of sexism and a call to dismantle patriarchy, repackaging it so that it is finally only about gender equality with men of their class in the public

sphere. No matter the skill with which Paglia consistently argues that women are different from men, more body than mind, more emotional than rational, and so on; in her reactionary introductory chapter to *Sexual Personae*, "Sex and Violence, or Nature and Art," she is not so retrograde as to want to do away with equal access to the privileged spheres of careers, money, and power even though that access exists as a consequence of the militant feminist work she downgrades or ignores. Sadly, radical/ revolutionary feminist thinkers have been unable to intervene strategically and alter the public understanding of feminism that audiences receive from the messages of Paglia. Such an intervention is necessary. Paglia would never have been able to publicly cast herself as a feminist activist, even with the support of the male-dominated mass media, if there had existed an organized radical/revolutionary feminist movement.

Even though we have many powerful individual spokespersons who educate for critical consciousness, teaching feminist thought and practice, we have lost an organized base from which to project revolutionary agendas. The most organized segment of feminist movement is the reformist conservative/ liberal strain. From the onset of contemporary feminist movement, this segment has lobbied for equal access in the public sphere, primarily in the work arena. And as I and other progressive thinkers have written, a changing national and global economy created a context where it was in the class and race interests of privileged white men to accept the disruption of gender roles in the public sphere. Hence, economic shifts have been as much a factor in creating a cultural climate for disruption of gender roles as has feminist movement. Now that that disruption has been relatively successful, there is no need for folks to lobby publicly for the inclusion of women in the work force—that is now the norm. And now that it is also evident that such inclusion will not lead to the displacement and disruption of patriarchal, white male power, the site of feminist struggle is shifting

to the issue of power and control in the sphere of domestic relationships between males and females.

At the peak of the contemporary feminist movement, a Virginia Slims commercial showed a woman shifting roles, moving from gender equality in the work force to traditional femininity in the home. Those of us who remember it can see that to some extent this ad was prophetic. As the white woman portrayed shifted roles, signified by the changing of clothes, stripping off her work suit for sexy lingerie, she sang: "I can bring home the bacon, fry it up in the pan, and never let you forget I'm a woman." The words and scenario fit neatly with the version of feminism women such as Paglia, Wolf, and Roiphe advocate. (Although if such an ad were airing today it would include the image of a cook making dinner so that the only role the "power feminist" would need to shift from is that of hardcore work equal to soft feminine sexual partner).

In most of her work, Paglia makes the female body the site of her insistence on a binary structure of gender difference, particularly in relation to the issue of sexuality, of desire and pleasure. Without ever using words such as inferior and superior, she implies the naturalness of these distinctions with statements that affirm hierarchy:

> Sexual freedom. Sexual liberation. A modern delusion. We are hierarchical animals. Sweep one hierarchy away, and another will take its place, perhaps less palatable than the first. There are hierarchies in nature and alternate hierarchies in society. In nature, brute force is the law, a survival of the fittest.

Or

> The identification of woman with nature is the most troubled and troubling term in this historical argument. Was it ever true? Can it still be true? Most feminist readers will disagree, but I

> think this identification is not myth but reality. All the genres of
> philosophy, science, high art, athletics, and politics were
> invented by men ... Every human being must wrestle with
> nature. But nature's burden falls more heavily on one sex. With
> luck, this will not limit woman's achievement, that is, her
> action in male-created social space. But it must limit eroticism,
> that is, our imaginative lives in sexual space, which may overlap
> social space but is not identical with it.

It is this revamped patriarchal logic passing for "new feminism"
that the mass media hypes, and that sexist men and women
cheer.

Paglia's conservative sense of gender is coupled with an
equally conservative take on race and the issues of multicultural-
ism. Embedded in all her statements about African American
culture is the age-old white cultural elitism that acknowledges
sports and music as domains where black genius has appeared
even as she discounts through a process of non-acknowledgment
black contributions in all other arenas. Superficially, it may
appear that Paglia was supported by sexist men solely because of
her antifeminist stance; however, that support is linked as well
with her Western white nationalist stance, particularly in relation
to education, attempts to critique biases in curriculum, and so
on. Mass audiences fascinated with Paglia mainly heard sen-
sational sound bites that often appear radical and transgressive of
the status quo, or clever negative put-downs of feminism, so it
may not be as apparent to these groups that many of her agendas
are utterly conservative. And even those "new feminists" who
claim no allegiance to Paglia take pride in their support of a
traditional curriculum in the academy. Despite the hype that
implies that students, particularly those in Women's Studies, are
in danger of not knowing "great white Western" canonical
works, these subjects continue to dominate the curriculum
everywhere. No one is denied access to them. Contrary to what

some folks would have us believe, it is not tragic, even if undesirable, for a person to leave a liberal arts education not having read major works from this canon. Their lives are not ending. And the exciting dimension of knowledge is that we can learn a work without formally studying it. If a student graduates without reading Shakespeare and then reads or studies this work later it does not delegitimize whatever formal course of study that was completed. Obviously, Paglia's academic conservativism was welcomed, encouraged, and supported by the existing power structure—and it did influence public opinion. If nothing else, it created a space for other self-proclaimed "feminist" leaders to follow in her foot-steps. Progressive thinkers, especially feminists, often dismissed Paglia's antifeminism without identifying the specific ways she undermines feminist movement and progressive struggle in general. Issues of exploitation and oppression never surface in Paglia's work. This absence is especially appealing in an antiintellectual culture that urges everyone to feel that all intense critical thought, especially that which promotes radical political activism, crushes our capacity to experience pleasure. This thinking is at the heart of the assumption that supporting feminist politics means being antisex and ultimately antipleasure. Yet progressive critical thinkers, especially feminists, who are only concerned with exchanging ideas within academic circles, concede the space of popular cultural debate to those individuals who are eager to have a turn at stardom. This concession helps promote the rise of individuals like Paglia.

Not every point Paglia makes is inaccurate. Indeed, she has been difficult to dismiss precisely because her ideas often contradict one another. There is often a conservative and radical mix. This ambiguity notwithstanding, most of her primary ideas are rooted in conservative, white supremacist capitalist patriarchal thought. Shrewdly, Paglia avoids public appearances with individuals, myself included, who might undermine the negative representation of feminist thought she has helped

popularize. Radical/revolutionary feminist thought and practice must emerge as a force in popular culture if we are to counter in a constructive way the rise of Paglia and those who eagerly seek the same spotlight. This means that we must work harder to gain a hearing.

There must be more effort to write and talk about feminist ideas in ways that are accessible. Those of us who already have been successfully working in this way must strive individually and collectively to make our voices heard by a wider audience. If we do not actively enter the terrain of popular culture, we will be complicit in the antifeminist backlash that is at the heart of the mass media's support of antifeminist women who claim to speak on behalf of feminism. This speaking is really a seductive foreplay that intends to provoke, excite, and silence. The time has come to interrupt, intervene, and change the channel.

8

DISSIDENT HEAT

Fire with fire

Life-transforming ideas have always come to me through books. Even when profound experiences alter my sense of reality, those lived moments usually return me to ideas I have read or lead me to further reading. My critical engagement with feminist thinking began with books. And even as an undergraduate, during the heyday of my involvement with Women's Studies courses, consciousness-raising, and moments of organized rebellion, I always felt the need to ground these experiences with careful reading and the study of written work. Whenever I am asked by anyone about feminist thinking or feminist movement, I refer to books. I never encourage them to seek out individuals, to follow feminist "stars." Cautioning them against idolatry (and that caution extends to my advising them against placing me on a pedestal), I urge them to grapple with feminist ideas and to read, interrogate, and think critically.

As a young feminist thinker, I was deeply moved by the emphasis many radical feminists placed on anonymity. It fascinated me to read feminist work where writers used pseudonyms as a strategy to critique both the sexist thinking that pits female thinkers against one another and also as a way to emphasize ideas over personalities. Certainly my choice to use a pseudonym was influenced by the longing, however utopian, to be among a community of feminist thinkers and activists who were seriously committed to intellectual development, to a dialectical exchange of ideas rather than opportunistic bids for stardom.

The institutionalization of feminist thought in the academy, along with the megasuccess of popular feminist books, fundamentally altered the focus on anonymity. As with any other "hot" marketable topic, feminism has become an issue that can be pimped opportunistically by feminists and nonfeminists alike. Indeed, there are so many successful feminist writers that it is easy for readers to forget that the vast majority of feminist thinkers and writers work years without seeing any material reward for their labor. Concurrently, much of the work labeled "feminist" that is now produced and marketed does not emerge from active struggle and engagement with feminist movement, or even from collaborative feminist thinking. Many authors feel quite comfortable pushing their brands of feminist thought without feeling any need to relate that thought to feminist political practice.

In the past, more so than today, many feminist thinkers, myself included, developed our ideas in various public locations of social interchange—whether consciousness-raising groups, classrooms, lectures, or one-on-one debate. I still relish the hours of intense debate, disagreement, and critical exchange I had with feminist comrade Zillah Eisenstein when we first met at a conference. We were both working on new books. Our friendship grew out of the intensity of that exchange. Or the fierce debates that took place in Donna Haraway's feminist theory

classrooms and the long hours of discussion and processing that took place after class. Many of the women I encountered during that time—Lata Mani, Ruth Frankenberg, Katie King, Caren Kaplan, to name just a few—have gone on to make significant contributions to feminist thinking. Rigorous in our critique of ideas, we wanted to subject our work to an intellectual alchemical process wherein thoughts that were self-indulgent, wasteful, or harmful to our shared political project—advancing feminist movement—would fall away. We never talked about wanting to be recognized as hotshot academics or famous feminists, not because status did not matter to us, but simply because we were more preoccupied with the issues. We were concerned about our relationship to women and men outside the academy, about writing books in a style that would reach wider audiences, and we were genuinely possessed and driven by the longing to create feminist thought and theory that would transform our lives, and the lives of all women, men, children. We yearned to be part of a feminist community that would create new visions of justice and freedom for everyone.

It is difficult not to be nostalgic for that camaraderie (we were not all white, not all straight, not from the same class or national backgrounds, some of us were deep into spiritual stuff and others had no use for gods) watching young college-educated women come to feminist thinking without an engagement with feminist movement, lacking a commitment to feminist politics that has been tested in lived experience. It is tempting for these young women to produce feminist writing that is self-indulgent, opportunistic, that sometimes shows no concern for promoting and advancing feminist movement that seeks to end sexist exploitation and oppression. It is equally tempting for this new group of thinkers and writers to seek to shield themselves from critique by setting up a scenario that suggests they are being crushed or harshly judged by older feminists who are jealous of their rise to power. Many established feminists would

testify that throughout feminist movement there has been an effort to engage new work critically and rigorously. Such critical interrogation maintains the integrity of feminist thought and practice. Reading work by new feminist writers, I am most often struck by how this writing completely ignores issues of race and class, how it cleverly makes it seem as though these discussions never took place within feminist movement. These attitudes and assumptions are given voice in the recent work of Katie Roiphe and Naomi Wolf.

Unlike Roiphe, whose book The Morning After has been harshly critiqued by many established feminist writers and thinkers, Wolf's work, Fire with Fire, strategically manages to avoid rigorous critique even though it has been subjected to some very negative reviews. Given the visceral response many feminists had to Roiphe's work I was fascinated by the fact that they seemed not to be equally disturbed by Fire with Fire—especially since many passages in Wolf's work could easily have been excerpts from The Morning After. For example, in the section entitled "Harassment and Date Rape: Collapsing the Spectrum," Wolf recalls her sense of empathy at the many stories she heard about rape at a rally, only to highlight her awareness of stories that struck "a false note." She recalls, "In one of those moments, a grieving woman took the mike and recounted an episode that brought her shame, embarrassment, humiliation, or sorrow, an episode during which she was unable to vocalize 'No.' " Wolf tells readers:

> My heart went out to her because the event had felt like a rape. There had, doubtless, been many ways in which that woman's sense of self, of her right to her own boundaries, had been transgressed long ago. But I kept thinking that, as terrible as it is to be unable to speak one's claim to one's body, what the sobbing woman described was not rape. I also thought of how appalled I would be if I had had sex with someone whose consent I was certain of, only to find myself accused of criminal behavior.

Readers could easily ignore passages which echo Roiphe's rhet-
oric because Wolf spends so much time trashing Roiphe's work.
This skillful manipulation of ideas and allegiances, the blatant
juxtaposition of contradictory opinions, characterizes much of
Wolf's writing in *Fire with Fire*.

Even though she is critical of "insider feminism," Wolf has
used power garnered after writing the bestselling *The Beauty Myth*
to network, to create a support structure that makes feminist
individuals fear reprisal if they publicly criticize her work—
power that could have been used to establish forums for progres-
sive debate and dissent. Evidently, Katie Roiphe lacked such
powerful, established, feminist backing. Even though Wolf claims
to support dissent, declaring that "it is not dissent that is harmful
to feminism, but consensus," her work reveals no evidence that
she constructively engages ideas that are different from her own.
Indeed, the false dichotomy she constructs in the section
"Victim Feminism versus Power Feminism" allows her to set up
a competitive area (again quite similar to the competitive tone in
Roiphe's work) where all feminists who do not agree with her
thinking are either shown to be lacking, lined up in a kind of
metaphorical firing squad and shot down (she summarizes the
work of Adrienne Rich, Susan Brownmiller, Andrea Dworkin,
Catharine MacKinnon in compact sections of one or two para-
graphs), or simply ignored. Given this standpoint, Wolf's con-
tention that "sisterhood is problematic" makes sense. Any reader
schooled in radical or revolutionary thought would understand
this insistence on competition to be a mirroring of internalized
sexist thinking about power, about the way in which women
have traditionally been socialized to relate to one another in
patriarchal society. Rather than offering a new vision of female
power, Wolf transposes the old sorority girl, dog-eat-dog will to
power away from the arenas of competitive dressing and dating
onto feminism.

Meeting Naomi Wolf when I gathered with a group of

feminist thinkers to engage in dialogue at the behest of *Ms.* magazine, I did not realize that I was in the presence of "power feminism." I did see that I was in the presence of a young feminist who has come to power without in any way interrogating the way her body-politic and speech patterns negate possibilities of meaningful dialogue. Rapid, aggressive speech, a refusal to acknowledge others who wish to speak (recognizing them only after they interrupt and talk over you), and not listening are all tactics that remind me of the strategies for power outlined in patriarchal manuals that teach folks how to win through intimidation. These same strategies were used by Wolf when she appeared on the Charlie Rose talk show to discuss date rape. Appearing on a panel with women and white men, she seemed to find it easier to aggressively interrupt the black woman speaker while patiently listening to the words of white male speakers. A critical examination of this video would be a useful way to illustrate the practice of "power feminism." When Wolf and I were introduced at the *Ms.* discussion she told me that she had been using my work to inform the writing of the then unpublished *Fire with Fire* but that she had to "stop reading it because of anxiety about influence." At the time this seemed to be a rather backhanded compliment. I responded in my usual direct manner by sweetly stating, "I hope you won't be like other white women who use my work and never acknowledge it." She assured me that this was not the case. And any readers who choose to pore over the copious notes at the end of *Fire with Fire* will find my work cited and long passages quoted. In the prefatory statements to Note 180 Wolf writes:

> "Victim Feminism": Many feminist theorists have addressed the issues I raise. bell hooks's work in *Feminist Theory: From Margin to Center* on sisterhood, victim culture, "trashing" and differences, has been particularly influential.

The long passages from my books Wolf appreciatively cites in her notes (which are not correlated numerically to specific passages in the main body of her work) seem to belie the fact that the one time my work is mentioned in the text its meaning is distorted and it is evoked as part of a passage that is meant to illustrate wrongminded thinking. Wolf contends, "Rather than bringing mainstream women to feminism in what writer bell hooks calls 'a conversion process,' insider feminism should go to them." In actuality, I used the phrase "conversion process" to speak about the experience we undergo to become revolutionary feminists—when we give up one set of ideas to take up another. Concurrently, in the context in which this phrase was used I was emphasizing the need for feminist thinkers to create feminist theory that speaks to masses of women and men (not simply "mainstream women," which seems in Wolf's work to be a comfortable euphemism masking her central concern with women from mostly white and/or privileged class groups).

Throughout *Fire with Fire*, Naomi Wolf skillfully manipulates the meaning and message of much feminist thought so that she stands heroically alone as the "power feminist" with the insights and the answers. In a critique I wrote of Katie Roiphe's work, I shared that I was compelled to write about *The Morning After* because I was so struck by the erasure of progressive feminist standpoints that recognize race and class to be factors that shape what it is to be female, and by her gratuitous attack on Alice Walker. Symbolically, I saw this attack as a form of backlash against those women within feminist movement, particularly women of color, who challenged all women and men engaged in feminist politics to recognize differences of race and class. It is as though privileged young white women feminists, unlike their older counterparts, feel much more comfortable publicly dismissing difference, dismissing issues of race and class when it suits them. As though given their own competitive vision, they see themselves as heroically wresting the movement away from

issues that do not centralize the concerns of white women from privileged classes.

Wolf consistently universalizes the category "woman" in Fire with Fire when she is speaking about the experiences of privileged white women. Though at times she gives lip service to a politics of inclusion, even going so far as to suggest that we need to hear more from feminist thinkers who are women of color, her own writing in no way highlights any such work. And even though she selects a quote from Audre Lorde as an epigraph for her book ("The Master's tools will never dismantle the Master's house"), she critiques it throughout as faulty, misguided logic.

Finally, in the middle of the book, she triumphantly declares in opposition not just to Lorde, but to the challenge to oppose patriarchy implicit in the original quote, that "the master's tools can dismantle the master's house." Although I would never pick this particular quote (so often evoked by white women) to represent the significance of Lorde's contribution to feminist thinking, Wolf decontextualizes this comment to deflect attention away from Lorde's call for white women and all women to interrogate our lust for power within the existing political structure, our investment in oppressive systems of domination.

While trashing Lorde's quote and making no meaningful reference to the large body of work she produced, Wolf attempts to represent Anita Hill and Madame C. J. Walker (inventor of the pressing comb and other hair straightening products) as examples of "power feminism." The choice of Hill would seem more appropriate to the "victim category," since her rise to prominence was based on the very premise of victimhood Wolf castigates. Madame C. J. Walker may have become a millionaire, but she did so by exploiting black folks' profound, internalized racial self-hatred. I can respect Walker's business acumen and long to follow that example without needing to claim her as a "feminist." I can also fight for Hill's right to have

justice as a victim of sexual harassment without needing to reinvent her as a feminist when she in no way identified herself as such.

Wolf's flowery rhetoric tends to mask the aggressive assault on radical and revolutionary feminist thinking her work embodies. Charmed by her enthusiasm, by the hopefulness in her work, readers can overlook the frightening dismissal and belittling of feminist politics that is at the core of this book. Her insistence that capitalist power is synonymous with liberation and self-determination is profoundly misguided. It would be such a disempowering vision for masses of women and men who might easily acquire what she calls "a psychology of plenty" without ever having the kind of access to jobs and careers that would allow them material gain. In keeping with its denial of any political accountability for exploitation and oppression, particularly in relation to class elitism, "power feminism" is in no way inclusive. It resolutely chooses to ignore the lived experiences of masses of women and men who in no way have access to the "mainstream" of this society's political and economic life. This rejection and erasure occurs because it would be impossible for Wolf to represent all the material and political gains of "power feminism" within the existing political and economic structure if she were to include folks who are underprivileged or poor. Her new vision of female power works best for the middle class. Indeed, she seeks to avoid political critique by stripping feminist practice of its radical political significance.

By rejecting feminism as a political movement that seeks to eradicate sexism, sexist exploitation, and oppression, replacing it with the notion that feminism is simply "a theory of self-worth" even as she concedes that those who want a more social vision can "broadly" understand it as a "humanistic movement for social justice," Wolf conveniently creates a feminist movement she can guide and direct. Thus depoliticized, this movement can embrace everyone, since it has no overt political tenets. This

"feminism" turns the movement away from politics back to a vision of individual self-help.

Both radical and revolutionary feminists long ago critiqued this opportunistic use of feminist thinking to improve one's individual lifestyle. At times, *Fire with Fire* reads as a wordy, upbeat polemical tract, encouraging ruling-class white women and yuppie women of all races to forge ahead with their individual quests to, "have it all" within the capitalist culture of narcissism, and to take note of the way in which fighting for gender equality can advance their cause. Her message is that "women" can be pro-capitalist, rich, and progressive at the same time. Wolf's insistence that "feminism should not be the property of the left or of Democrats" belies the political reality that reformist feminism has been the "only" feminist perspective the mass media has ever highlighted. No left feminism has been continuously spotlighted on national television or on the bestseller list. According to Wolf:

> Many millions of conservative and Republican women hold fierce beliefs about opportunity for women, self-determination, ownership of business, and individualism; these must be respected as a right-wing version of feminism. These women's energy and resources and ideology have as much right to the name of feminism, and could benefit women as much as and in some situations more than can left-wing feminism. The latter, while it is my own personal brand, does not hold a monopoly on caring about women and respecting their autonomy.

Sadly, Wolf's genuine concern for women's freedom is undermined by her refusal to interrogate self-centered notions of what it means to be on the left. Unwilling to expose the stereotype that all left feminists are not dogmatic, she reproduces it. Reading her work, one would think there is no visionary feminist thinking on the left. Such distortions of reality undermine her

insistence that she is offering a more inclusive, more respectable feminist vision. In actuality, her work (like that of Roiphe's) exploits accounts of feminist excesses to further her argument. Her construction of a monolithic group of "mainstream women" who have been so brutalized by feminist excess that they cannot support the movement seems to exploit the very notion of victimhood she decries.

While I agree with her insistence that feminist thought and theory do not fully speak to the needs of masses of women and men, I do not think that we should strive to stimulate that interest by packaging a patronizing, simplistic brand of feminism that we can soft-sell.

Feminist movement is not a product—not a lifestyle. History documents that it has been a political movement emerging from the concrete struggle of women and men to oppose sexism and sexist oppression. We do a disservice to that history to deny its political and radical intent. Wolf's trivialization of that intent undermines her chosen identification with left politics. Moreover, is it difficult to see the ways in which this identification informs the agenda she sets for feminism in *Fire with Fire*. Much of the "new" vision she espouses is a reworking of reformist liberal feminist solutions aimed at changing society primarily in those ways that grant certain groups of women social equality with men of their same class. Wolf is certainly correct in seeing value in reforms (some of her suggestions for working within the system are constructive). Reformist feminism was built on the foundation of radical and revolutionary feminist practice. Unlike Wolf, left-feminists like myself can appreciate the importance of reform without seeing it as opposing and negating revolutionary possibilities.

Luckily, the publication of *Fire with Fire* has created a public space where Wolf has many opportunities to engage in critical discussion about the meaning and significance of her work. Hopefully, the success of this work, coupled with all the new

information she can learn in the wake of dissident dialogues, will provide her time to read and think anew. Like Wolf, I believe feminist thinking is enriched by dissent. Opposing viewpoints should not be censored, silenced, or punished in any way. Deeply committed to a politics of solidarity wherein sisterhood is powerful because it emerges from a concrete practice of contestation, confrontation, and struggle, it is my dream that more feminist thinkers will live and work in such a way that our being embodies the power of feminist politics, the joy of feminist transformation.

9

KATIE ROIPHE

A little feminist excess goes a long way

From the very onset of the contemporary movement for "women's liberation," feminist thinkers and activists have had difficulty coping with dissent. The call for unity and solidarity structured around notions that women constitute a sex class/ caste with common experiences and common oppression made confrontation and contestation difficult. Divisions were often coped with by the forming of separate groups and by the development of different definitions and labels (radical feminist, reformist, liberal, Marxist, and so on). Significantly, conflict around the issue of common oppression reached its peak in discussions of race and class differences. Individual women of color, particularly black females, some of whom had been involved in the movement from its inception, some jointly engaged with women's liberation and black power struggle, called attention to differences that could not be reconciled by

sentimental evocations of sisterhood; the face of feminism—the rhetoric, the theory, the definitions—began to change.

Visions of solidarity between women necessarily became more complex. Suddenly, neither the experiences of materially privileged groups of white females nor the category "woman" (often used when the specific experiences of white women were referred to) could be evoked without contestation, without white supremacy looming as the political ground of such assertions. These changes strengthened the power of feminist thought and feminist movement politically. They compelled feminist thinkers to problematize and theorize issues of solidarity, to recognize the interconnectedness of structures of domination, and to build a more inclusive movement. That work risks being undone and undermined by some of the current feminist writing by young white privileged women who strive to create a narrative of feminism (not a feminist movement) that recenters the experience of materially privileged white females in ways that deny race and class differences, not solely in relation to the construction of female identity but also in relation to feminist movement.

Despite political differences in the works of Katie Roiphe and Naomi Wolf, for example, both women write as though their experiences reflect the norm without testing many of their assumptions to see if what they have to say about feminism and female experience is true across class and race boundaries. In *The Beauty Myth*, Wolf does not address differences in ways women think about beauty across race and class, about whether fashion magazines address all women in the same ways. By not calling attention to differences, we never hear about ways groups of women may confront issues of beauty that are more empowering than that white female relationship to beauty deemed "the norm." Does it remain unthinkable in our society that women who are not white might have information, knowledge, strategies that should become a norm for white women and all

women? Reading Wolf's book, I was disturbed by her universal-ization of the category "woman," but I did not see this work as having any power to undermine feminist work that has been altered by recognition of race and class difference. Yet as more and more books by individual feminist thinkers (mostly white, young, materially privileged) are marketed to a mass public and become the "texts" that teach these audiences what feminism is or is not, there is a danger that any critical interrogation of the universal category "woman" will be erased. We may end up right back where contemporary feminist movement began: with the false assumption that feminism is primarily for and about materially privileged white women.

More than any work by Wolf, Katie Roiphe's *The Morning After* is a harbinger of this trend. It attempts to construct and attack a monolithic young "feminist" group that shares a common response to feminist thinking, most particularly around issues of sexuality and physical assault. The book begins with the evo-cation of a cultural family genealogy in which feminism is evoked as a legacy handed down from mother to daughter, a strategy which from the onset makes feminism at least symboli-cally a turf that, like a small country, can be owned and occu-pied by some and not others. Hence, the white book-writing women within feminism can have daughters such as Roiphe who feel that they are the movement's natural heirs. It is just this claim to ownership of feminist movement that women of color and progressive white women have challenged, insisting on the ongoing understanding that feminism is a political movement—that all who make a commitment to the tenets belong, that there are no owners.

In this book, the feminist agendas that are talked about, however negatively, are always only those set by white females. Purporting to bring a newer, fresher feminist vision, *The Morning After* disturbs precisely because of the erasure of difference both in its perspectives on the issues discussed and the overall erasure

of the voices and thoughts of women of color. This latter erasure cannot be viewed as a sign of the author's ignorance or naiveté. That erasure is opportunistic. It has more to do with the fact that many feminist thinkers and activists who are women of color would be among those who do not neatly fit into the categories Roiphe erroneously suggests constitute the feminist norm. My decision to write about Roiphe's work was prompted by the fact that the only time she mentioned a woman of color (specifically a black woman) she did so with the intent to ridicule and devalue her work. This gesture did not appear to be innocent. It fit all too well Roiphe's construction of a feminist arena where the chosen (who are coincidentally young, white, and privileged) don their boxing gloves to see who is the better feminist.

The Morning After is subtitled *Sex, Fear, and Feminism on Campus*. Yet this book does not offer a broad, substantive look at feminism on any campus. Instead, it narrowly targets and critiques expressions of white privileged feminist hysteria and extremism when it comes to issues such as date rape, sexual harassment, and pornography. When Roiphe turns her powerful critical spotlight on these feminist excesses she does so in a manner that completely overshadows and erases that which is meaningful in feminist critiques of and resistance to sexism, patriarchy, and male domination. It is this erasure that renders suspect her self-congratulatory insistence that she is the representative voice of a less "rigid feminist orthodoxy" speaking on behalf of "some feminisms" which "are better than others."

Unlike many feminist thinkers, I do not believe that Roiphe's critiques are all wrong-minded. Nor am I that concerned with whether she has the facts right. Whether she likes it or not, her book is a polemical work. Its power does not lie in the realm of research. The feminist thinkers who want to refute her work on this basis should do so. Strategically, however, it advances feminist movement more for us to acknowledge that

some of the examples of feminist excess she calls attention to are familiar. And not only that; we should acknowledge the many feminist thinkers who have warned against these excesses and worked to deflect the interests of young feminists away from the sentimentalization of feminist concerns.

By cleverly calling no attention to the work of powerful feminist thinkers who have continually critiqued the very excesses she names (Judith Butler, Audre Lorde, Kimberlé Crenshaw, and Diana Fuss, to name a few) Roiphe makes it appear that her ideas offer a new and fresh alternative to feminist dogmatism. In fact, her book draws heavily upon and restates critiques that have been continually voiced within feminist circles, yet voiced in those circles in a manner that in no way ridicules or mocks the seriousness of feminist agendas. No respect is given these agendas in The Morning After.

Clearly, ending male violence against women is a feminist agenda. Roiphe completely ignores the connection between maintaining patriarchy and condoning male violence against women. She is so eager to be provocative that she is unwilling to pollute her polemic by declaring in a serious way that male violence against women—including sexual assault —is utterly acceptable in our society, and that the various ways women organize to protest that violence, despite excess or flaws in strategy, should be praised and applauded. Roiphe's polemic leaves readers with no understanding of constructive ways feminists have challenged male violence. The chapter I wrote on violence in Feminist Theory: From Margin to Center almost ten years ago cautioned feminists not to see women solely as victims but to recognize both the ways we use power and the ways power is used against us. Though critical of ways feminist responses to male violence seemed to exacerbate the problem, I was not willing to act as though mistakes in feminist organizing and, yes, even moments of hysteria and sentimentality, overshadow the gravity of the situation. It is the tone of ridicule and contempt

that gives Roiphe's polemic an air of insincerity, as though indeed she is much more concerned with duking it out with her peers and winning the fight than she is with challenging patriarchy.

In her chapter "Catharine MacKinnon, the Antiporn Star," Roiphe concedes that she is not the first or only feminist to raise concerns about rigid feminist orthodoxy. Yet she consistently repeats the phrase "many feminists" to refer to those scholars, writers, and critical thinkers who have diligently worked to offer a broader, more complex understanding of feminist theory and practice as regards sexuality, male violence against women, and a host of other issues. These feminists are not named. Their works are never referred to or cited. The absence of our works and our words makes it appear that Roiphe stands alone in her will to name and critique aspects of feminism. Forget the nature of her argument, the underlying message irrespective of the issues she raises is that most feminists refuse to embrace any form of dissent, are rigid and dogmatic—with the exception of herself and perhaps Camille Paglia. Had she insisted on acknowledging the range of dissenting voices within feminism, the multidimensional critiques that already exist, the underlying premise of her book would have lost its bite. Without any mention of the words and deeds of dissenting feminists, Roiphe presents herself as, dare I say it, a "victim," punished by her willingness to say what no "young" feminists are willing to say. Indeed it is the evocation of the young and her peers that is meant to both excuse the erasure of slightly older voices and strengthen her position as a "young" authority. Yet even young feminist thinkers who have made and make similar critiques are ignored. She does not highlight the book *Feminist Fatale* by Paula Kamen, which is one of the most well researched and thoughtful discussions of the factors that shape young women's responses to feminism.

Roiphe's construction of the image of herself as "maverick,"

standing alone in a feminist jungle where no one will listen, deflects away from the diverse critiques that exist, some of which target similar excesses, though they are not as crudely stated as her own. Roiphe does not stand alone. She stands in the shadows of feminist thinkers who have passionately worked to bring to the public a deeper awareness of the political significance of feminist movement, who have sought to deflect popular attention away from a simplistic equation of feminism with anti-male and anti-sex sentiments. Roiphe draws from this body of feminist thought even as she distorts and undermines it by insisting in *The Morning After* that narrow, rigid feminism goes uncritiqued, that it is both widespread and representative.

To achieve this end, Roiphe refuses to acknowledge all the critiques of sentimental white bourgeois feminist thought made by radical black women, women of color, and progressive white women. Perhaps Roiphe would not be so enraged at young white feminists from privileged backgrounds at Harvard and Princeton who have "created their own rigid orthodoxy" if she were embracing the work and activism of feminist thinkers that promote and encourage dissent, if she were convinced that it was her mission to share these ideas. Clearly, Roiphe has no desire to connect her critique with critical interrogations of narrow feminist dogma that seek not simply to expose the flaws and weakness in some feminist activism and thought but work to clarify issues in such a way as to refocus attention on meaningful feminist concerns. For it is that feminist thought and practice that would broaden her understanding of the politics of white supremacist capitalist patriarchy. So much so that she would even be able to see how her work "as is" advances the agenda of antifeminists who so often control the mass media, and who represent feminism one-dimensionally—stereotypically.

Obviously, it is not merely Roiphe's concern that feminist movement be a place where dissenting voices can be heard, where ideas can be challenged (if indeed that is her genuine

concern), that has led her into the limelight. And even if her book never becomes a big seller, her work has been featured in major popular magazines and will certainly influence public understanding of feminism. Many unquestioning readers will assume that the version of feminism described by Roiphe is accurate—that women who advocate feminist politics are primarily small-minded, dogmatic, and willing to curtail free speech when it suits their fancy. Careful readers will certainly wonder whether they can really believe Roiphe's insistence that feminist censorship is so pervasive on her campus that "no" feminists would allow her to "say that Alice Walker was just a bad writer." Certainly, Roiphe has one-upped those "censoring peers," for she managed (no doubt through powerful connections in the publishing world) to move her ideas beyond the narrow cultural confines of an Ivy League graduate program and has been rewarded with a public forum where her ideas are not only being heard, but well advertised and promoted. No interviews with Roiphe that I have read ask the author if she has critically interrogated the reason her work has received so much attention, or if she sees any connection between that attention and the antifeminist backlash. For powerful forces in the publishing world have called public attention to Roiphe's work and made it appear that it somehow matters what Katie Roiphe thinks about Alice Walker; these forces convince readers that Roiphe is bringing to light suppressed, hidden truths other feminists seek to deny.

Earlier in this piece I stated that I was compelled to write about The Morning After in part because I found it both significant and disturbing that the only mention of a single woman of color occurs in a context where she is devaluing that writer's work. This dismissal connects with the recent attack on Women's Studies published in Mother Jones, which also suggested that among those not very academic folks who are being read (and should not be) were black women writers: myself and Audre

Lorde. I wonder about this need to trash black women writers and critical thinkers who have been among those who have worked hardest to challenge the assertion that the word "woman" can be used when it is the specific experience of white females that is being talked about, who have argued that race and class must be considered when we develop feminist thought and theory. Doesn't this need reflect a competitive impulse, a desire to wrest the discourse of the movement away from these directions? By this I mean that individual white women who feel that some feminists, "women of color in particular," should not have shifted the direction of feminist thinking by insisting that white women confront white supremacy, are now seeking to shift the movement back to those stages when it was acceptable to ignore, devalue, even trash these concerns. And it is interesting that this effort to denigrate black women writers emerges at a time when so many progressives move to challenge literary canons so that they will include the works of women of all colors are themselves being attacked and challenged. With her seemingly innocent assertion about Walker's work, Roiphe, along with other white women who take similar standpoints (for example, the white woman reporter who trashed Toni Morrison in an editorial about the Nobel Prize), unites with conservative thinkers (many of whom are white and male) who hold similar views, who also have the power in many instances to prevent those works from being published, reviewed, read, or studied.

All too often in The Morning After, Roiphe evokes a vision of feminist movement that simplistically mirrors patriarchal stereotypes. No doubt it is this mirroring that allows her voice, and not the voices of visionary critiques of feminist dogma, to receive such widespread attention and acclaim. Roiphe ends her book warning readers about the dangers of "excessive zeal" in relation to advancing political concerns, cautioning that it can lead to blind spots, a will to exaggeration, distortions in perspective.

Regrettably, Roiphe did not allow her work to be guided by this insight.

While it is useful for everyone to critique excesses in feminist movement, as well as mistakes and bad strategies, it is important for the future of feminism that those critiques reflect a genuine will to advance feminist politics. Like Roiphe, I wrote a very provocative feminist book when I was young. And I know firsthand how important it is for young feminist thinkers to be courageous in their thinking and action, to claim the right and power to speak their minds. At the same time, it is equally important that those who advocate feminism, young and old, female and male, continually search our hearts and minds to be clear that our interests are not motivated by opportunistic concerns or articulated in shallow ways that mirror and perpetuate antifeminist sentiment. Although my books rigorously critique and interrogate aspects of feminist thoughts, they also insist on the primacy of a fierce feminist commitment to ending sexism and sexist oppression. A progressive, revolutionary feminist movement must welcome and create a context for constructive conflict, confrontation, and dissent. Through that dialectical exchange of ideas, thoughts, and visions, we affirm the transformative power of feminist politics.

10

SEDUCED BY VIOLENCE NO MORE

We live in a culture that condones and celebrates rape. Within a phallocentric patriarchal state, the rape of women by men is a ritual that daily perpetuates and maintains sexist oppression and exploitation. We cannot hope to transform "rape culture" without committing ourselves fully to resisting and eradicating patriarchy. In his recent essay "Black America: Multicultural Democracy in the Age of Clarence Thomas and David Duke," Manning Marable writes:

> Rape, spouse abuse, sexual harassment on the job, are all essential to the perpetuation of a sexist society. For the sexist, violence is the necessary and logical part of the unequal, exploitative relationship. To dominate and control, sexism requires violence. Rape and sexual harassment are therefore not accidental to the structure of gender relations within a sexist order.

This is no new revelation. In all our work as thinkers and activists, committed feminist women have consistently made this same point. However, it is important to acknowledge that our movement to transform rape culture can only progress as men come to feminist thinking and actively challenge sexism and male violence against women. And it is even more significant that Marable speaks against a sexist order from his position as an African American social critic.

Black males, utterly disenfranchised in almost every arena of life in the United States, often find that the assertion of sexist domination is their only expressive access to the patriarchal power they are told all men should possess as their gendered birthright. Hence, it should not surprise or shock that many black men support and celebrate "rape culture." That celebration has found its most powerful contemporary voice in misogynist rap music. Significantly, there are powerful alternative voices. Mass media pays little attention to those black men who are opposing phallocentrism, misogyny, and sexism. The "it's-a-dick-thing" version of masculinity that black male pop icons such as Spike Lee and Eddie Murphy promote is a call for "real" black men to be sexist and proud of it, to rape and assault black women and brag about it. Alternative, progressive, black male voices in rap or cinema receive little attention, but they exist. There are even black males who do "rap against rape" (their slogan), but their voices are not celebrated in patriarchal culture.

Overall, cultural celebration of black male phallocentrism takes the form of commodifying these expressions of "cool" in ways that glamorize and seduce. Hence, those heterosexual black males that the culture deems most desirable as mates or erotic partners tend to be pushing a "dick-thing" masculinity. They can talk tough and get rough. They can brag about disciplinin' their women, about making sure the "bitches" respect them. Many black men have a profound investment in the perpetuation and maintenance of rape culture. So much of their sense of value

and self-esteem is hooked into the patriarchal macho image; these brothers are not about to surrender their "dick-thing" masculinity. This was most apparent during the Mike Tyson trial. Brothers all over were arguing that the black female plaintiff should not have gone to Tyson's hotel room in the wee hours of the morning if she had no intention of doing the wild thing. As one young brother told me last week, "I mean, if a sister came to my room that late, I would think she got one thing on her mind." When I suggested to him and his partners that maybe a woman could visit the room of a man she likes in the wee hours of the night because she might like to talk, they shook their heads saying, "No way." Theirs is a deeply ingrained sexism, a profoundly serious commitment to rape culture.

Like many black men, they are enraged by any feminist call to rethink masculinity and oppose patriarchy. And the courage-ous brothers who do, who rethink masculinity, who reject patriarchy and rape culture, often find that they cannot get any play—that the very same women who may critique macho male nonsense contradict themselves by making it clear that they find the "unconscious brothers" more appealing.

On college campuses all over the United States, I talk with these black males and hear their frustrations. They are trying to oppose patriarchy and yet are rejected by black females for not being masculine enough. This makes them feel like losers, that their lives are not enhanced when they make progressive changes, when they affirm feminist movement. Their black female peers confirm that they do indeed hold contradictory desires. They desire men not to be sexist, even as they say, "But I want him to be masculine." When pushed to define "mascu-line," they fall back on sexist representations. I was surprised by the number of young black women who repudiated the notion of male domination, but who would then go on to insist that they could not desire a brother who could not take charge, take care of business, be in control.

Their responses suggest that one major obstacle preventing us from transforming rape culture is that heterosexual women have not unlearned a heterosexist-based "eroticism" that constructs desire in such a way that many of us can only respond erotically to male behavior that has already been coded as masculine within the sexist framework. Let me give an example of what I mean. For most of my heterosexual erotic life I have been involved with black males who are into a "dick-thing" masculinity. For more than ten years I was in a nonmonogamous relationship with a black man committed to nonsexist behavior in almost every aspect of daily life—the major exception being the bedroom. I accepted my partner's insistence that his sexual desires be met in any circumstance where I had made sexual overtures (kissing, caressing, and so on). Hence ours was not a relationship in which I felt free to initiate sexual play without going forward and engaging in coitus. Often I felt compelled to engage in sexual intercourse when I did not want to.

In my fantasies, I dreamed of being with a male who would fully respect my body rights, my right to say "no," my freedom not to proceed in any sexual activity that I did not desire even if I initially felt that I wanted to be sexual. When I left this relationship, I was determined to choose male partners who would respect my body rights. For me this meant males who did not think that the most important expression of female love was satisfying male sexual desire. It meant males who could respect a woman's right to say "no," irrespective of the circumstance.

Years passed before I found a partner who respected those rights in a feminist manner, with whom I made a mutual covenant that neither of us would ever engage in any sexual act that we did not desire to participate in. I was elated. With this partner I felt free and safe. I felt that I could choose not to have sex without worrying that this choice would alienate or anger my partner. Though most women were impressed that I had found such a partner, they doubted that this could be a chosen

commitment to female freedom on any man's part; they raised suspicious questions. Braggin' about him to girlfriends and acquaintances, I was often told, "Girl, you betta be careful. Dude might be gay." I also began to feel doubts. Nothing about the way this dude behaved was familiar. His was not the usual "dick-thing" masculinity that had aroused feelings of pleasure and danger in me for most of my erotic life. While I liked his alternative behavior, I felt a loss of control—the kind that we experience when we are no longer acting within the socialized framework of both acceptable and familiar heterosexual behavior. I worried that he did not find me really desirable. Then I asked myself whether aggressive emphasis on his desire, on his need for "the pussy" would have reassured me. It seemed to me, then, that I needed to rethink the nature of female heterosexual eroticism, particularly in relation to black culture.

Critically interrogating my responses, I confronted the reality that despite all my years of opposing patriarchy, I had not fully questioned or transformed the structure of my desire. By allowing my erotic desire to still be determined to any extent by conventional sexist constructions, I was acting in complicity with patriarchal thinking. Resisting patriarchy ultimately meant that I had to reconstruct myself as a heterosexual, desiring subject in a manner that would make it possible for me to be fully aroused by male behavior that was not phallocentric. In basic terms, I had to learn how to be sexual with a man in a context where his pleasure and his hard-on is decentered and mutual pleasure is centered instead. That meant learning how to enjoy being with a male partner who could be sexual without viewing coitus as the ultimate expression of desire.

Talking with women of varying ages and ethnicities about this issue, I am more convinced than ever that women who engage in sexual acts with male partners must not only interrogate the nature of the masculinity we desire, we must also actively construct radically new ways to think and feel as desiring subjects.

By shaping our eroticism in ways that repudiate phallocentrism, we oppose rape culture. Whether this alters sexist male behavior is not the point. A woman who wants to engage in erotic acts with a man without reinscribing sexism will be much more likely to avoid or reject situations in which she might be victimized. By refusing to function within the heterosexist framework that condones male erotic domination of women, females would be actively disempowering patriarchy.

Without a doubt, our collective, conscious refusal to act in any way that would make us complicit in the perpetuation of rape culture within the sphere of sexual relations would undermine the structure. Concurrently, when heterosexual women are no longer attracted to macho men, the message sent to men would at least be consistent and clear. That would be a major intervention in the overall effort to transform rape culture.

11

GANGSTA CULTURE—
SEXISM AND MISOGYNY

Who will take the rap?

For the past several months, the white mainstream media has been contacting me to hear my views on gangsta rap. Whether major television networks, or small independent radio shows, they seek me out for the black and feminist take on the issue. After I have my say, I am never called back, never invited to do the television shows, the radio spots. I suspect they call me, confident that when we talk they will hear the hardcore "feminist" trash of gangsta rap. When they encounter instead the hardcore feminist critique of white supremacist capitalist patriarchy, they lose interest.

To the white-dominated mass media, the controversy over gangsta rap makes great spectacle. Besides the exploitation of these issues to attract audiences, a central motivation for high-lighting gangsta rap continues to be the sensationalist drama of

demonizing black youth culture in general and the contributions of young black men in particular. It's a contemporary remake of Birth of a Nation—only this time we are encouraged to believe it is not just vulnerable white womanhood that risks destruction by black hands, but everyone. When I counter this demonization of black males by insisting that gangsta rap does not appear in a cultural vacuum, that it is not a product created in isolation within a segregated black world but is rather expressive of the cultural crossing, mixings, and engagement of black youth culture with the values, attitudes, and concerns of the white majority, some folks stop listening.

The sexist, misogynist, patriarchal ways of thinking and behaving that are glorified in gangsta rap are a reflection of the prevailing values in our society, values created and sustained by white supremacist capitalist patriarchy. As the crudest and most brutal expression of sexism, misogynistic attitudes tend to be portrayed by the dominant culture as always an expression of male deviance. In reality, they are part of a sexist continuum, necessary for the maintenance of patriarchal social order. While patriarchy and sexism continue to be the political and cultural norm in our society, feminist movement has created a climate where crude expressions of male domination are likely to be called into question, especially if they are made by men in power. It is useful to think of misogyny as a field that must be labored in and maintained both to sustain patriarchy but also to nourish an antifeminist backlash. And what better group to labor on this "plantation" than young black men?

To see gangsta rap as a reflection of dominant values in our culture rather than as an aberrant pathological standpoint does not mean that a rigorous feminist critique and interrogation of the sexist and misogyny expressed in this music is not needed. Without a doubt black males, young and old, must be held politically accountable for their sexism. Yet this critique must always be contextualized or we risk making it appear that the

problems of misogyny, sexism, and all the behaviors this think-ing supports and condones, including rape, male violence against women, is a black male thing. And this is what is happening. Young black males are forced to take the heat for encouraging via their music the hatred of and violence against women that is a central core of patriarchy.

Witness the recent piece by Brent Staples in the *New York Times*, entitled "The Politics of Gangster Rap: A Music Celebrating Murder and Misogyny." Defining the turf, Staples writes, "For those who haven't caught up, gangster rap is that wildly success-ful music in which all women are 'bitches' and 'whores' and young men kill each other for sport." No mention of white supremacist capitalist patriarchy in this piece. Not a word about the cultural context that would need to exist for young males to be socialized to think differently about gender. No word about feminism. Staples unwittingly assumes that black males are writ-ing their lyrics off in the "jungle," faraway from the impact of mainstream socialization and desire. At no point does he inter-rogate why it is huge audiences, especially young white male consumers, are so turned on by this music, by the misogyny and sexism, by the brutality. Where is the anger and rage at females expressed in this music coming from, the glorification of all acts of violence? These are the difficult questions that Staples feels no need to answer.

One cannot answer them honestly without placing account-ability on larger structures of domination (sexism, racism, class elitism) and the individuals—often white, usually male, but not always—who are hierarchally placed to maintain and perpetuate the values that uphold these exploitative and oppressive systems. That means taking a critical look at the politics of hedonistic consumerism, the values of the men and women who produce gangsta rap. It would mean considering the seduction of young black males who find that they can make more money produc-ing lyrics that promote violence, sexism, misogyny than with

any other content. How many disenfranchised black males would not surrender to expressing virulent forms of sexism if they knew the rewards would be unprecedented material power and fame?

More than anything, gangsta rap celebrates the world of the material, the dog-eat-dog world where you do what you gotta do to make it even if it means fucking over folks and taking them out. In this world view killing is necessary for survival. Significantly, the logic here is a crude expression of the logic of white supremacist capitalist patriarchy. In his new book *Sexy Dressing Etc.*, privileged white male law professor Duncan Kennedy gives what he calls "a set of general characterizations of U.S. culture," explaining that "it is individual (cowboys), material (gangsters), and philistine." This general description of mainstream culture would not lead us to place gangsta rap on the margins of what this nation is about but at the center. Rather than seeing it as a subversion or disruption of the norm, we would need to see it as an *embodiment* of the norm.

That viewpoint was graphically highlighted in the film *Menace II Society*, a drama not only of young black males killing for sport, but which included scenes where mass audiences voyeuristically watched and in many cases enjoyed the kill. Significantly, at one point in the film we see that the young black males have learned their gangsta values from watching movies and television and shows where white male gangsters are center stage. The importance of this scene is how it undermines any notion of "essentialist" blackness that would have viewers believe that the gangsterism these young black males embraced emerged from some unique black cultural experience.

When I interviewed rap artist Ice Cube for *Spin* magazine recently, he talked about the importance of respecting black women, of communication across gender. In our conversation, he spoke against male violence against women, even as he lapsed into a justification for antiwoman lyrics in rap by insisting on the

madonna/whore split where some females "carry" themselves in a manner that determines how they will be treated. But when this interview came to press it was sliced to ribbons. Once again it was a mass media set-up. Folks (mostly white and male) had thought that if the hardcore feminist talked with the hardened mack, sparks would fly; there would be a knock-down, drag-out spectacle. When Brother Cube and myself talked to each other with respect about the political, spiritual and emotional self-determination of black people, it did not make good copy. I do not know if his public relations people saw the piece in its entirety and were worried that it would be too soft an image, but clearly folks at the magazine did not get the darky spectacle they were looking for.

After this conversation, and after talking with other rappers and folks who listen to rap, it became clear that while black male sexism is real and a serious problem in our communities, some of the more misogynist stuff in black music was there to stir up controversy, to appeal to audiences. Nowhere is this more evident than in the image used with Snoop Doggy Dogg's record *Doggystyle*. A black male music and cultural critic called me from across the ocean to ask if I had checked this image out, sharing that for one of the first times in his music-buying life he felt he was seeing an image so offensive in its sexism and misogyny he did not want to take it home. That image—complete with doghouse, "Beware the Dog" sign, a naked black female head in the doghouse, her naked butt sticking out—was reproduced "uncritically" in the November 29, 1993 issue of *Time* magazine. The positive music review of this album written by Christopher John Farley titled "Gangsta Rap, Doggystyle" makes no mention of sexism and misogyny, or any reference to the cover. If a naked white female body had been inside the doghouse, presumably waiting to be fucked from behind, I wonder if *Time* would have reproduced an image of the cover along with their review. When I see the pornographic cartoon that graces the cover of *Doggystyle*

I do not think simply about the sexism and misogyny of young black men, I think about the sexist and misogynist politics of the powerful white adult men and women (and folks of color) who helped produce and market this album.

In her book *Misogynies*, Joan Smith shares her sense that while most folks are willing to acknowledge unfair treatment of women, discrimination on the basis of gender, they are usually reluctant to admit that hatred of women is encouraged because it helps maintain the structure of male dominance. Smith suggests, "Misogyny wears many guises, reveals itself in different forms—which are dictated by class, wealth, education, race, religion, and other factors, but its chief characteristic is its pervasiveness." This point reverberated in my mind when I saw Jane Campion's widely acclaimed film *The Piano*, which I saw in the midst of the mass media's focus on sexism and misogyny in gangsta rap. I had been told by many friends in the art world that this was "an incredible film, a truly compelling love story." Their responses were echoed by numerous positive reviews. No one speaking about this film mentions misogyny and sexism or white supremacist capitalist patriarchy.

The nineteenth-century world of the white invasion of New Zealand is utterly romanticized in this film (complete with docile happy darkies—Maori natives—who appear to have not a care in the world). And when the film suggests they care about white colonizers digging up the graves of their dead ancestors it is the sympathetic poor white male who comes to the rescue. Just as the conquest of natives and lands is glamorized in this film, so is the conquest of femininity, personified by white womanhood, by the pale, speechless, corpse-like Scotswoman Ada who journeys into this dark wilderness because her father has arranged for her to marry the white colonizer Stewart. Although mute, Ada expresses her artistic ability, the intensity of her vision and feelings, through piano playing. This passion attracts Baines, the illiterate white settler who wears the facial

tattoos of the Maori—an act of appropriation that makes him (like the traditional figure of Tarzan) appear both dangerous and romantic. He is Norman Mailer's "white negro." Baines seduces Ada by promising to return the piano that Stewart has exchanged with him for land, and the film leads us to believe that Ada's passionate piano playing has been merely a substitution for repressed eroticism. When she learns to let herself go sexually she ceases to need the piano. We watch the passionate climax of Baines's seduction as she willingly seeks him sexually. We watch her husband Stewart in the role of voyeur, standing with his dog outside the cabin where they fuck, voyeuristically consuming their pleasure. Rather than being turned off by her love for Baines, it appears to excite Stewart's passion; he longs to possess her all the more. Unable to win her back from Baines, he expresses his rage, rooted in misogyny and sexism, by physically attacking her and chopping off her finger with an ax. This act of male violence takes place with her young daughter, Flora, as a witness. Though traumatized by the violence she witnesses, she is still about to follow the white male patriarch's orders and take the bloody finger to Baines, along with the message that each time he sees Ada she will suffer physical mutilation.

Violence against land, natives, and women in this film, unlike that of gangsta rap, is portrayed uncritically, as though it is "natural"—the inevitable climax of conflicting passions. The outcome of this violence is all positive. Ultimately, the film suggests Stewart's rage was only an expression of irrational sexual jealousy, that he comes to his senses and is able to see "reason." In keeping with the male exchange of women, he gives Ada and Flora to Baines. They leave the wilderness. On the voyage over, Ada demands that her piano be thrown overboard because it is "soiled," tainted with horrible memories. Surrendering it she lets go her longing to display passion through artistic expression. A nuclear family now, Baines, Ada, and Flora resettle and live happily ever after. Suddenly, patriarchal order is restored. Ada

becomes a modest wife, wearing a veil over her mouth so that no one will see her lips struggling to speak words. Flora has no memory of trauma and is a happy child turning somersaults. Baines is in charge.

The Piano seduces and excites audiences with its uncritical portrayal of sexism and misogyny. Reviewers and audiences alike seem to assume that Campion's gender, as well as her breaking of traditional boundaries that inhibit the advancement of women in film, indicate that her work expresses a feminist standpoint. And indeed she does employ feminist tropes even as her work betrays feminist visions of female actualization, celebrating and eroticizing male domination. Smith's discussion of misogyny emphasizes that woman-hating is not solely the province of men: "We are all exposed to the prevailing ideology of our culture, and some women learn early on that they can prosper by aping the misogyny of men; these are the women who win provisional favor by denigrating other women, by playing on male prejudices, and by acting the 'man's woman'." Since this is not a documentary film that needs to remain faithful to the ethos of its historical setting, why is it that Campion does not resolve Ada's conflicts by providing us with an imaginary landscape where a woman can express passionate artistic commitment *and* find fulfillment in a passionate relationship? This would be no more farfetched than her cinematic portrayal of Ada's miraculous transformation from muteness into speech. Ultimately, Campion's The Piano advances the sexist assumption that heterosexual women will give up artistic practice to find "true love." That "positive" surrender is encouraged by the "romantic" portrayal of sexism and misogyny.

While I do not think that young black male rappers have been rushing in droves to see The Piano, there is a bond between those folks involved with high culture who celebrate and condone the ideas and values upheld in this film and those who celebrate and condone gangsta rap. Certainly, Kennedy's description of the

United States as a "cowboy, gangster, philistine" culture would also accurately describe the culture evoked in *The Piano*. Popular movies that are seen by young black females—for example *Indecent Proposal, Mad Dog and Glory, True Romance, One False Move*—all eroticize male domination that expresses itself via the exchange of women as well as the subjugation of other men through brutal violence.

A racist white imagination assumes that most young black males, especially those who are poor, live in a self-created cultural vacuum, uninfluenced by mainstream cultural values. Yet it is the application of those values, largely learned through passive, uncritical consumption of the mass media, that is most revealed in gangsta rap. Brent Staples is willing to challenge the notion that "urban primitivism is romantic" when it suggests that black males become "real men" by displaying the will to do violence, yet he remains resolutely silent about that world of privileged white culture that has historically romanticized primitivism and erotized male violence. Contemporary films like *Reservoir Dogs* and *The Bad Lieutenant* celebrate urban primitivism. Many of the artistically less successful films create or exploit the cultural demand for graphic depictions of hardcore macks who are willing to kill for sport.

To take gangsta rap to task for its sexism and misogyny while accepting and perpetuating expressions of that ideology which reflect bourgeois standards (no rawness, no vulgarity) is not to call for a transformation of the culture of patriarchy. Ironically, many black male ministers who are themselves sexist and misogynist are leading the attacks against gangsta rap. Like the mainstream world that supports white supremacist capitalist patriarchy, they are most concerned with advancing the cause of censorship by calling attention to the obscene portrayals of women. For them, rethinking and challenging sexism both in the dominant culture and in black life is not the issue.

Mainstream white culture is not at all concerned about black

male sexism and misogyny, particularly when it is mainly unleashed against black women and children. It is concerned when young white consumers utilize black vernacular popular culture to disrupt bourgeois values. A young white boy expresses his rage at his mother by aping black male vernacular speech (a true story); young white males (and middle-class men of color) reject the constraints of bourgeois bondage and the call to be "civilized" by acts of aggression in their domestic households. These are the audiences who feel such a desperate need for gangsta rap. It is much easier to attack gangsta rap than to confront the culture that produces that need.

Gangsta rap is part of the antifeminist backlash that is the rage right now. When young black males labor in the plantations of misogyny and sexism to produce gangsta rap, white supremacist capitalist patriarchy approves the violence and materially rewards them. Far from being an expression of their "manhood," it is an expression of their own subjugation and humiliation by more powerful, less visible forces of patriarchal gangsterism. They give voice to the brutal, raw anger and rage against women that it is taboo for "civilized" adult men to speak. No wonder, then, that they have the task of tutoring the young, teaching them to eroticize and enjoy the brutal expressions of that rage (both language and acts) before they learn to cloak it in middle-class decorum or Robert Bly-style reclaimings of lost manhood. The tragedy for young black males is that they are so easily duped by a vision of manhood that can only lead to their destruction.

Feminist critiques of the sexism and misogyny in gangsta rap, and in all aspects of popular culture, must continue to be bold and fierce. Black females must not allow ourselves to be duped into supporting shit that hurts us under the guise of standing beside our men. If black men are betraying us through acts of male violence, we save ourselves and the race by resisting. Yet our feminist critiques of black male sexism fail as meaningful

political interventions if they seek to demonize black males, and do not recognize that our revolutionary work is to transform white supremacist capitalist patriarchy in the multiple areas of our lives where it is made manifest, whether in gangsta rap, the black church, or in the Clinton administration.

12

ICE CUBE CULTURE

A shared passion for speaking truth
bell hooks and Ice Cube in dialogue

bell hooks: People have been really, really excited about me talking to you because they think that we exist in worlds apart, because I do feminist theory and all this other stuff. But one of the reasons I really wanted to talk to you is that I feel very strongly that black people have to talk to each other across our differences. I've been listening to *Predator* a lot, and I wanted to know whether you're trying a wider range of musical styles, making this kind of a softer album even though the lyrics are still tough.

Ice Cube: Well, I want each record to have its own identity. I don't want the records to sound alike. And I think *Amerikkka's Most Wanted* doesn't sound like *Death Certificate*, and *Death Certificate* doesn't sound like *Predator*. So what I did on *Amerikkka's*

Most Wanted was use The Bomb Squad for a different sound, and then on *Death Certificate* I used more West Coast producers for that sound. That record was more like, I was stuck in the format with the Death side and the Life side. On *Predator* I didn't want to stick myself in that kind of format. I just wanted to do jams. I just wanted to do a record, put 'em together, put 'em in order and call it the record. And on this record I kind of wanted to show my skills as an MC, with more style, with really political messages. I just wanted to get a record with its own identity, and that's about it. And that's what I want to do on every record, you know. My next record will probably be way more political than anything I ever put out, just because that would be a different record.

bh: Well, I'm glad you raised the question of politics, because for months I've been going around just to regular people saying, "if you had a chance to talk to Ice Cube, what would you talk to him about?" And by and large people wanted to talk about politics, and particularly about the malt liquor shit. And I don't really want to talk about that as much as I wanted to raise the political question of whether it matters how we earn our money. Because one of the things I've been saying a lot this year in my talks is that black capitalism is not black self-determination. That doesn't mean we don't need black capitalism, but we can't confuse the two.

IC: See, that's a crazy question because people say, well, selling drugs to each other or this or that is the wrong way to earn money. You know, all these things people say.

bh: Well, like, for example, I just bought myself a Beamer for my birthday, and because my writing is real political, a lot of people said, "How could you do that?" I said "Well, shit, I've been driving a trap for thirteen years, you know."

IC: That's ridiculous. People actually ask you why you buy a Beamer?

bh: But I think that people don't understand and that's why people are raising the question of the difference between being political and trying to decide what is ethical about how we spend our money. I think that we all deserve the best.

IC: Just because we black and we write the way we write don't mean we don't want the finer things in life. And that don't mean we don't want a nice, big house and all the goodies. And if we work, and earn the money, then we should be able to buy these things without the neighborhood saying, "Why you coming around in this or why you going around in that?" I don't really think the way we spend money as individuals is even relevant. The thing is, nobody wants to be a follower. Everybody wants to be their own leader. Nobody wants to pool money. Because there are a lot of rich black people in America, but nobody want to pool their money, say, I'm going to invest with such and such and we're going to try to do this and put this together and put a market in the neighborhood. See, that's the problem that I have, and I think it's just because of self-hate.

bh: The question of love and self-hate is something you raise a lot. I wanted you to talk a bit about black men and the question of self-love. I very much believe that we need to have a renewed black liberation struggle, but it seems to me that there's a lot standing in the way of that.

IC: It's hard to be black in America. Look at all the images that run across us, from television, school, just everything in general. It's hard. You got to fight to love yourself. They put everybody in such a bad light. They don't put us on anything, you know. It's mainly their fault, our self-hate. We got to really fight to love ourselves, because all these images of

white TV, that's the only thing we see. So when we look in the mirror, we changin' our hair, we changin' our eyes, try to change our features, try to not be black. We got to reverse that.

bh: I know you're a parent. I know you got a child. What are you doing to make it possible for that child to love himself?

IC: Well, see, when I grew up I didn't have a lot of black . . . you know, you remember, kind of like the pictures in your house and stuff like that?

bh: Oh, Yeah.

IC: And see, we didn't have no . . . I got pictures of a black man and a black woman pulling on an American flag like a tug rope. Pictures and images of yourself just all around the house. Got pictures of Elijah Muhammad, Master Farrar, Muhammad, this picture this guy did for me where it's black man reaching down and you see an arm of another black man, like he's trying to help him up, got pictures of Malcolm X, got calendars and all that. Just to show and give them an image of who we are, for when they come up to me and say, "Well, who is this?" My son is too young to really know who these people are. When the day comes and he says something like, "Who is this?" I'll be able to break it down to him and give him a sense of who he is and what time it is.

bh: I've run into a lot of black folks and they'll say, "I got pictures on the wall but my little kid came home from school and said she wants to be blond," or what have you. It seems to me that one of our crises is that no matter what we do at home, we send these children out into a world that does not value them, does not value blackness. What do you think we can do to combat that? Because your peers sometimes

will have a stronger influence than what is taking place in the home.

IC: Yeah. I think they make white look so good and so nice and so sweet. My wife had a son. When I met her, her son was three years old. And now he's like six, so now I can really break it down to him. I say, look, here's what they've done to us, and here's what they continue to do to us. We end up loving white more than we love ourselves. So you have to make that look unattractive. They got to be found guilty for the things that they done to nonwhites all over the world. So when you break it down to the kids like that, white people don't look so attractive. And then you start pumping love for yourself, and you slowly reverse the process. But you gotta damn near fight your body to love yourself around here because you see so many images of you not in a good light.

bh: I read that you liked the Malcolm movie, which really pissed me off as a black woman because I felt that that's exactly what Spike did with the white woman; he made her look more sexy, more attractive.

IC: I didn't say I liked the Malcolm X movie; I said it's interesting.

bh: I would say that, too.

IC: It was an interesting movie. I got problems with the movie, you know, but I think the best person to talk to about that is Spike Lee.

bh: I was jumping on that point for a lot of black females. Even though Malcolm was supposed to be downgrading the white woman, by the very fact that the movie focused on her first for an hour and fifteen minutes, it's saying that relationship's on a par to his relationship with his wife.

IC: Yeah, they really didn't go into him and his wife but for a couple of times.

bh: One of our issues as black folks is: If the major buying audience is white and we want to reach that audience, to what extent do we compromise ourselves in trying to reach that audience? My books are products, they're commodities. I want to sell them to as many people as will buy them, right?

IC: Well, see, I feel that I've gotten the most success by not compromising. And I say it in interviews, that I do records for black kids, and white kids are basically eavesdropping on my records. But I don't change what I'm sayin'. I won't take out this word or that word because I got white kids buying my records. White kids need to hear what we got to say about them and their forefathers and uncles and everybody that's done us wrong. And the only way they're goin' to hear it uncut and uncensored is rap music, because I refuse to censor anything I have to say about anybody—the black community, Koreans, anybody who I feel distracts our harmony. That's who needs to be, I won't say attacked, but needs to be really checked.

bh: How do you reconcile that kind of nationalistic stance with strategies to reach a larger audience that seem apparent when you hook up with Red Hot Chili Peppers and the Lollapalooza tour?

IC: Well, the Lollapalooza tour was a tour that I had talked to Ice-T about going on. He said, well, you know, do you guys want to play to just one side of your fans or do you want to play to everybody? I feel it really don't matter who I play to, as long as it's a gig. I like to perform. I'm a performing junkie. (Laughs.) I'd perform in a club with seventeen people in it. So when this came up and they asked me to

do it, I said, okay, I'd do it, because even though they're eavesdropping on our records, they need to hear it.

bh: I know that you said, quote, "When I speak I'm not speakin' to white America," and one of things I said is that we know they're listening. What are they hearing?

IC: They're hearing exactly what they need to hear. A young black man speakin' and not takin' feelings into consideration. I think what I say is just as healthy for black people as for white people. And the Red Hot Chili Peppers, they was cool with me. Really, white people brought this color thing to the foreground and made this the issue. You know, that ain't never been the issue for black people. Black people don't care if you're red or green or purple, you know what I'm sayin'? As long as you're cool, we can hang and we can kick it. It's always been them sayin' you black, you this, you ain't white, trying to get on this genetic annihilation thing. They just want to hold everybody back. But, you see, that's just never been black people's hang-up. If you cool with me, I don't give a damn what color you are. But if you fuck over me, or your people fuck over me, then we got a problem.

bh: That raises a really interesting point, because I was thinking about critical consciousness and how music like yours has raised a lot of black folks' consciousness about white supremacy, and yet we're not together. And I'm wanting to know whether you think gangsta mentality keeps us apart.

IC: I mean, I don't think . . . see, we gotta do a lot of reversing here. My message is to point the finger, you know what I mean? And hold people accountable. Even hold ourselves accountable. I don't feel that my records have a gangsta mentality.

bh: No, I didn't mean your records, I meant just the mentality

out there in the world. Do you think that keeps us apart as black people? One of the things that Malcolm says that's really important to me is that we don't have to worry about how white people are treating us, because we need to treat each other with warmth.

IC: Oh, yeah, definitely. But if I don't love myself, I don't love the image of myself, you know what I'm sayin'? So you pull up in your BMW, and instead of me saying, damn, that's a nice car, I say that to you—but behind your back—I be like, oh, this and that, thinks she got, boom boom. You know what I'm sayin'? It comes off negative, but that's just because we haven't reeducated ourselves to love ourselves and put black first. And that's the whole problem. Once we do that, all of our problems are solved 'cause we're able to trust each other and go into business with each other, and not be so quick to kill each other.

bh: It seems to me that there is a kind of gangsta ideology that says I'll kill you if you fuck with me, period.

IC: Well, I think that's the law of the world. See, what happens is, and it goes all the way back to slavery, when white people made black people slaves, they put greed in front of humanity. So they really stripped us of all our knowledge of the whole story and became our teachers. So now, what we do is put greed in front of humanity. So it's easy for us to kill and shoot each other for the almighty dollar, because that's the way our teachers do.

bh: I know that you made a lot of fine political arguments for black self-defense. How do you think we can teach our children the difference between self-defense and meaningless violence?

IC: Most people that are involved in violence are looking for

trouble. We got to teach our kids that confrontation is not always the best way—I'm talking about a physical confrontation—to handle a problem. Even if somebody owe you five dollars and you go down there and beat 'em up, you might of beat 'em up, but you still ain't got your five dollars.

bh: So we gotta teach our children to negotiate to get your five dollars, if that's what you want.

IC: Yeah, I mean, you got to negotiate. But there is a point where you can't take no more. In some cases violence is very, very necessary. When you take the riots, if we'd just picketed and held signs and walked in a big line for a day, people'd be like, oh yeah, you can really do what you want with them because all they're gonna do is hold signs. And I don't think negotiating on that level was necessary or the right thing to do. I think what was done was the right thing to do. So you just gotta tell them there's a time and a place for everything. There's a time for talkin' and there's a time for violence.

bh: Well, since we're talkin' about violence, one of the things is that people love you in *Boyz N the Hood*. I mean, we all loved you. We identified with you. You were the character to love. But on one hand, you was also rotten. You was sellin' the crack. How do you think this affects us, then, because everybody loved you more than any other character?

IC: It shows that Doughboy coulda been either one of them. Doughboy coulda been Tre, Ricky, you know.

bh: But Tre just came off like a wimp, a crybaby. He was just so weak. He came off weak in the movie.

IC: No, to me he came off tryin' to do the right thing. The neighborhood was really frustratin' him out, because he was tryin' to do the right thing and everybody else was doin' the

wrong thing. And I think Doughboy woulda been just like him if he had the right guidance, the right father. It's a thin line between 'em all. Tre was about to be like Doughboy for a minute until he thought about it.

bh: I feel like if I was a kid lookin' at that movie, I wouldn't wanna be him, I'd wanna be you, because your character had the jazz. I mean, your character was cool, your character had feelings. I mean, why couldn't he have been a strong person?

IC: I think what John Singleton was tryin' to do was show three separate people that's friends, you know. He coulda gave Tre a little more, like you said, a little more jazz, even though I know people that straight up, but they wouldn't really be hangin' with us.

bh: I gave a talk at the Schomberg recently with the black philosopher Cornel West, and one of the things we were sayin' is that that guy didn't look glamorous to kids. You don't want to be him 'cause he didn't have no humor hardly, he didn't have much. Part of what I try to do as a teacher, a professor, is to show people just 'cause you're a professor and you got a Ph.D., you don't have to be all tired, with no style and with no presence. If I come on like I don't have no style, then I'm not really being somebody that black kids are gonna wanna say, "Yeah, this is interesting, you know, I could still have my shit together and be this, I could still be down and be this." Because then kids will look at us and think, she's cool, she's down. I want to be like that. I felt like in terms of real love for the character, I think most people felt the love for you, because your character, even though he was wicked, he was presented as having feelings.

IC: Like I said, he coulda turned out either way. He's a good kid inside, but circumstances had him the way he was. At the

end, it really expressed that I just pretty much wanted to be a regular mo'fucker around here, like everybody else was. I didn't get the right things at home. I think it's because he had depth and he looked more like a person than anybody else who was really locked in and then would go up and down. He went from killing somebody to cryin' on the porch in less than ten minutes. He was like all these kids just stuck up in the penitentiary. They're the same way—they just took the wrong turn. It's a fine line between all of 'em, because all of 'em could switch positions anytime. The thing about our neighborhood, you know, now you have the kid that comes from a broken home who turns out to be the best kid. Then you have a kid with a mother and father that's boom boom, just wild. So we know that it starts young. But we have to start doin' some things different.

bh: One of the things that you said that's really important is the depth. I think that obviously you are a very deep person, a contemplative, complex person in your personal life. How can we create a context where more folks can see that complexity?

IC: It's like feedin' a baby steak. You can't do that, you know what I mean? I just can't, at this point in time, I can't do because I don't think . . .

bh: . . . people are ready?

IC: Because I don't want to flip, like, bam! You know what I'm sayin'? People identify me with the Nation of Islam, which I'm a definite supporter, but I'm not in the Nation. The Muslims have got a bad rap, not because of what they've done here in America, but see, the Arab Muslims, the press done given the word "Muslim" a bad rap, so when people hear it, they think, oh, no, no, no, I'm church. So if I flip, they're gonna say, aw, those Muslims done got his head,

boom, boom, boom. I'd turn a lot of people off. I talked to the minister about this, how I really wanna put more messages. He tell me that it's not wise to really flip the script on people like that. You have to gradually sneak it in. Give 'em what they want but gradually sneak it in, and that's what I think I'm doin' now. And pretty soon I get to the point where kids be comin' to me and sayin' you need to speak more on this and speak more on that. Right now it's just an enlightening period because kids that listen to me, what they hear is black this and black that. But through my records they say, damn, that's true. And then it lights that light that's up there. So I'm tryin' to evolve to the point where I can do just straight political records and still get the same love from the people.

bh: Well, one of the threads that runs through all your albums has been representing black men as both the architects and the representations of evil. Who's the primary predator now? Are we preying on each other?

IC: Of course, yeah, that's the case, but that's not the focus of my records.

bh: Well, talk a little bit more about who the predator is and how you see the concept of "predator."

IC: Well, I think black people have been the victim of everything. I think we've been on the defensive on everything. And a predator is definitely on the offensive, you know. And I think that's what we need to do, start not sitting back and letting things happen to us, but start creating better things for ourselves. We can do that through a mental revolution which I think needs to take place before anything positive really happens. If we don't have a mental revolution, if we ever get involved in a physical revolution, we'd get blown out of the water. Because there'd be too many people

tryin' to lead, and too many people goin' in their own direction. It just won't be on and it won't be clickin'. The mental revolution is gonna take time, but it's happenin' as we speak.

bh: Well, what do you think about people like Shelby Steele, and the black voices that are saying our problem is that we focus too much on victimization, that we gotta get off this victim kick?

IC: I don't know . . . You gotta definitely remember the past.

bh: I think that we can't get stuck in victimization, but we gotta know who the enemy is, what the enemy has done to us, and we have to name that.

IC: We can't sidestep that. And that's what black people been tryin' to do. But that ain't the case. That ain't the case because the same thing is happenin', just in different ways. The enemy has got more wicked and more wise, and we haven't.

bh: The way that white people continue their power is, in part through their control of our images and our representation.

IC: Oh, Yeah. I think Dr. Frances Cress-Welsing's philosophy on racism, I think that's the whole root of the problem, about the genetic annihilation, and that we all become one big melting pot. In some years in the future, white people won't even exist. So to make sure that they do exist, they got to put walls around themselves, and they really have to block everybody out. To block everybody out they feel they should murder 'em. I think we need to recognize that they're attackin' us, and we're tryin' to sidestep. But now we're on the offensive, we know how to go around this, this bullshit. But if you in denial of the problem, you're never gonna solve it.

bh: I write a lot about white supremacy, and then people say to me, she doesn't like white people. And I keep tryin' to get people to see it's a difference between attacking the institutionalized structures of white supremacy and individual white people.

IC: Yeah, I mean, I don't dislike white people. I just understand 'em. And since I understand 'em, I should read what they tryin' to do. I mean, this is what they have to do to survive, to exist as a white race, 'cause if not, genetically they can be just taken off the planet.

bh: I have more problems than you do with Cress-Welsing, 'cause I feel like that sidesteps the issue of power. I feel like even if white people knew they were going to be on the planet forever, they wouldn't want to give up the power and control of the planet. Because it's not just about whiteness, it's about the world's resources, oil . . .

IC: It's definitely about that, but I think all that goes hand in hand. I think since they got the power, of course now they wouldn't give it up. But when they went to countries and raped the women and come back and the babies are the color of the women they raped, you know, they like, wait a minute, and then came up with a plan. So consciously that's what he holds onto when you're talking about racism. And I think by him using his methods to exist, he gained power and said wait a minute—I like this, too. I ain't gonna let go of this no matter what. So I think it all goes hand in hand.

bh: Do you think the average dude out there is thinkin' the way you think about racism and white supremacy?

IC: No. Because I think the average dudes haven't been exposed to as many people. The average dude really ain't been nowhere outside their neighborhood. So they ain't really

that concerned. They worried about how to get food on the table. They don't care who's the president and who's mayor. They still gotta get money. And that becomes their drive—money. And nothin' else.

bh: There's so much emphasis on black men and violence. What about black male pain and grief? What do you do with your pain and your grief?

IC: Well, I really just try to suck it up. I don't let it become routine because pain and grief never supposed to be routine to nobody. Killin' has become a way of life. Very little talkin', a lot of shootin'. And, I mean, that really has a big effect on us, you know. Television, you look at the violence before television and the violence after television. Now they can show an actual murder on TV, you know what I'm sayin'? A couple of days ago, an actual murder.

bh: I know, it was too much.

IC: And it's like, it wasn't even shocking. It's a thin line between reality and the fake movie stuff. But the reality, it didn't look as gory as the movie shit does. I think subconsciously some people say, damn, that was real, and they shocked and they don't like that. But I think violence has become a way of life, and I think black people have always carried guns to protect ourselves from white men. And I think white men themselves can't integrate, but they're really gonna pump this self-hate so that the guns will never be pointed up, but will always point inward toward each other. And that's what we're stuck in. We got to put somebody to blame for this, because somebody is. You screw somebody out of their culture and their know-how and make them dependent on you, then you got to point that out. You got to show them that this black face that you're about to shoot is not the enemy. On my records I refuse to say I shot a nigger for this,

I shot a nigger for that. On my past records when I didn't have no knowledge . . . I wouldn't say some of the things now that I would in '89, '87, '88, because, I mean, I've grown as a person. I need to grow as an artist, so I would never say, yo, I'm lookin' for a nigger to shoot. I'd rather say, I got my gun pointed at the cracker, because the black man and the black woman is not my enemy. Although we do things within our community that need to be checked.

bh: Do you think white supremacy oppresses black women?

IC: Hell, yeah. I think white supremacy sometimes uses the black woman to get to the black man. You know, we'll hire her, but we won't hire you.

bh: But don't you think it also uses black men? Like to me, Clarence Thomas is a case of the black man being used.

IC: Oh, yeah, it uses everybody. It takes a person like Clarence Thomas and it feels like a lot of black people would be proud, and it puts him on TV and rips him apart. A lot of people—I'm not one of them—but a lot of people look, oh yeah, we got a black man, we got Thurgood Marshall, and now we got Clarence Thomas, that's cool.

bh: There's a big difference between Thurgood Marshall and Clarence Thomas, and they don't see that.

IC: No, it's a black face, it's a pacifier. It's kind of like, every inner city has a Martin Luther King Boulevard, you know what I'm sayin'? It's to pacify us. Y'all say we're racist? Y'all got Martin Luther King Boulevard. Y'all got the *Cosby Show*. And if you look at talk shows, white people say y'all got this. They throw out a pacifier. "What about Colin Powell?" They always use the pacifier as a scapegoat to show that they've been fair and lovin' and understandin', they bend over backwards for black people.

bh: One of the main things a lot of people said to me is "Why you want to talk to Ice Cube? 'cause he don't even like black women." I wanted you to talk some about whether you believe black men and women must work together to challenge dominations.

IC: Yeah, on the business level, I think a black woman is the best thing to have, because black women are focused. My manager, a black woman, when it comes to business, she is sharp. [He laughs.]

bh: So you think we need to have a vision of partnership?

IC: Yeah, I think black women have always been the backbone of the community, and it's up to the black man to support the backbone, to show strength. I think black women have been the glue. Black women is trying to hold it together and it's up to the black man to lock it in. In some cases we jump at the occasion, and in some cases we fail. But I think the black women have been the most consistent.

bh: Do you think we can be leaders together, side by side?

IC: Yeah, definitely.

bh: I gave a talk at Harvard recently, and a black woman stood up—I was on a panel with some black men—and she said, "I'm black and I'm poor and I want to know why black men don't like us." I'm not talking about you, I'm asking you about black men in general. Do you think black men, in general, like black women?

IC: I think self-hate plays a lot in everything. They make the white woman look so glamorous, and you have to be this, and you have to be skinny, and this color, and I think it takes its toll on the black man. So black man end up over-stepping the guilt and looking for white women, or someone who

appears to be white, or close to white. And black men for some reason—I know the reason—they feel that they can show themselves to be a man sexually. So they'll get the woman pregnant, but won't be her man. And she's stuck with a baby, and she's holding that weight. And nobody wants to stop and take the responsibility. And now she has two or three kids and a man don't want to get with her, and the cycle just continues and continues and continues.

bh: How do you think we can change it? I've been thinking a lot about this myself: How can I give my insight, my resources, back to black folks so that we can begin to change some of this? So many people said, "bell, why would you want to talk to him?" I feel like part of the magic of us talking is a lot more people have to see you differently. You're not just saying, "I don't want to talk to bell hooks, I mean, she's into this feminist thinking." And I'm not saying, "I don't want to talk to Ice Cube, he's a sexist, he doesn't like black women."

IC: If people really follow Ice Cube and know what Ice Cube about, they have to look at Yo-Yo. You know what I mean? Ice Cube put that thing together as far as her comin' out. I think the kids need a balance of each dose. Me being a male, a male has a certain ego, you can't get away. I think that of males all over the world. And that comes out in the music. And I think women need to really show, "Yo, we can do this and we can educate. We can be the same way." And then what's gonna happen is everything is gonna melt together and hopefully turn out cool.

bh: On *Predator* there's a number of different female voices. The rough song, of course, for a black woman to listen to is "Don't Trust It," which kinda dogs us out and says bitches got a brand new game. Bitches all over with some new improved shit. But you have other moments on the album

where women are speaking very differently. There's the voice-over interview. Do you think that people register those other images of black womanhood? Or do they only focus on the bitches one?

IC: Well, people always focus on the most controversial thing. Because the evil of America outweighs the good, so people tend to hunger for the bad thing. They want to see the car wrecks. They want to see the sex scandals. They don't want to see the straight-A student. Since we live in the society that we live in, people are gonna tend to identify with the "Don't Trust It" record because they identify with the controversies more than they identify with the lady on "I'm Scared," saying, "Yo, you know, we do this, we do that, we live in Harlem." But I think it's startin' to be more and more socially correct to start identifyin' with that lady that's sayin', you know, this and that.

bh: What do you think black men and women can do to come closer to one another?

IC: I think we have to really identify our problems. I think self-love, that's the key to all our problems.

bh: Do you feel like your wife is a conscious person like yourself? How do you guys deal with a conflict? What if she thinks your shit is raggedy? How does she tell you? Do you talk?

IC: Yeah, she sit there and tell me. And, I mean, I take heed to it. But I been doin' this a lot longer than I've known her and on some things I say, "Damn, baby you right." And on some things I have a strong passion to say it and I'll say, "Yo, you know, I've got to follow my own judgment on this." We're one but we're still individuals and we disagree. But we handle it civilized. And I listen to what my wife has to say

because we're in disagreement, and a woman is really lookin' for security. And if she think I'm goin' way out, she's like, "Wait a minute you might disrupt my security."

bh: My black male partner, I know he's really been struggling in terms of the job market and stuff. And I feel like that's part of our difficulty as black people, that many of us are insecure. We've been emotionally abandoned or wounded or we haven't been materially taken care of the way we desire. It's important for us to recognize that each of us needs that.

IC: Yeah, definitely.

bh: I know that when you was talkin' to Greg Tate a while back in his interview "Man-Child at Large," he was askin' you about women and you said the whole damn world is hostile to women. But do you think you help intensify the hostility?

IC: Well, it matters in the way you look at it. Definitely, I mean it's just like lookin' at a glass half-full or half-empty. If you look at it in the way that I hope to present it in showing a way of life that's not acceptable or an action or, you know, having a woman to be the bait so the man can come in and kidnap the guy. That's unacceptable and we want to point this out and we want to make this look as unattractive as we can.

bh: Or even like having women seduce men to get them into crack.

IC: Yeah, or whatever is the thing that's the unacceptable action. How do you deal with that? Do you say, "Well, because we can't say nothin' bad about each other don't even speak on that topic?" Or do you attack the thing, hold it and say, "Look, here's what's goin' on. Watch yourself women, be cool." And I tell men the same thing on records. But see, people focus on the women thing.

bh: You seem to think that it's really important for the family for both men and women to be there.

IC: Yeah. You know, my father never left home. He's still at home. And I think that's the reason that I'm the way I am. Because, you know, a woman can raise a boy to be respectable. But, a woman can't raise a boy to be a man. You need a man there. Like, if I had a daughter and no wife, it's just two different people. We don't have the same problems.

bh: The only thing I don't agree with is that mostly I feel like every child needs to be loved. Sometimes you got a man and woman together, but you don't have any love. I don't think that child is gonna be any better off than the child who's just with one parent, but is being loved.

IC: Yeah, but I'm sayin', like there's some things a boy wants that's with his father.

bh: Or with a man. I don't think it has to be his father.

IC: Yeah, with any man that he looks up to or he thinks is givin' him the right information or the right advice. Some things my friends wouldn't even tell their mother. Some things I wouldn't tell my mother, but I sit down and talk to my father and the problem gets handled. I think when that doesn't exist, the kid tends to turn to friends and that's just like the blind leading the blind. And their friends become— especially older people in the neighborhoods, you know like older dudes that gangbang or whatever—the people they look up to. It's like being led by the wrong people. And all this stuff that's happenin' to the community is happenin' because of that.

bh: I really want to respect the black women single parents who have raised their kids through the hardships of poverty in

this country and aloneness, and although I believe that every child needs men and women in their life, we can't focus too much on saying we need "the" father because a lot of kids are never gonna have contact with "the" father. I have a sister who's on welfare who doesn't have a husband, but her child has a really deep and loving relationship with my dad. I feel like, in lots of ways she has a more positive idea of black men than she would have if my sister just grabbed any ol' nigger to marry just to have a daddy. Because a daddy that's not loving, that's not gonna help you.

IC: Nah, not at all. You're definitely right on that tip because, like I said, I want to see my stepson with a better understanding of the world goin' into school than I had. I didn't know what the powers that be was and I didn't know what time it was on this and what time it was on that. And to give him that understanding at six years old on "Here's the situation, here's what's goin' on, here's what you're gonna be up against." When the teacher tells him that George Washington was the founding father of our country, he can raise his hand and say, "Wait a minute," and really drop the real deal. And to be able to do that, I think that we're startin' to reverse the process that's been goin' on since we've been here and I think this is the generation to do it.

bh: That was really an important point to make. I really appreciate you talkin' about yourself some, 'cause I think also that we need to know that we can love children that come into our life. They don't have to be our children, like your blood child. I think there's been a lot of negativity around people feelin' like if it's not your child, like men sometime feel like, "If it's not my child, you know, if it didn't come from my seed, then I don't want to have a relationship to it." And I think that kind of thinkin' is out.

IC: That's way off line.

bh: Tell me somethin' about what you hope for your children, and for yourself, in the years to come.

IC: Well, you know, I hope that I grow as a person and as an artist. I hope for my children to know who they are and know what they up against and just be responsible people. Whether they turn out to do whatever they want to do in life, that doesn't matter as long as they responsible and as long as they know that they're black first. That's how everybody in this country think besides us. You know, you pick a police officer, if he's Japanese, he's a Japanese police officer. And he's gonna deal with his people a certain way. And black people need to do the same thing. If you're a black police officer, you're black first.

bh: Do you feel that black men dominate black women?

IC: Only if they let 'em. 'Cause I don't dominate my woman. Because she ain't gonna go for that, and I don't try to inflict that because that ain't what I want. If I wanted to give orders, I would get me a German shepherd or somethin'. I think that black women gotta stand strong. Black women, if they lookin' for a man, it's not any ol' man but a man that's conscious and a man that knows what time it is and a man that can feed their kids with somethin' other than go get me a beer.

bh: One of the things that I hear you saying is that you and your partner talk to one another. Because a lot of times when I talk to black groups, many of us talk about growing up in homes where we didn't really see our parents talking to one another, having a conversation with one another; they talked *at* one another. But talkin' about something and talkin' about something deep, I think that has a real impact on kids. It says this is what you can do.

IC: The TV cuts off all conversation—except some comment on what's on TV—instead of commentin' on what's goin' on in your life, or what happened to you today. Instead you, like, "Damn, did you hear what happened to such and such?" "Yeah, so and so got caught up in some scandal, or some affair."

bh: Communication has to be the "dope" thing in black liberation struggle—like you and me talking culture this way down home and revolutionary-like.

13

SPENDING CULTURE

Marketing the black underclass

At the end of *Class*, Paul Fussell's playful book on the serious issue of social status, there is a discussion of a category outside the conventional structures entitled "The X Way Out." Folks who exist in category X, he reports, "earn X-personhood by a strenuous effort of discovery in which curiosity and originality are indispensable." They want to escape class. Describing the kind of people who are Xs, Fussell comments:

> The old-fashioned term Bohemians gives some idea; so does the term the talented. Some Xs are intellectual, but a lot are not: they are actors, musicians, artists, sport stars, "celebrities," well-to-do former hippies, confirmed residers abroad, and the more gifted journalists ... They tend to be self-employed, doing what social scientists call autonomous work ... X people are independent-minded, free of anxious regard

for popular shibboleths, loose in carriage and demeanor. They adore the work they do ... Being an X person is like having much of the freedom and some of the power of a top-out-of-sight or upper class person, but without the money. X category is a sort of unmonied aristocracy.

Even though I grew up in a Southern black working-class household, I longed to be among this X group. Radicalized by black liberation struggle and feminist movement, my effort to make that longing compatible with revolution began in college. It was there that I was subjected to the indoctrination that would prepare me to be an acceptable member of the middle class. Then, as now, I was fundamentally anti-bourgeois. To me this does not mean that I do not like beautiful things or desire material well-being. It means that I do not sit around longing to be rich, and that I believe hedonistic materialism to be a central aspect of an imperialist colonialism that perpetuates and maintains white supremacist capitalist patriarchy. Since this is the ideological framework that breeds domination and a culture of repression, a repudiation of the ethic of materialism is central to any transformation of our society. While I do not believe that any of us really exists in a category outside class, in that free space of X I do believe that those of us who repudiate domination must be willing to divest of class elitism. And it would be useful if progressive folks who oppose domination in all its forms, but who manage to accumulate material plenty or wealth, would share their understanding of ways this status informs their commitment to radical social change and their political allegiances, publicly naming the means by which they hold that class privilege in ways that do not exploit or impinge on the freedom and welfare of others.

Lately, when I find myself among groups of black academics or intellectuals where I raise the issue of class, suggesting that we need to spend more time talking about class differences among

black people, I find a refusal to deal with this issue. Most are unwilling to acknowledge that class positionality shapes our perspectives and standpoints. This refusal seems to be rooted in a history of class privilege wherein privileged black folks, writers, artists, intellectuals, and academics have been able to set the agenda for any public discourse on black culture. That agenda has rarely included a willingness to problematize the issue of class. Among these groups of black folks there is a tacit assumption that we all long to be upper-class and, if at all possible, rich. Throughout my years in college and graduate school, black professors were among those committed to policing and punishing in the interest of maintaining privileged-class values. My twenty years of working as a professor in the academy have not altered this perception. I still find that most black academics, whether they identify themselves as conservative, liberal, or radical, religiously uphold privileged-class values in the manner and style in which they teach, in their habits of being, in mundane matters like dress, language, decor, and so on. Increasingly, I find these same attitudes in the world of black cultural production outside academic settings. These values tend to be coupled with the particular crass opportunism that has come to be socially acceptable, a sign that one is not so naive or stupid to actually believe that there could be any need to repudiate capitalism or the ethic of materialism.

To a grave extent, the commodification of blackness has created the space for an intensification of opportunistic materialism and longing-for privileged class status among black folks in all classes. Yet when the chips are down it is usually the black folks who already have some degree of class privilege who are most able to exploit for individual gain the market in blackness as commodity. Ironically, however, the sign of blackness in much of this cultural marketplace is synonymous with that of the under-class, so that individuals from backgrounds of privilege must either pretend to be "down" or create artwork from the

standpoint either of what could be called "darky nostalgia" or the overseer's vision of blackness. When I recently commented to several black women scholars doing work in feminist literary criticism that I thought it was useful to talk about ways the shifting class positionality of writers such as Alice Walker and Toni Morrison inform their writing, style, content, and construction of characters they responded hostilely, as though my suggestion that we talk about the way in which privileged-class status shapes black perspectives was in some way meant to suggest these writers were not "black," were not "authorities." That was my intent. Since I do not believe in monolithic constructions of blackness and am not a nationalist, I want to call attention to the real and concrete ways class is central to contemporary constructions of black identity. It not only determines the way blackness is commodified and the way our sense of it shapes political standpoint. These differences in no way negate a politics of solidarity that seeks to end racist exploitation and oppression while simultaneously creating a context for black liberation and self determination; however, they do make it clear that this united front must be forged in struggle, and does not emerge solely because of shared racial identity.

To confront class in black life in the United States means that we must deconstruct the notion of an essential binding blackness and be able to examine critically ways in which the desire to be accepted into privileged-class groups within mainstream society undermines and destroys commitment to a politics of cultural transformation that consistently critiques domination. Such a critique would necessarily include the challenge to end class elitism and call for a replacing of the ethic of individualism with a vision of communalism. In his *Reconstructing Memory*, Fred Lee Hord calls attention to the way his students at a predominantly black institution make it clear that they are interested in achieving material success, "that if black communal struggle is in conflict with the pursuit of that dream, there will be no

struggle." Like Hord, I believe that black experience has been and continues to be one of internal colonialism, and that "the cultural repression of American colonial education serves to distort." I would add that the contemporary commodification of blackness has become a dynamic part of that system of cultural repression. Opportunistic longings for fame, wealth, and power now lead many black critical thinkers, writers, academics and intellectuals to participate in the production and marketing of black culture in ways that are complicit with the existing oppressive structure. That complicity begins with the equation of black capitalism with black self-determination.

The global failings of socialism have made it easier for individuals within the United States to reject visions of communalism or of participatory economics that would redistribute this society's resources in more just and democratic ways, just as it makes it easy for folks who want to be seen as progressive to embrace a socialist vision even as their habits of being affirm class elitism, and passive acceptance of domination and oppression. In keeping with the way class biases frame discussions of blackness, privileged African American critics are more than willing to discuss the nihilism, the pervasive hopelessness of the underclass, while they ignore the intense nihilism of many black folks who have always known material privilege yet who have no sense of agency, no conviction that can make meaningful changes in the existing social structure. Their nihilism does not lead to self-destruction in the classic sense; it may simply lead to a symbolic murder of the self that longs to end domination so they can be born again as hard-core opportunists eager to make it within the existing system. Academics are among this group. I confront that hard-core cynicism whenever I raise issues of class. My critical comments about the way class divisions among black people are creating a climate of fascism and repression tend to be regarded by cynics as merely an expression of envy and longing. Evidently many black folks, especially the

bourgeoisie, find it difficult to believe that we are not all eagerly embracing an American dream of wealth and power, that some of us might prefer to live simply in safe, comfortable, multiethnic neighborhoods rather than in mansions or huge houses, that some of us have no desire to be well-paid tokens at ruling-class white institutions, or that there might even exist for us aspects of black life and experience that we hold sacred and are not eager to commodify and sell to captive colonized imaginations. I say this because several times when I have tried at academic conferences to talk in a more complex way about class, I have been treated as though I am speaking about this only because I have not really "made it." And on several occasions, individual black women have regarded me with patronizing contempt, as though I, who am a well-paid member of the professional-managerial academic class, have no right to express concern about black folks of all classes uncritically embracing an ethic of materialism. In both instances, the individuals in question came from privileged class backgrounds. They assume that I have made it and that my individual success strips me of any authority to speak about the dilemmas of those who are poor and destitute, especially if what I am saying contradicts the prevailing bourgeois black discourse.

One dimension of making it for many black critics, academics, and intellectuals is the assertion of control over the discourse and circulation of ideas about black culture. When their viewpoints are informed by class biases, there is little recourse for contestation since they have greater access to the white-dominated mass media. A consequence of this is that there is no progressive space for black thinkers to engage in debate and dissent. Concurrently, black thinkers who may have no commitment to diverse black communities, who may regard black folks who are not of their class with contempt and disrespect, are held up in the mass media as spokespersons even if they have never shown themselves to be at all concerned with a

critical pedagogy that seeks to address black audiences as well as other folks.

The commodification of blackness strips away that component of cultural genealogy that links living memory and history in ways that subvert and undermine the status quo. When the discourse of blackness is in no way connected to an effort to promote collective black self-determination it becomes simply another resource appropriated by the colonizer. It then becomes possible for white supremacist culture to be perpetuated and maintained even as it appears to become inclusive. To distract us from the fact that no attempt to radicalize consciousness through cultural production would be tolerated, the colonizer finds it useful to create a structure of representation meant to suggest that racist domination is no longer a norm, that all blacks can get ahead if they are just smart enough and work hard. Those individual black folks who are either privileged by birth or by assimilation become the primary symbols used to suggest that the American dream is intact, that it can be fulfilled. This holds true in all academic circles and all arenas of cultural production. No matter the extent to which Spike Lee calls attention to injustice. The fact that he, while still young, can become rich in America leads many folks to ignore the attempts he makes at social critique (when the issue is racism) and to see him only as an evidence that the existing system is working. And since his agenda is to succeed within that system as much as possible, he must work it by reproducing conservative and even stereotypical images of blackness so as not to alienate that crossover audience. Lee's work cannot be revolutionary and generate wealth at the same time. Yet it is in his class interest to make it seem as though he, and his work, embody the "throw-down ghetto" blackness that is the desired product. Not only must his middle-class origin be downplayed; so must his newfound wealth. Similarly, when Allen and Albert Hughes, young biracial males from a privileged class background, make the film *Menace II*

Society fictively highlighting not the communities they live in but the world of the black underclass, audiences oppose critique by insisting that the brutal, dehumanizing images of black family life that are portrayed are real. They refuse to see that while there may be aspects of the fictional reality portrayed in the film that are familiar, the film is not documentary. It is not offering a view of daily life; it is a fiction. The refusal to see that the class positionality of the filmmakers informs those aspects of black underclass life they choose to display is rooted in denial not only of class differences but of a conservative politics of representation in mainstream cinema that makes it easier to offer a vision of black underclass brutality than of any other aspect of that community's daily life.

Privileged black folks who are pimping black culture for their own opportunistic gain tend to focus on racism as though it is the great equalizing factor. For example, when a materially successful black person tells the story of how no cab will stop for the person because of color, the speaker claims unity with the masses of black folks who are daily assaulted by white supremacy. Yet this assertion of shared victimhood obscures the fact that this racial assault is mediated by the reality of class privilege. However hurt or even damaged the individual may be by a failure to acquire a taxi immediately, that individual is likely to be more allied with the class interests of individuals who share similar status (including whites) than with the needs of those black folks whom racist economic aggression render destitute, who do not even have the luxury to consider taking a taxi. The issue is, of course, audience. Since all black folks encounter some form of racial discrimination or aggression every day, we do not need stories like this to remind us that racism is widespread. Nonblack folks, especially whites, most want to insist that class power and material privilege free individual black folks from the stereotypes associated with the black poor and, as a consequence, from the pain of racial assault. They and colonized

black folks who live in denial are the audience that must be convinced that race matters. Black bourgeois opportunists, who are a rising social class both in the academy and in other spheres of cultural production, are unwittingly creating a division where, "within class, race matters." This was made evident in the *Newsweek* cover story, "The Hidden Rage of Successful Blacks." Most of the black folks interviewed seemed most angry that they are not treated as equals by whites who share their class. There was less rage directed at the systemic white supremacy that assaults the lives of all black folks, but in particular those who are poor, destitute, or uneducated. It might help convince mainstream society that racism and racist assault daily inform interpersonal dynamics in this society if black individuals from privileged classes would publicly acknowledge the ways we are hurt. But such acknowledgements might only render invisible class privilege, as well as the extent to which it can be effectively used to mediate our daily lives so that we can avoid racist assault in ways that materially disadvantaged individuals cannot. Those black individuals, myself included, who work and/or live in predominantly white settings, where liberalism structures social decorum, do not confront fierce, unmediated, white racist assault. This lived experience has had the potentially dangerous impact of creating in some of us a mind set that denies the impact of white supremacy, its assaultive nature. It is not surprising that black folks in these settings are more positive about racial integration, cultural mixing, and border crossing than folks who live in the midst of intense racial apartheid.

By denying or ignoring the myriad ways class positionality informs perspective and standpoint, individual black folks who enjoy class privilege are not challenged to interrogate the ways class biases shape their representations of black life. Why, for example, does so much contemporary African American literature highlight the circumstances and condition of underclass black life in the South and in big cities when it is usually written

by folks whose experiences are just the opposite? The point of raising this question is not to censor but rather to urge critical thought about a cultural marketplace wherein blackness is commodified in such a way that fictive accounts of underclass black life in whatever setting may be more lauded, more marketable, than other visions because mainstream conservative white audiences desire these images. As rapper Dr. Dre calls it, "People in the suburbs, they can't go to the ghetto so they like to hear about what's goin' on. Everybody wants to be down." The desire to be "down" has promoted a conservative appropriation of specific aspects of underclass black life, whose reality is dehumanized via a process of commodification wherein no correlation is made between mainstream hedonistic consumerism and the reproduction of a social system that perpetuates and maintains an underclass.

Without a sustained critique of class power and class divisions among black folks, what is represented in the mass media, in cultural production, will merely reflect the biases and standpoints of a privileged few. If that few have not decolonized their minds and choose to make no connection between the discourse of blackness and the need to be engaged in an ongoing struggle for black self-determination, there will be few places where progressive visions can emerge and gain a hearing. Coming from a working-class background into the academy and other arenas of cultural production, I am always conscious of a dearth of perspectives from individuals who do not have a bourgeois mind-set. It grieves me to observe the contempt and utter uninterest black individuals from privileged classes often show in their interactions with disadvantaged black folks or their allies in struggle, especially if they have built their careers focusing on "blackness," mining the lives of the poor and disadvantaged for resources. It angers me when that group uses its class or power and its concomitant conservative politics to silence, censor or delegitimize counter-hegemonic perspectives on blackness.

Irrespective of class background or current class positionality, progressive black individuals whose politics include a commitment to black self-determination and liberation must be vigilant when we do our work. Those of us who speak, write, and act in ways other than from privileged class locations must self-interrogate constantly so that we do not unwittingly become complicit in maintaining existing exploitative and oppressive structures. None of us should be ashamed to speak about our class power, or lack of it. Overcoming fear (even the fear of being immodest) and acting courageously to bring issues of class as well as radical standpoints into the discourse of blackness is a gesture of militant defiance, one that runs counter to the bourgeois insistence that we think of money in particular, and class in general, as a private matter. Progressive black folks who work to live simply because we respect the earth's resources, who repudiate the ethic of materialism and embrace communalism must gain a public voice. Those of us who are still working to mix the vision of autonomy evoked by X category with our dedication to ending domination in all its forms, who cherish openness, honesty, radical will, creativity, and free speech, and do not long to have power over others, or to build nations (or even academic empires), are working to project an alternative politics of representation—working to free the black image so it is not enslaved to any exploitative or oppressive agenda.

14

SPIKE LEE DOING MALCOLM X

Denying black pain

Shortly after the brutal assassination of Malcolm X, Bayard Rustin predicted that "White America, not the Negro people, will determine Malcolm X's role in history." At the time, this statement seemed ludicrous. White Americans appeared to have no use for Malcolm X, not even a changed Malcolm, no longer fiercely advocating racial separatism. Today, market forces in white supremacist capitalist patriarchy have found a way to use Malcolm X. Where black images are concerned, the field of representation has always been a plantation culture. Malcolm X can be turned into hot commodity, his militant black nationalist, anti-imperialist, anticapitalist politics can be diffused and undermined by a process of objectification. Calling attention to the dangers inherent in this marketing trend in his essay "On Malcolm X: His Message and Meaning," Manning Marable warns: "There is a tendency to drain the radical message of a

dynamic, living activist into an abstract icon, to replace radical content with pure image." Politically progressive black folks and our allies in struggle recognize that the power of Malcolm X's political thought, the capacity of his work to educate for critical consciousness is threatened when his image and ideas are commodified and sold by conservative market forces that strip the work of all radical and revolutionary content.

Understanding the power of mass media images as forces that can overdetermine how we see ourselves and how we choose to act, Malcolm X admonished black folks: "Never accept images that have been created for you by someone else. It is always better to form the habit of learning how to see things for yourself: then you are in a better position to judge for yourself." Interpreted narrowly, this admonition can be seen as referring only to images of black folks created in the white imagination. More broadly, however, its message is not simply that black folks should interrogate only the images white folks produce while passively consuming images constructed by black folks; it urges us to look with a critical eye at all images. Malcolm X promoted and encouraged the development of a critical black gaze, one that would be able to move beyond passive consumption and be fiercely confronting, challenging, interrogating.

At this cultural moment, this critical militancy aimed at the realm of the visual must be reinvoked in all serious discussions of Spike Lee's film, Malcolm X. Celebrated and praised in mainstream media, this joint project by white producers and a black filmmaker, Lee's Malcolm X risks receiving no meaningful cultural critique. More often than not, black admirers of Lee and his work, both from the academic front and the street, seek to censor, by discrediting or punishing, any view of the film that is not unequivocally celebratory. Black folks who subject the film to rigorous critique risk being seen as traitors to the race, as petty competitors who do not want to see another black person succeed, or as having personal enmity towards Lee. Filmmaker

Marlon Riggs powerfully emphasizes the dangers of such silencing in a recent interview in *Black Film Review*. Calling attention to the example of audience response to Spike Lee (who is often quick to denounce publicly all forms of critique as betrayal or attack), Riggs stresses that we cannot develop a body of black cultural criticism as long as all rigorous critique is censored.

> There's also a crying desire for representation. That's what you see when audiences refuse to allow any critique of artists. I've witnessed this personally. At one forum, Spike Lee was asked several questions by a number of people, myself included, about his representations in his movies. The audience went wild with hysterical outbursts to "shut up," "sit down," "make your own goddam movies," "who are you, this man is doing the best he can, and he is giving us dignified images, he is doing positive work, why should you be criticizing him?" I admit that there is often trashing just for the sake of trashing. But even when it is clear that the critique is trying to empower and trying to heal certain wounds within our communities, there is not any space within our culture to constructively critique. There is an effort simply to shut people up in order to reify these gods, if you will, who have delivered some image of us which seems to affirm our existence in this world. As if they make up for the lack, but, in fact they don't. They can become part of the hegemony.

This is certainly true of Spike Lee. Despite the hype that continues to depict him as an outsider in the white movie industry, someone who is constantly struggling to produce work against the wishes and desires of a white establishment, Lee is an insider. His insider position was made most evident when he was able to use his power to compel Warner to choose him over white director Norman Jewison to make the film. In the business to make money, Warner was probably not moved by Spike's

narrow identity politics (his insistence that having a white man directing *Malcolm X* would be "wrong with a capital w!"), but rather by the recognition that his presence as a director would likely draw the biggest crossover audience and thus insure that the movie would be a financial success.

Committed as well to making a film that would be a mega-success, Spike Lee had to create a work that would address the needs and desires of a consuming audience that is predominantly white. Ironically, to achieve this end his film had to be made in such a way as to be similar to other Hollywood epic dramas, especially fictive biographies; hence there is no visual standpoint or direction in *Malcolm X* that would indicate that a white director could not have made this film. This seems especially tragic since Spike Lee's brilliance as a filmmaker surfaces most when he combines aspects of documentary in fictive dramas, providing us with insights we have never before seen on the screen, representations of blackness and black life that emerge from the privileged standpoint of familiarity. No such familiarity surfaces in *Malcolm X*. The documentary footage seems more like an add-on that aims to provide the radical portrait of a revolutionary Malcolm lacking in the fictive scenes.

To appeal to a crossover audience, Spike Lee had to create a fictive Malcolm that white folks as well as conservative black and other non-white viewers would want to see. His representation of Malcolm has more in common with Steven Spielberg's representation of Mister in the film version of *The Color Purple* than with real-life portraits of Malcolm X. By choosing not to construct the film chronologically, Spike Lee was able to focus on that part of Malcolm's story that would easily fit with Hollywood's traditional stereotypical representations of black life. In her insightful essay on *The Color Purple*, "Blues For Mr. Spielberg," Michele Wallace asserts:

The fact is there's a gap between what blacks would like to see

> in movies about themselves and what whites in Hollywood are willing to produce. Instead of serious men and women encountering consequential dilemmas, we're almost always minstrels, more than a little ridiculous; we dance and sing without continuity, as if on the end of a string.

Sadly, these comments could be describing the first half of *Malcolm X*. With prophetic vision, Wallace continues her point, declaring

> I suspect that blacks who wish to make their presence known in American movies will have to seek some middle ground between the stern seriousness of black liberation and the tap dances of Mr. Bojangles and Aunt Jemima.

Clearly, Spike Lee attempts to negotiate this middle ground in *Malcolm X*, but does so unsuccessfully.

The first half of the film constantly moves back and forth from neo-minstrel spectacle to tragic scenes. Yet the predominance of spectacle, of the coon show, whether or not an accurate portrayal of this phase of Malcolm's life, undermines the pathos that the tragic scenes (flashbacks of childhood incidents of racial oppression and discrimination) should, but do not, evoke. At the same time, by emphasizing Malcolm as street hustler, Spike Lee can highlight Malcolm's romantic and sexual involvement with the white woman Sophia, thereby exploiting this culture's voyeuristic obsession with interracial sex. It must be remembered that critics of Lee's project, like Baraka, were concerned that this would be the central focus so as to entertain white audiences; the progression of the film indicates the astuteness of this earlier insight about the direction Lee would take. While his relationship with Sophia was clearly important to Malcolm for many years, it is portrayed with the same shallowness of vision that characterizes Lee's vision of interracial romance between black

men and white women in *Jungle Fever*. Unwilling and possibly unable to imagine that any bond between a white woman and a black man could be based on ties other than pathological ones, Lee portrays Malcolm's desire for Sophia as rooted solely in racial competition between white and black men. Yet Malcolm continued to feel affectional bonds for her even as he acquired a radical critique of race, racism, and sexuality.

Without the stellar performance of actor Delroy Lindo playing West Indian Archie, the first half of *Malcolm X* would have been utterly facile. The first character that appears when the film opens is not Malcolm, as audiences anticipate, but a comic Spike in the role of Shorty. Lee's presence in the film intensifies the sense of spectacle. And it seems as though his character is actually competing for attention with Malcolm Little. His comic antics easily upstage the Little character, who appears awkward and stupid. Denzel Washington had been chosen to portray Malcolm before Spike Lee joined the producers at Warner. A box office draw, he never stops being Denzel Washington giving us his version of Malcolm X. Despite his powerful acting, Washington cannot convey the issues around skin color that were so crucial to Malcolm's development of racial consciousness and identity. Lacking Malcolm's stature, and his light hue, Denzel never comes across as a "threatening" physical presence. Washington's real-life persona as everybody's nice guy makes it particularly difficult for him to convey the seriousness and intensity of a black man consumed with rage. By choosing him, white producers were already deciding that Malcolm had to be made to appear less militant, more open, if white audiences were to accept him.

Since so much of the movie depicts Malcolm's days as Detroit Red, the remainder is merely a skeletal, imagistic outline of his later political changes in regard to issues of racial separatism. None of his powerful critiques of capitalism and colonialism are dramatized in this film. Early on in the second part of the

film, the prison scenes raise crucial questions about Lee's representation of Malcolm. No explanations have been given as to why Lee chose not to portray Malcolm's brother and sister leading him to Islam, but instead created a fictional older black, male prisoner, Blaines (played by Albert Hall), who is tutor and mentor to Malcolm Little, educating him for critical consciousness, leading him to Islam. This element in the filmic narrative is the kind of distortion and misrepresentation of individual biography that can occur in fictional biographies and that ultimately violates the integrity of the life portrayed. Indeed, throughout the film Malcolm X's character is constructed as being without family, even though some member of his family was always present in his life. By presenting him symbolically as an "orphan" Lee not only erases the complex relations Malcolm had to black women in his life—his mother, his older sister—making it appear that the only important women are sexual partners, he makes it appear that Malcolm is more a lone, heroic figure, and by so doing is able to reinscribe him within a Hollywood tradition of heroism that effaces his deep emotional engagement with family and community. Lee insists, along with white producer Worth, that there is no revisionism in this film, that as Worth puts it, "We're not playing games with making up our opinion of the truth. We're doing *The Autobiography of Malcolm X*." Yet the absence of any portrayal of significant family members and the insertion of fictional characters who never existed does indeed revise and distort the representation of Malcolm. That misrepresentation is not redeemed by Lee's uses of actual speeches or the placing of them in chronological order. He has boasted that this film will "teach," educate folks about Malcolm. In *By Any Means Necessary*, the book that describes the behind-the-scenes production of the film, Lee asserts: "I want our people to be all fired up for this. To get inspired by it. This is not just some regular bullshit Hollywood movie. This is life and death we're dealing with.

This is a mind-set, this is what Black people in America have come through."

To insure that *Malcolm X* would not be a "regular bullshit Hollywood movie," Lee could have insisted on accuracy despite the fictionalized dramatic context. To do so might have meant that he would have had to make sacrifices, relinquishing complete control, allowing more folks to benefit from the project if need be. It might have meant that he would have to face the reality that masses of people, including black folks, will see this film and will never know the true story because they do not read or write, and that misrepresentations of Malcolm's life and work in the film version could permanently distort their understanding.

Knowing that he had to answer to a militant Nation of Islam, Spike Lee was much more careful in the construction of the character of Elijah Muhammad (portrayed by Al Freeman, Jr.), preserving the integrity of his spirit and work. It is sad that the same intensity of care was not given either the Malcolm character or the fictional portrait of his widow Betty Shabazz. Although the real-life Shabazz shared with Spike Lee that she and Malcolm did not argue (no doubt because what was deemed most desirable in a Nation of Islam wife was obedience), the film shows her "reading" him in the same bitchified way that all black female characters talk to their mates in Spike Lee films. Nor was Shabazz as assertive in romantic pursuit of Malcolm as the film depicts. As with the white character Sophia, certain stereotypical sexist images of black women emerge in this film. Women are either virgins or whores, madonnas or prostitutes— and that's Hollywood. Perhaps Spike Lee could not portray Malcolm's sister Ella, because Hollywood has not yet created a space for a politically progressive black woman to be imagined on the screen.

If Lee's version of Malcolm X's life becomes the example all other such films must follow then it will remain equally

true that there is no place for black male militant political rage in Hollywood. For it is finally Malcolm's political militance that this film erases. (Largely because it is not the politically revolutionary Malcolm X that Lee identifies with.) Even though Lee reiterates in By Any Means Necessary that it was crucial that the film be made by an African American director "and not just any African American director, either, but one to whom the life of Malcolm spoke very directly," the film suggests Lee is primarily fascinated by Malcolm's fierce critique of white racism, and his early obsession with viewing racism as being solely about a masculinist phallocentric struggle for power between white men and black men. It is this aspect of Malcolm's politics that most resembles Lee's, not the critique of racism in conjunction with imperialism and colonialism, and certainly not the critique of capitalism. Given this standpoint it is not surprising that the major filmic moment that seeks to capture any spirit of political resistance shows Malcolm galvanizing men in the Nation of Islam to have a face-off with white men over the issue of police brutality. Malcolm is portrayed in these scenes as a Hitler type leader who rules with an iron, leather-clad fist. Downplaying the righteous resistance to police brutality that was the catalyst for this confrontation, the film makes it appear that it's a "dick thing"—yet another shoot out at the OK Corral—and that's Hollywood. But Hollywood at its best, for this is one of the more powerful scenes in the movie.

The closing scenes of Malcolm X highlight Lee's cinematic conflict, his desire to make a black epic drama that would both compete with and yet mirror white Hollywood epics made by white male directors he perceives as great, as well as his longing to preserve and convey the spirit and integrity of Malcolm's life and work. In the finale, viewers are bombarded, overloaded with images: stirring documentary footage, compelling testimony, and then the use of schoolchildren and Nelson Mandela to show that Malcolm's legacy is still important and has global impact.

Tragically, by the time the film ends, all knowledge of Malcolm X as militant black revolutionary has been utterly erased, consumed by images. Gone is the icon who represents our struggle for black liberation, for militant resistance, and in its place we are presented with a depoliticized image with no substance or power. In *Heavenly Bodies: Film Stars and Society*, Richard Dyer describes the way in which Hollywood manipulates the black image with the intent to render it powerless.

> The basic strategy of these discourses might be termed deactivation. Black people's qualities could be praised to the skies, but they must not be shown to be effective qualities active in the world. Even when portrayed at their most vivid and vibrant, they must not be shown to do anything, except perhaps to be destructive in a random sort of way.

The Malcolm we see at the end of Spike Lee's film is tragically alone, with only a few followers, suicidal, maybe even losing his mind. The didacticism of this image suggests only that it is foolhardy and naive to think that there can be meaningful political revolution—that truth and justice will prevail. In no way subversive, *Malcolm X* reinscribes the black image within a colonizing framework.

The underlying political conservatism of Lee's film will be ignored by those seduced by the glitter and glamor, the spectacle, the show. Like many other bad Hollywood movies with powerful subject matter, *Malcolm X* touches the hearts and minds of folks who bring their own meaning to the film and connect it with their social experience. That is why young black folks can brag about the way the fictional Malcolm courageously confronts white folks even as young white folks leave the theater pleased and relieved that the Malcolm they see and come to know is such a good guy and not the threatening presence they may have heard about. Spike Lee's focus on Malcolm follows in the wake

of a renewed interest in his life and work generated by hip-hop, by progressive contemporary cultural criticism, by political writings, and by various forms of militant activism. These counter-hegemonic voices are a needed opposition to conservative commodifications of Malcolm's life and work.

Just as these forms of commodification freeze and exploit the image of Malcolm X while simultaneously undermining the power of his work to radicalize and educate for critical consciousness, they strip him of iconic status. This gives rise to an increase in cultural attacks, especially in the mainsteam mass media that now bombards us with information that seeks to impress on the public consciousness the notion that, ultimately, there is no heroic dimension to Malcolm, his life, or his work. One of the most powerful attacks has been that by white writer Bruce Perry. Even though Malcolm lets any reader know in his autobiography that during his hustling days he committed "unspeakable" acts (the nature of which would be obvious to anyone familiar with the street culture of cons, drugging, and sexual hedonism), Perry assumes that his naming of these acts exposes Malcolm as a fraud. This is the height of white supremacist patriarchal arrogance. No doubt Perry's work shocks and surprises many folks who need to believe their icons are saints. But no information Perry reveals (much of which was gleaned from interviews with Malcolm's enemies and detractors) diminishes the power of the political work he did to advance the global liberation of black people and the struggle to end white supremacy.

Perry's work has received a boost in media attention since the opening of Spike Lee's movie and is rapidly acquiring authoritative status. Writing in the *Washington Post*, Perry claims to be moved by the film even as he seizes the moment of public attention to insist that Lee's version of Malcolm "is largely a myth" (the assumption being that his version is "truth"). Magazines such as the *New Yorker*, which rarely focus on black life,

have highlighted their anti-Malcolm pieces. The December 1992 issue of Harper's has a piece by black scholar Gerald Early ("Their Malcolm, My Problem") which also aims to diminish the power of his life and work. Usually, when black folks are attempting to denounce Malcolm, they gain status in the white press. Unless there is serious critical intervention, Bayard Rustin's dire prediction that nonprogressive white folks will determine how Malcolm is viewed historically may very well come to pass. Those of us who respect and revere Malcolm as teacher, political mentor, and comrade must promote the development of a counter-hegemonic voice in films, talks, and political writings that will centralize and sustain a focus on his political contribution to black liberation struggle, to the global fight for freedom and justice for all.

Spike Lee's filmic fictive biography makes no attempt to depict Malcolm's concern for the collective well-being of black people, a concern that transcended his personal circumstance, his personal history. Yet the film shows no connection between his personal rage at racism and his compassionate devotion to alleviating the sufferings of all black people. Significantly, Spike Lee's Malcolm X does not compel audiences to experience empathetically the pain, sorrow, and suffering of black life in white supremacist, patriarchal culture. Nothing in the film conveys an anguish and grief so intense as to overwhelm emotionally. And nothing that would help folks understand the necessity of that rage and resistance. Nothing that would let them see why, after working all day, Malcolm would walk the streets for hours, thinking "about what terrible things have been done to our people here in the United States." While the footage of the brutal beating of Rodney King shown at the beginning of the film is a graphic reminder of "the terrible things," the pathos that this image evokes is quickly displaced by the neominstrel show that entertains and titillates.

As sentimental, romanticized drama, Malcolm X seduces by

encouraging us to forget the brutal reality that created black rage and militancy. The film does not compel viewers to confront, challenge, and change. It embraces and rewards passive response—inaction. It encourages us to weep, but not to fight. In his powerful essay "Everybody's Protest Novel," James Baldwin reminds readers that

> sentimentality, the ostentatious parading of excessive and spurious emotion, is the mark of dishonesty, the inability to feel; the wet eyes of the sentimentalist betray his aversion to experience, his fear of life, his arid heart; and it is always, therefore, the signal of secret and violent inhumanity, the mask of cruelty.

As Wallace warns, there is no place in Hollywood movies for the "seriousness of black liberation." Spike Lee's film is no exception. To take liberation seriously we must take seriously the reality of black suffering. Ultimately, it is this reality the film denies.

15

SEEING AND MAKING CULTURE

Representing the poor

Cultural critics rarely talk about the poor. Most of us use words such as "underclass" or "economically disenfranchised" when we speak about being poor. Poverty has not become one of the new hot topics of radical discourse. When contemporary Left intellectuals talk about capitalism, few if any attempts are made to relate that discourse to the reality of being poor in America. In his collection of essays *Prophetic Thought in Postmodern Times*, black philosopher Cornel West includes a piece entitled "The Black Underclass and Black Philosophers" wherein he suggests that black intellectuals within the "professional-managerial class in U.S. advanced capitalist society" must "engage in a kind of critical self-inventory, a historical situating and positioning of ourselves as persons who reflect on the situation of those more disadvantaged than us even though we may have relatives and friends in the black underclass." West does not speak of poverty

or being poor in his essay. And I can remember once in conversation with him referring to my having come from a "poor" background; he corrected me and stated that my family was "working class." I told him that technically we *were* working class, because my father worked as a janitor at the post office, however the fact that there were seven children in our family meant that we often faced economic hardship in ways that made us children at least think of ourselves as poor. Indeed, in the segregated world of our small Kentucky town, we were all raised to think in terms of the haves and the have-nots, rather than in terms of class. We acknowledged the existence of four groups: the poor, who were destitute; the working folks, who were poor because they made just enough to make ends meet; those who worked and had extra money; and the rich. Even though our family was among the working folks, the economic struggle to make ends meet for such a large family always gave us a sense that there was not enough money to take care of the basics. In our house, water was a luxury and using too much could be a cause for punishment. We never talked about being poor. As children we knew we were not supposed to see ourselves as poor but we felt poor.

I began to *see* myself as poor when I went away to college. I never had any money. When I told my parents that I had scholarships and loans to attend Stanford University, they wanted to know how I would pay for getting there, for buying books, for emergencies. We were not poor, but there was no money for what was perceived to be an individualistic indulgent desire; there were cheaper colleges closer to family. When I went to college and could not afford to come home during breaks, I frequently spent my holidays with the black women who cleaned in the dormitories. Their world was my world. They, more than other folks at Stanford, knew where I was coming from. They supported and affirmed my efforts to be educated, to move past and beyond the world they lived in, the world I was coming from.

To this day, even though I am a well-paid member of what West calls the academic "professional-managerial class," in everyday life, outside the classroom, I rarely think of myself in relation to class. I mainly think about the world in terms of who has money to spend and who does not. Like many technically middle-class folks who are connected in economic responsibility to kinship structures where they provide varying material support for others, the issue is always one of money. Many middle-class black folks have no money because they regularly distribute their earnings among a larger kinship group where folks are poor and destitute, where elder parents and relatives who once were working class have retired and fallen into poverty.

Poverty was no disgrace in our household. We were socialized early on, by grandparents and parents, to assume that nobody's value could be measured by material standards. Value was connected to integrity, to being honest and hardworking. One could be hardworking and still be poor. My mother's mother Baba, who did not read or write, taught us—against the wishes of our parents—that it was better to be poor than to compromise one's dignity, that it was better to be poor than to allow another person to assert power over you in ways that were dehumanizing or cruel.

I went to college believing there was no connection between poverty and personal integrity. Entering a world of class privilege which compelled me to think critically about my economic background, I was shocked by representations of the poor learned in classrooms, as well as by the comments of professors and peers that painted an entirely different picture. They almost always portrayed the poor as shiftless, mindless, lazy, dishonest, and unworthy. Students in the dormitory were quick to assume that anything missing had been taken by the black and Filipina women who worked there. Although I went through many periods of shame about my economic background, even before I educated myself for critical consciousness about class by reading

and studying Marx, Gramsci, Memmi, and the like, I contested stereotypical negative representations of poverty. I was especially disturbed by the assumption that the poor were without values. Indeed one crucial value that I had learned from Baba, my grandmother, and other family members was not to believe that "schooling made you smart." One could have degrees and still not be intelligent or honest. I had been taught in a culture of poverty to be intelligent, honest, to work hard, and always to be a person of my word. I had been taught to stand up for what I believed was right, to be brave and courageous. These lessons were the foundation that made it possible for me to succeed, to become the writer I always wanted to be, and to make a living in my job as an academic. They were taught to me by the poor, the disenfranchised, the underclass.

Those lessons were reinforced by liberatory religious traditions that affirmed identification with the poor. Taught to believe that poverty could be the breeding ground of moral integrity, of a recognition of the significance of communion, of sharing resources with others in the black church, I was prepared to embrace the teachings of liberatory theology, which emphasized solidarity with the poor. That solidarity was meant to be expressed not simply through charity, the sharing of privilege, but in the assertion of one's power to change the world so that the poor would have their needs met, would have access to resources, would have justice and beauty in their lives.

Contemporary popular culture in the United States rarely represents the poor in ways that display integrity and dignity. Instead, the poor are portrayed through negative stereotypes. When they are lazy and dishonest, they are consumed with longing to be rich, a longing so intense that it renders them dysfunctional. Willing to commit all manner of dehumanizing and brutal acts in the name of material gain, the poor are portrayed as seeing themselves as always and only worthless. Worth is gained only by means of material success.

Television shows and films bring the message home that no one can truly feel good about themselves if they are poor. In television sitcoms the working poor are shown to have a healthy measure of self-contempt; they dish it out to one another with a wit and humor that we can all enjoy, irrespective of our class. Yet it is clear that humor masks the longing to change their lot, the desire to "move on up" expressed in the theme song of the sitcom The Jeffersons. Films which portray the rags-to-riches tale continue to have major box-office appeal. Most contemporary films portraying black folks—Harlem Nights, Boomerang, Menace II Society, to name only a few—have as their primary theme the lust of the poor for material plenty and their willingness to do anything to satisfy that lust. Pretty Woman is a perfect example of a film that made huge sums of money portraying the poor in this light. Consumed and enjoyed by audiences of all races and classes, it highlights the drama of the benevolent, ruling-class person (in this case a white man, played by Richard Gere) willingly sharing his resources with a poor white prostitute (played by Julia Roberts). Indeed, many films and television shows portray the ruling class as generous, eager to share, as unattached to their wealth in their interactions with folks who are not materially privileged. These images contrast with the opportunistic avaricious longings of the poor.

Socialized by film and television to identify with the attitudes and values of privileged classes in this society, many people who are poor, or a few paychecks away from poverty, internalize fear and contempt for those who are poor. When materially deprived teenagers kill for tennis shoes or jackets they are not doing so just because they like these items so much. They also hope to escape the stigma of their class by appearing to have the trappings of more privileged classes. Poverty, in their minds and in our society as a whole, is seen as synonymous with depravity, lack, and worthlessness. No one wants to be identified as poor. Teaching literature by African American women writers at a major urban

state university to predominantly black students from poor and working-class families, I was bombarded by their questioning as to why the poor black women who were abused in families in the novels we read did not "just leave." It was amazing to me that these students, many of whom were from materially disadvantaged backgrounds, had no realistic sense about the economics of housing or jobs in this society. When I asked that we identify our class backgrounds, only one student—a young single parent—was willing to identify herself as poor. We talked later about the reality that although she was not the only poor person in the class, no one else wanted to identify with being poor for fear this stigma would mark them, shame them in ways that would go beyond our class. Fear of shame-based humiliation is a primary factor leading no one to want to identify themselves as poor. I talked with young black women receiving state aid, who have not worked in years, about the issue of representation. They all agree that they do not want to be identified as poor. In their apartments they have the material possessions that indicate success (a VCR, a color television), even if it means that they do without necessities and plunge into debt to buy these items. Their self-esteem is linked to not being seen as poor.

If to be poor in this society is everywhere represented in the language we use to talk about the poor, in the mass media, as synonymous with being nothing, then it is understandable that the poor learn to be nihilistic. Society is telling them that poverty and nihilism are one and the same. If they cannot escape poverty, then they have no choice but to drown in the image of a life that is valueless. When intellectuals, journalists, or politicians speak about nihilism and the despair of the underclass, they do not link those states to representations of poverty in the mass media. And rarely do they suggest by their rhetoric that one can lead a meaningful, contented, and fulfilled life if one is poor. No one talks about our individual and collective accountability to the poor, a responsibility that begins with the politics of representation.

When white female anthropologist Carol Stack looked critically at the lives of black poor people more than twenty years ago and wrote her book *The Culture of Poverty*, she found a value system among them which emphasized the sharing of resources. That value system has long been eroded in most communities by an ethic of liberal individualism, which affirms that it is morally acceptable not to share. The mass media has been the primary teacher bringing into our lives and our homes the logic of liberal individualism, the idea that you make it by the privatized hoarding of resources, not by sharing them. Of course, liberal individualism works best for the privileged classes. But it has worsened the lot of the poor who once depended on an ethic of communalism to provide affirmation, aid, and support.

To change the devastating impact of poverty on the lives of masses of folks in our society we must change the way resources and wealth are distributed. But we must also change the way the poor are represented. Since many folks will be poor for a long time before those changes are put in place that address their economic needs, it is crucial to construct habits of seeing and being that restore an oppositional value system affirming that one can live a life of dignity and integrity in the midst of poverty. It is precisely this dignity Jonathan Freedman seeks to convey in his book *From Cradle to Grave: The Human Face of Poverty in America*, even though he does not critique capitalism or call for major changes in the distribution of wealth and resources. Yet any efforts to change the face of poverty in the United States must link a shift in representation to a demand for the redistribution of wealth and resources.

Progressive intellectuals from privileged classes who are themselves obsessed with gaining material wealth are uncomfortable with the insistence that one can be poor, yet lead a rich and meaningful life. They fear that any suggestion that poverty is acceptable may lead those who have to feel no accountability towards those who have not, even though it is unclear how they

reconcile their pursuit with concern for and accountability towards the poor. Their conservative counterparts, who did much to put in place a system of representation that dehumanized the poor, fear that if poverty is seen as having no relation to value, the poor will not passively assume their role as exploited workers. That fear is masked by their insistence that the poor will not seek to work if poverty is deemed acceptable, and that the rest of us will have to support them. (Note the embedded assumption that to be poor means that one is not hardworking.) Of course, there are many more poor women and men refusing menial labor in low-paid jobs than ever before. This refusal is not rooted in laziness but in the assumption that it is not worth it to work a job where one is systematically dehumanized or exploited only to remain poor. Despite these individuals, the vast majority of poor people in our society want to work, even when jobs do not mean that they leave the ranks of the poor.

Witnessing that individuals can be poor and lead meaningful lives, I understand intimately the damage that has been done to the poor by a dehumanizing system of representation. I see the difference in self-esteem between my grandparents' and parents' generations and that of my siblings, relatives, friends and acquaintances who are poor, who suffer from a deep-seated, crippling lack of self-esteem. Ironically, despite the presence of more opportunity than that available to an older generation, low self-esteem makes it impossible for this younger generation to move forward even as it also makes their lives psychically unbearable. That psychic pain is most often relieved by some form of substance abuse. But to change the face of poverty so that it becomes, once again, a site for the formation of values, of dignity and integrity, as any other class positionality in this society, we would need to intervene in existing systems of representation.

Linking this progressive change to radical/revolutionary political movements (such as eco-feminism, for example) that

urge all of us to live simply could also establish a point of connection and constructive interaction. The poor have many resources and skills for living. Those folks who are interested in sharing individual plenty as well as working politically for redistribution of wealth can work in conjunction with individuals who are materially disadvantaged to achieve this end. Material plenty is only one resource. Literacy skills are another. It would be exciting to see unemployed folks who lack reading and writing skills have available to them community-based literacy programs. Progressive literacy programs connected to education for critical consciousness could use popular movies as a base to begin learning and discussion. Theaters all across the United States that are not used in the day could be sites for this kind of program where college students and professors could share skills. Since many individuals who are poor, disadvantaged or destitute are already literate, reading groups could be formed to educate for critical consciousness, to help folks rethink how they can organize life both to live well in poverty and to move out of such circumstances. Many of the young women I encounter—black and white—who are poor and receiving state aid (and some of whom are students or would-be students) are intelligent, critical thinkers struggling to transform their circumstances. They are eager to work with folks who can offer guidance, know-how, concrete strategies. Freedman concludes his book with the reminder that

> it takes money, organization, and laws to maintain a social structure but none of it works if there are not opportunities for people to meet and help each other along the way. Social responsibility comes down to something simple—the ability to respond.

Constructively changing ways the poor are represented in every aspect of life is one progressive intervention that can challenge everyone to look at the face of poverty and not turn away.

16

BACK TO BLACK

Ending internalized racism

No social movement to end white supremacy addressed the issue of internalized racism in relation to beauty as intensely as did the Black Power revolution of the sixties. For a time, at least, this movement challenged black folks to examine the psychic impact of white supremacy. Reading Frantz Fanon and Albert Memmi, our leaders begin to speak of colonization and the need to decolonize our minds and imaginations. Exposing the myriad ways white supremacy had assaulted our self-concept and our self-esteem, militant leaders of black liberation struggle demanded that black folks see ourselves differently—see self-love as a radical political agenda. That meant establishing a politics of representation which would both critique and integrate ideals of personal beauty and desirability informed by racist standards, and put in place progressive standards, a system of valuation that would embrace a diversity of black looks.

Ironically, as black leaders called into question racist defined notions of beauty, many white folks expressed awe and wonder that there existed in segregated black life color caste systems wherein the lighter one's skin the greater one's social value. Their surprise at the way color caste functioned in black life exposed the extent to which they chose to remain willfully ignorant of a system that white supremacist thinking had established and maintained. The construction of color caste hierarchies by white racists in nineteenth-century life is well documented in their history and literature. That contemporary white folks are ignorant of this history reflects the way the dominant culture seeks to erase—and thus deny—this past. This denial allows no space for accountability, for white folks in contemporary culture to know and acknowledge the primary role whites played in the formation of color castes. All black folks, even those who know very little if anything at all about North American history, slavery, and reconstruction, know that racist white folks often treated lighter-skinned black folks better than their darker counterparts, and that this pattern was mirrored in black social relations. But individual black folks who grow to maturity in all-white settings that may have allowed them to remain ignorant of color caste systems are soon initiated when they have contact with other black people.

Issues of skin color and caste were highlighted by militant black struggle for rights. The slogan "black is beautiful" worked to intervene and alter those racist stereotypes that had always insisted black was ugly, monstrous, undesirable. One of the primary achievements of Black Power movement was the critique and in some instances the dismantling of color caste hierarchies. This achievement often goes unnoticed and undiscussed, largely because it took place within the psyches of black folks, particularly those of us from working-class or poor backgrounds who did not have access to public forums where we could announce and discuss how we felt. Those black folks who came of age

before Black Power faced the implications of color caste either through devaluation or overvaluation. In other words, to be born light meant that one was born with an advantage recognized by everyone. To be born dark was to start life handicapped, with a serious disadvantage. At the onset of the contemporary feminist movement, I had only recently stopped living in a segregated black world and begun life in predominantly white settings. I remember encountering white female insistence that when a child is coming out of the womb one's first concern is to identify its gender, whether male or female; I called attention to the reality that the initial concern for most black parents is skin color, because of the correlation between skin color and success.

Militant black liberation struggle challenged this sensibility. It made it possible for black people to have an ongoing public discourse about the detrimental impact of internalized racism as regards skin color and beauty standards. Darker-skinned blacks, who had historically borne the brunt of devaluation based on color, were recognized as having been wronged by assaultive white supremacist, aesthetic values. New beauty standards were set that sought to value and embrace the different complexions of blackness. Suddenly, the assumption that each individual black person would also seek a lighter partner was called into question. When our militant, charismatic, revolutionary leader Malcolm X chose to marry a darker-skinned woman, he set different standards. These changes had a profound impact on black family life. The needs of children who suffered various forms of discrimination and were psychologically wounded in families or public school systems because they were not the right color could now be addressed. For example, parents of a dark-skinned child who, when misbehaving at school, was called a devil and unjustly punished now had recourse in material written by black psychologists and psychiatrists documenting the detrimental effects of the color-caste system. In all areas of black life the call to see black as beautiful was empowering. Large numbers of

black women stopped chemically straightening their hair since there was no longer any stigma attached to wearing one's hair with its natural texture. Those folks who had often stood passively by while observing other black folks being mistreated on the basis of skin color felt for the first time that it was politically appropriate to intervene. I remember when my siblings and I challenged our grandmother, who could pass for white, about the disparaging comments she made about dark-skinned people, including her grandchildren. Even though we were in a small Southern town, we were deeply affected by the call to end color-caste hierarchies. This process of decolonization created powerful changes in the lives of all black people in the United States. It meant that we could now militantly confront and change the devastating psychological consequences of internalized racism.

Even when collective militant black struggle for self-determination began to wane, alternative ways of seeing blackness and defining beauty continued to flourish. These changes diminished as assimilation became the process by which black folks could successfully enter the mainstream. Once again, the fate of black folks rested with white power. If a black person wanted a job and found it easier to get it if she or he did not wear a natural hairstyle, this was perceived by many to be a legitimate reason to change. And of course many black and white folks felt that the gain in civil rights, racial integration, and the lifting of many long-standing racial taboos (for example, the resistance to segregated housing and interracial relationships) meant that militant struggle was no longer needed. Since freedom for black folks had been defined as gaining the rights to enter mainstream society, to assume the values and economic standing of the white privileged classes, it logically followed that it did not take long for interracial interaction in the areas of education and jobs to reinstitutionalize, in less overt ways, a system wherein individual black folks who were most like white folks in the way they looked, talked, and dressed would find it

easier to be socially mobile. To some extent, the dangers of assimilation to white standards were obscured by the assumption that our ways of seeing blackness had been fundamentally changed. Aware black activists did not assume that we would ever return to social conditions where black folks would once be grappling with issues of color. While leaders such as Eldridge Cleaver, Malcolm X, George Jackson and many others repeatedly made the issue of self-love central to black liberation struggle, new activists did not continue the emphasis on decolonization once many rights were gained. Many folks just assumed we had collectively resisted and altered color castes.

Few black activists were vigilant enough to see that concrete rewards for assimilation would undermine subversive oppositional ways of seeing blackness. Yet racial integration meant that many black folks were rejecting the ethic of communalism that had been a crucial survival strategy when racial apartheid was the norm. They were embracing liberal individualism instead. Being free was seen as having the right to satisfy individual desire without accountability to a collective body. Consequently, a black person could not feel that the way one wore one's hair was not political but simply a matter of choice. Seeking to improve class mobility, to make it in the white world, black folks begin to backtrack and assume once again the attitudes and values of internalized racism. Some folks justified their decisions to compromise and assimilate to white aesthetic standards by seeing it as simply "wearing the mask" to get over. This was best typified by those black females who wore straight, white-looking wigs to work covering a natural hairdo. Unfortunately, black acceptance of assimilation meant that a politics of representation affirming white beauty standards was being reestablished as the norm.

Without an organized, ongoing, and collective movement for black self-determination, militant black critical thinkers and activists begin to constitute a subculture. A revolutionary militant

stance, one that seriously critiqued capitalism and imperialism, was no longer embraced by the black masses. Given these circumstances, the radicalization of a leader such as Martin Luther King, Jr. went unnoticed by most black folks: his passionate critiques of militarism and capitalism were not heard. King was instead remembered primarily for those earlier stages of political work where he supported a bourgeois model of assimilation and social mobility. Those black activists who remained in the public eye did not continue a militant critique and interrogation of white standards of beauty. While radical activists such as Angela Davis had major public forums, continued to wear natural hair, and be black identified, they did not make the ongoing decolonization of our minds and imaginations central to their political agendas. They did not continually call for a focus on black self-love, on ending internalized racism.

Towards the end of the seventies, black folks were far less interested in calling attention to beauty standards. No one interrogated radical activists who begin to straighten their hair. Heterosexual black male leaders openly chose their partners and spouses using the standards of the color-caste system. Even during the most militant stages of black power movement, they had never really stopped allowing racist notions of beauty to define female desirability, yet they preached a message of self-love and an end to internalized racism. This hypocrisy also played a major role in creating a framework where color-caste systems could once again become the accepted norm.

The resurgence of interest in black self-determination, as well as of overt white supremacism, created in the eighties a context where attention could be given to the issue of decolonization, of internalized racism. The mass media carried stories about the fact that black children had low self-esteem, that they preferred white images over black ones, that black girls liked white dolls better than black ones. This news was all presented with awe, as though there was no political context for the repudiation and

devaluation of blackness. Yet the politics of racial assimilation had always operated as a form of backlash, intended to undermine black self-determination. Not all black people had closed our eyes to this reality. However, we did not have the access to the mass media and public forums that would have allowed us to launch a sustained challenge to internalized racism. Most of us continued to fight against the internalization of white supremacist thinking on whatever fronts we found ourselves. As a professor, I interrogated these issues in classrooms and as a writer in my books.

Nowadays, it is fashionable in some circles to mock Black Power struggle and see it solely as a failed social movement. It is easy for folks to make light of the slogan "black is beautiful." Yet this mockery does not change the reality that the interrogation of internalized racism embedded in this slogan and the many concrete challenges that took place in all areas of black life did produce radical changes, even though they were undermined by white supremacist backlash. Most folks refuse to see the intensity of this backlash, and place responsibility on radical black activists for having too superficial an agenda. The only justifiable critique we can make of militant black liberation struggle is its failure to institutionalize sustained strategies of critical resistance. Collectively and individually, we must all assume accountability for this failure.

White supremacist capitalist patriarchal assaults on movements for black self-determination aimed at ending internalized racism were most effectively launched by the mass media. Institutionalizing a politics of representation which included black images, thus ending years of racial segregation, while reproducing the existing status quo, undermined black self-determination. The affirmation of assimilation as well as of racist white aesthetic standards, was the most effective means to undermine efforts to transform internalized racism in the psyches of the black masses. When these racist stereotypes were

coupled with a concrete reality where assimilated black folks were the ones receiving greater material reward, the culture was ripe for a resurgence of color-caste hierarchy.

Color-caste hierarchies embrace both the issue of skin color and hair texture. Since lighter-skinned black people are most often genetically connected to intergenerational pairings of both white and black people, they tend to look more like whites. Females who were the offspring of generations of interracial mixing were more likely to have long, straight hair. The exploitative and oppressive nature of color-caste systems in white supremacist society has always had a gendered component. A mixture of racist and sexist thinking informs the way color-caste hierarchies detrimentally affect the lives of black females differently from black males. Light skin and long, straight hair continue to be traits that define a female as beautiful and desirable in the racist white imagination and in the colonized black mind set. Darker-skinned black females work to develop positive self-esteem in a society that continually devalues their image. To this day, the images of black female bitchiness, evil temper, and treachery continue to be marked by darker skin. This is the stereotype called "Sapphire"; no light skin occupies this devalued position. We see these images continually in the mass media whether they be presented to us in television sitcoms (such as the popular show *Martin*), on cop shows, (the criminal black woman is usually dark), and in movies made by black and white directors alike. Spike Lee graphically portrayed the conflict of skin color in his film *School Daze*, not via male characters but by staging a dramatic fight between light-skinned women and their darker counterparts. Merely exploiting the issue, the film is neither critically subversive nor oppositional. And in many theaters black audiences loudly expressed their continued investment in color-caste hierarchies by "dissing" darker-skinned female characters.

Throughout the history of white supremacy in the United

States, racist white men have regarded the biracial female as a sexual ideal. In this regard, black men have taken their cues from white men. Stereotypically portrayed as embodying a passionate sensual eroticism as well as a subordinate feminine nature, the biracial black woman has been and remains the standard other black females are measured against. Even when darker-skinned black women are given "play" in films, their characters are usually subordinated to lighter skinned females who are deemed more desirable. For a time, films that portrayed the biracial black woman as a "tragic mulatto" were passé, but contemporary films such as the powerful drama One False Move return this figure to center stage. The impact of militant black liberation struggle had once called upon white-dominated fashion magazines and black magazines to show diverse images of black female beauty. In more recent times, however, it has been acceptable simply to highlight and valorize the image of the biracial black woman. Black women models such as Naomi Campbell find that they have a greater crossover success if their images are altered by long, straight wigs, weaves, or bonded hair so that they resemble the "wannabes"—folks who affirm the equation of whiteness with beauty by seeking to take on the characteristic look of whiteness. This terrain of "drag" wherein the distinctly black-looking female is made to appear in a constant struggle to transform herself into a white female is a space only a brown-skinned black woman can occupy. Biracially black women already occupied a distinctly different, more valued place within the beauty hierarchy. As in the days of slavery and racial apartheid, white fascination with racial mixing once again determines the standard of valuation, especially when the issue is the valuation of female bodies. A world that can recognize the dark-skinned Michael Jordan as a symbol of black beauty scorns and devalues the beauty of Tracy Chapman. Black male pop icons mock her looks. And while folks comment on the fact that light-skinned and biracial women have become the stars of most movies that

depict black folks, no one has organized public forums to talk about the way this mass media focus on color undermines our efforts to decolonize our minds and imaginations. Just as whites now privilege lighter skin in movies and fashion magazines, particularly with female characters, folks with darker skin face a media that subordinates their image. Dark skin is stereotypically coded in the racist, sexist, or colonized imagination as masculine. Hence, a male's power is enhanced by dark looks while a female's dark looks diminish her femininity. Irrespective of people's sexual preferences, the color-caste hierarchy functions to diminish the desirability of darker-skinned females. Being seen as desirable does not simply affect one's ability to attract partners; it enhances class mobility in public arenas, in educational systems and in the work force.

The tragic consequences of color-caste hierarchy are evident among the very young who are striving to construct positive identity and healthy self-esteem. Black parents testify that black children learn early to devalue dark skin. One black mother in an interracial marriage was shocked when her four-year-old girl expressed the desire that her mom be white like herself and her dad. She had already learned that white was better. She had already learned to negate the blackness in herself. In high schools all around the United States, darker-skinned black girls must resist the socialization that would have them see themselves as ugly if they are to construct healthy self-esteem. That means they must resist the efforts of peers to devalue them. This is just one of the tragic implications of black reinvestment in color-caste hierarchies. Had there never been a shift in color consciousness among black people, no one would have paid special attention to the reality that many black children seem to be having as much difficulty learning to love blackness in this racially integrated time of multiculturalism as folks had during periods of intense racial apartheid. Kathe Sandler's documentary film *A Question of Color* examines the way black liberation politics of the sixties

challenged color caste even as she shows recent images of activ-
ists who returned to conventional racist defined notions of
beauty. Even though Sandler does not offer suggestions and
strategies for how we can deal with this problem now, this film is
an important intervention because it brings the issue back into
public discourse.

To describe the problems of color caste we must address it
politically as a serious crisis of consciousness if we are not to
return to an old model of class and caste where those blacks who
are most privileged will be light-skinned or biracial, acting as
mediators between the white world and a disenfranchised, dis-
advantaged mass of black folks with dark skin. Right now there is
a new wave of young, well-educated biracial folks who identify
as black and who benefit from this identification both socially
and when they enter the work force. Although they realize the
implicit racism when they are valued more by whites than
darker-skinned blacks, the ethic of liberal individualism sanc-
tions this opportunism. Ironically, they may be among those
who critique color caste even as they accept the perks that come
from the culture's reinvestment in color-caste hierarchies. Until
black folks begin collectively to critique and question the poli-
tics of representation that systematically devalues blackness, the
devastating effects of color caste will continue to inflict psycho-
logical damage on masses of black folks. To intervene and trans-
form those politics of representation informed by colonialism,
imperialism, and white supremacy, we have to be willing to
challenge mainstream culture's efforts to "erase racism" by sug-
gesting it does not really exist. Recognizing the power of mass
media images to define social reality, we need lobbyists in the
government, as well as organized groups who sponsor boycotts
in order to create awareness of these concerns and to demand
change. Progressive nonblack allies in struggle must join the
effort to call attention to internalized racism. Everyone must
break through the wall of denial that would have us believe a

hatred of blackness emerges from troubled individual psyches and acknowledge that it is systematically taught through processes of socialization in white supremacist society. We must acknowledge, too, that black folks who have internalized white supremacist attitudes and values are as much agents of this socialization as their racist nonblack counterparts. Progressive black leaders and critical thinkers committed to a politics of cultural transformation that would constructively change the lot of the black underclass and thus positively impact the culture as a whole need to make decolonizing our minds and imagination central when we educate for critical consciousness. Learning from the past, we need to remain critically vigilant, willing to interrogate our work as well as our habits of being to ensure that we are not perpetuating internalized racism. Note that more conservative black political agendas, such as the Nation of Islam and certain strands of Afrocentrism, are the only groups who make self-love central, and as a consequence capture the imagination of a mass black public. Revolutionary struggle for black self-determination must become a real part of our lives if we want to counter conservative thinking and offer life-affirming practices to black folks daily wounded by white supremacist assaults. Those wounds will not heal if left unattended.

17

MALCOLM X

The longed-for feminist manhood

Critical scholarship on Malcolm X contains no *substantial* work from a feminist standpoint. Always interested in psychoanalytical approaches to understanding the construction of individual subjectivity, I have been excited by recent work on Malcolm X that seeks to shed light on the development of his personality as militant spokesperson and activist for black liberation struggle by critically interpreting autobiographical information and, as a consequence, seriously highlighting the question of gender.

These are troubled times for black women and men. Gender conflicts abound, as do profound misunderstandings about the nature of sex roles. In black popular culture, black females are often blamed for the problems black males face. The institutionalization of black male patriarchy is often presented as the answer to our problems. Not surprisingly, a culture icon like Malcolm X, who continues to be seen by many black folks as the

embodiment of quintessential manliness, remains a powerful role model for the construction of black male identity. Hence, it is crucial that we understand the complexity of his thinking about gender.

Malcolm often blamed black women for many of the problems black men faced, and it took years for him to begin a critical interrogation of that kind of misogynist, sexist thinking. It seems ironic that Bruce Perry's recent biographical study, *Malcolm: A Life of the Man Who Changed Black America*, which offers much needed and previously unavailable information and attempts to "read" Malcolm's life critically using a psychological approach, holds the women in Malcolm's life accountable for any behavior that could be deemed dysfunctional. Though Perry appears to be appalled by the depths of Malcolm's sexism and misogyny at various periods of his life, he does not attempt to relate this thinking to the institution of patriarchy, to ways of thinking about gender that abound in a patriarchal culture, nor does he choose to emphasize the progressive changes in Malcolm's thinking about gender towards the end of his life. To have focused on these changes, Perry would have had to rethink a major premise of his book, that the "dominating" or abandoning black women in Malcolm's life created in him a monstrous masculinity, one that so emotionally crippled him that he was unable to recover himself and was, as a consequence, abusive and controlling towards others.

In a sense, Perry's biography attempts to deconstruct and demystify Malcolm by highlighting in an aggressive manner his flaws, shortcomings, and psychological hang-ups. And it is particularly through his exploration and discussion of Malcolm's relationship to women that Perry critically interprets material in such a way as to emphasize (even overemphasize) that Malcolm was not the stuff of which role models, heroes, and cultural icons should be made. To decontextualize Malcolm's sexism and misogyny, and make it appear to be solely a reaction to

dysfunctional family relations, is to place him outside history, to represent him as though he were solely a product of black culture and not equally an individual whose identity and sense of self, particularly his sense of manhood, was shaped by the prevailing social ethos of white supremacist capitalist patriarchal society. Using such a narrow framework to analyze Malcolm's life can only lead to distortion and over-simplification. Needless to say, Perry does not apply tools of feminist analysis to explain Malcolm's attitude towards women or his thinking about gender relations. There have been few attempts to discuss Malcolm's life, his political commitments, from a feminist perspective. All too often, feminist thinkers have, like Perry, simply chosen to focus on the sexism and misogyny that shaped Malcolm's thinking and actions throughout much of his life, using that as a reason either to invalidate or dismiss his political impact. Contemporary resurgence of interest in the writings and teachings of Malcolm X has helped to create a critical climate where we can reassess his life and work from a variety of standpoints. Young black females and males, choosing Malcolm as icon and teacher, raise questions about his thinking on gender. In my classes, young black females want to know how we reconcile his sexism and his misogyny with progressive political teachings on black liberation.

To reassess Malcolm's life and work from a feminist standpoint, it is absolutely essential to place him firmly within the social context of patriarchy. We must understand Malcolm in light of that historical legacy in which racism and white supremacy are forms of domination where violation and dehumanization have been articulated and described through a gendered patriarchal rhetoric. That is to say, when folks talk about the cruel history of white domination of black people in the United States—as exemplified by the emasculation of black men—they often make liberation synonymous with the establishment of black patriarchy, of black men gaining the right to dominate women and children.

The "manhood" Malcolm X evoked in his passionate speeches as a representative of the Nation of Islam was clearly defined along such patriarchal lines. While Malcolm did not directly advocate the establishment of black patriarchy as a way of affording black men the right to dominate black women, he talked about the need to "protect" black women, thus using a less obvious strategy to promote black patriarchy. He evoked what might be called a "benevolent" patriarchy in which the patriarchal father/ruler would assume full responsibility for caring for his family—his woman, his children. In one of his most famous speeches, "The Ballot or the Bullet," Malcolm articulated the tenets of black nationalism using patriarchal rhetoric: "The political philosophy of black nationalism means that the black man should control the politics and the politicians in his own community ..." Black nationalist liberation rhetoric clearly placed black women in a subordinate role. It's important to note here that Malcolm did not invent this rhetoric. It was part and parcel of the conservative ideology underlying the Black Muslim religion and both reformist and radical approaches to black liberation.

That ideology was promoted by black females as well as by black males. Many black women joined the Nation of Islam because they felt they would find respect for black womanhood, the patriarchal protection and care denied them in the dominant culture. The price of subordination did not seem too high to pay for masculinist regard. At one of his early appearances with the great black freedom fighter Fannie Lou Hamer, Malcolm castigated black men for their failure to protect black women and children from racist brutality.

When I listen to Mrs. Hamer, a black woman—could be my mother, my sister, my daughter—describe what they had done to her in Mississippi, I ask myself how in the world can we ever expect to be respected as *men* with black women being beaten

and nothing being done about it? No, we don't deserve to be recognized and respected as men as long as our women can be brutalized in the manner that this woman described, and nothing being done about it . . .

Socialized to think along sexist lines about the nature of gender roles, most black people in Malcolm's day believed that men should work and provide for their families, and that women should remain in the home taking care of domestic life and children. (Today, most black folks assume that both genders will work outside the home.) It was often understood that racism in the realm of employment often meant that black men were not able to assume the position of economic providers, that black females often found low-paying jobs when males could find no work. One promise of Elijah Muhammad's Islam was that black women would find husbands who would have jobs. Whatever sexism and misogyny Malcolm X embraced prior to his involvement with the Nation of Islam was intensified by his participation in this organization. In the context of the Nation, the misogynist fear and hatred of women that he had learned as a street hustler was given a legitimate ideological framework. Yet, there it was assumed that if black women were dominant it was not because they were inherently "evil" but because black men had allowed themselves to become emasculated and weak. Hence, any black man who had the courage could reclaim this patriarchal role and thus straighten out the wayward black woman. As a street hustler, Malcolm was often enraged when females were able to outsmart and control men.

Underlying his distrust of women was a fear of emasculation, of losing control, of being controlled by others. Indeed, Malcolm was obsessed with the notion of emasculation and concerned that black men assert control over their lives and the lives of others. In his autobiography, Malcolm explained Muslim teachings on the nature of gender roles, stating that

> the true nature of a man is to be strong, and a woman's true
> nature is to be weak, and while a man must at all times respect
> his woman, at the same time he needs to understand that he
> must control her if he expects to get her respect.

Such sexist thinking continues to inform contemporary Black
Muslim thought. It was recently given renewed expression in
Shahrazad Ali's popular book *The Blackman's Guide to Understanding
the Blackwoman*. She asserts that black female "disrespect for the
Blackman is a direct cause of the destruction of the Black family."
In many ways Ali's book was a rephrasing of the 1956 addresses
on black women that Malcolm gave at the Philadelphia Temple.
Whenever he spoke about gender during his years with the
Nation, Malcolm consistently accused black women of acting in
complicity with white men. Calling black women "the greatest
tool of the devil" he insisted that the uplift of black people was
impeded by "this evil black woman in North America who does
not want to do right and holds the man back from saving him-
self." Bruce Perry attempts to show that Malcolm generalized
about all women based on his personal experiences with indi-
vidual black females who were not progressive in their thinking
about either gender or race.

There is no justification for Malcolm's sexism. Speaking about
that sexism in his comparative work *Martin and Malcolm: A Dream or
A Nightmare*, James Cone emphasizes that both men "shared much
of the typical American male's view of women." He elaborates:
"Both believed that the woman's place was in the home, the
private sphere, and the man's place was in society, the public
arena, fighting for justice on behalf of women and children."
Significantly, Cone insists that we not ignore the negative con-
sequences to black life that were the result of both Martin and
Malcolm's support of sexist agendas.

> While we black men may understand the reasons for Martin's

and Malcolm's or our own sexism, we must not excuse it or
justify it, as if sexism was not and is not today a serious matter
in the African American community. As we blacks will not
permit whites to offer plausible excuses for racism, so we can-
not excuse our sexism. Sexism like racism is freedom's oppos-
ite, and we must uncover its evil manifestations so we can
destroy it.

Few black men have taken up Cone's challenge. And the teach-
ings of Malcolm X are often evoked by black men today to justify
their sexism and the continued black domination of black
females.

The truth is, despite later changes in his thinking about gen-
der issues, Malcolm's earlier public lectures advocating sexism
have had a much more powerful impact on black consciousness
than the comments he made during speeches and interviews
towards the end of his life which showed a progressive evolution
in his thinking on sex roles. This makes it all the more crucial
that all assessments of Malcolm's contribution to black libera-
tion struggle emphasize this change, not attempting in any
way to minimize the impact of his sexist thought but rather to
create a critical climate where these changes are considered and
respected, where they can have a positive influence on those
black folks seeking to be more politically progressive. In his
autobiography, Malcolm declared his ongoing personal com-
mitment to change: "My whole life has been a chronology of
changes—I have always kept an open mind, which is necessary
to the flexibility that must go hand in hand with every intelligent
search for truth." Given progressive changes in Malcolm's think-
ing about gender prior to his death, it does not seem in any way
incongruous to see him as someone who would have become an
advocate for gender equality. To suggest, as he did in the
speeches of his last year, that black women should play an equal
role in the struggle for black liberation, constitutes an implicit

challenge to sexist thinking. Had he lived, Malcolm might have explicitly challenged sexist thinking in as adamant a manner as he had advocated it. Cone makes this insightful observation in his discussion of Malcolm's sexism:

> Whatever views Malcolm held on any subject, he presented them in the most extreme from possible so that no one would be in doubt about where he stood on the subject. When he discovered his error about something, he was as extreme in his rejection of it as he had been in his affirmation. Following his split with the Nation of Islam and his subsequent trips to the Middle East and Africa, Malcolm made an about-face regarding his view on women's rights, as he began to consider the issue not only in the context of religion and morality but, more importantly, from the standpoint of mobilizing the forces needed to revolutionize society.

Often, sexist black men and women who think of Malcolm as a cultural icon suppress information about these changes in his thinking because they do not reinforce their own sexist agenda.

Feminist assessments of Malcolm's life have not been encouraged by individuals who are concerned with defining his legacy and the impact of his work. If there is a conference or panel about Malcolm and his work, Betty Shabazz, his widow, is usually the representative female voice. Until very recently, sexist consorship has determined who the female voices are that can speak about Malcolm and gain a hearing. Since Shabazz makes few if any comments about progressive changes in Malcolm's thinking about gender and she remains the representative female voice interpreting his legacy, she participates in closing down the discussion of Malcolm's views on gender. Clearly, for practically all of their marriage, Malcolm assumed a benevolent patriarchal role in the family. This Shabazz documents in her essay "Malcolm X as a Husband and Father." Still, it would be too

simplistic to regard Shabazz solely as a victim of his sexist agenda. She too had a sexist agenda. She was equally committed to ways of thinking about gender roles that were expressed and advocated by the Nation of Islam. And though Shabazz made a break with the Nation, interviews and dialogues give no indication that she made substantial changes in her thinking about gender, that she in any way advocates feminism.

Even though Shabazz attempted to assert an autonomous identity and presence after Malcolm's death, she continued and continues to assume the position that, as his widow, she has the right (accorded with patriarchy) to be the primary, authentic spokesperson, letting the world know who Malcolm X, the man, really was. Legally, she controls the estate of Malcolm X. Yet if, as sources suggest, she and Malcolm were drifting apart (perhaps even on the verge of divorce), it may very well be that despite his patriarchal dominance in the family, his thinking on gender was more progressive than hers. It would of course not be in her interest to reveal such conflict, because it would raise problematic questions about her continued role as the voice of Malcolm, the man.

Ultimately, it may be that any feminist assessment of Malcolm's life and work must concede that, given the sexist politics of their family life, Shabazz cannot shed much light on Malcolm's changing views on the woman question. And if indeed her own views are not particularly progressive or feminist, she does not really hold a standpoint from which to articulate the changes in his thinking. Bluntly stated, Shabazz may advocate gender equality in the realm of work but see no need for women and men unequivocally to resist sexism and sexist oppression in all areas of life. She has not publicly indicated a conversion to feminist politics, nor to the kind of feminist thinking that would provide her with a theoretical standpoint enabling her to talk about progressive change in Malcolm (or for that matter anyone's thinking about gender). Yet just the fact of having been

Malcolm's wife makes her an icon in the eyes of many black folks who are seeking to learn from Malcolm's life and work. If Betty Shabazz acts as though progressive changes in Malcolm's thinking about gender were not important, then she is complicit with those who choose to ignore or dismiss these changes.

Many younger black females (myself included) who have an opportunity to be in Shabazz's presence admire her fortitude in coping with the adversity she and her children faced as a result of Malcolm's political choices and his death, as well as the way she has managed to forge a separate and unique identity. Yet such admiration does not change the fact that in most public settings where Shabazz appears with men, she assumes a traditional sexist positionality (i.e., paying close attention to what males are saying in their interpretations of Malcolm's work, while ignoring or actively discounting female interpretations). Though often supportive of women, Betty Shabazz has not shown ongoing concern with issues of women's rights. Certainly she has a right to determine what political concerns interest her. What I wish to suggest here, however, is that were Shabazz more outspoken about changes in Malcolm's thinking about gender, if she were more outspoken about how difficult it was to conform to his sexist domination in family life, if indeed she could articulate her own "bitterness" (if it is present) that Malcolm did not live to offer her the benefits of his progressive thinking about gender, we would have a greater understanding of his developing critical consciousness around the question of gender.

In his biography of Malcolm, Perry attempts to construct Malcolm as a sexist "abuser" whose wife was to some extent liberated by his death.

> Freed from Malcolm's control, Betty, who was catapulted to national prominence by his assassination, blossomed. Like Louise Little, she maintained that her deceased husband, to

whom she had been married seven years, had been a good one. She returned to school, obtained a doctorate, and became a public figure in her own right. "I'm not just Malcolm's widow," she proudly told a reporter. During the interview, she alluded to men who misuse women. Such abuse, she said, is spawned by unhappy childhood relationships with mothers or sisters.

Ironically, Perry enlists Shabazz to support his sexist agenda, his critical interpretation of Malcolm which is biased by that very same sexist thinking he critiques in Malcolm, making it appear that only the actions of females (as mothers and sisters) shape and form male identity. Shabazz's comment reinforces this sexist interpretation of childhood influences. But what about society—and the role of fathers and other men—in shaping Malcolm's attitudes and actions towards women? Why do Perry and Shabazz both deny patriarchal influence and engage in their own form of mother blame?

This seems ironic since Shabazz's refusal to talk with Perry implies that she does not see him as the spokesperson to interpret Malcolm's life and work. But like Perry, she does not fully interrogate the question of gender from a nonsexist perspective. If Shabazz cannot interrogate her own sexist thinking it is understandable that she may be unable to interrogate publicly Malcolm's gendered habits of being. She may not wish to discuss openly either his sexism or the fact that his changed attitudes were possibly not reflected in his personal life. Similarly, it may be difficult for Malcolm's daughters to be publicly critical, or self-reflexive about his attitudes towards females, his thinking on gender, because they may only remember that period when he was most committed to a benevolent patriarchal stance and was the kind of father who was rarely home. We can only hope that as time goes on, as black people collectively fully accept that we can know the negative aspects of our cultural icons without losing profound respect for their personal and political

contributions, all who knew Malcolm X intimately will feel that they can speak more openly and honestly about him. Shabazz may then also be able to be more openly critical of black male domination.

Despite Malcolm's sexism, he helped Shabazz to become a more politically aware person. Interviewed in the February 1990 issue of *Emerge* Magazine, which focused on "Remembering Malcolm X 25 Years Later," Betty Shabazz honestly states that she was politicized through her relationship to Malcolm, the man.

> He expanded my conceptual framework. As a little middle-class girl in Detroit, Michigan, with older parents and no siblings, it was very limited. Malcolm gave me a world perspective—expanded how I saw things ... I think [had I not met and married Malcolm] I would still be a Methodist woman whose concerns were with the community in which I lived, as opposed to the concerns of world society.

Significantly, Shabazz's statements indicate that sexist agendas did not keep her from learning to think and act politically from the example of Malcolm X. Angela Davis has also spoken about the way in which Malcolm contributed to the development of her social and political thought, her militancy. I myself I have stated, again and again, that the writings of Malcolm X were essential to my political development. For many of us, his unequivocal critique of internalized racism coupled with his unapologetic stance on the need for militant resistance was the kind of political intervention that transformed our consciousness and our habits of being. This transformation happened in spite of Malcolm's sexism.

Significantly, it was Malcolm's break with the patriarchal father embodied in Elijah Muhammad that created the social space for him to transform his thinking about gender. Although his relationship with Betty (who did not conform to sexist

stereotypes of female behavior) had already created a personal context for him to rethink misogynist assumptions, to some extent he first had to become "disloyal" (to use Adrienne Rich's word) to the patriarchy before he could think differently about women, about our role in resistance struggle, and potentially about feminist movement. Contemporary thinkers do Malcolm a great disservice when they attempt to reinscribe him iconically within the very patriarchal context he so courageously challenged. His resistance to the patriarchy was exemplified by his break with the Nation, the critique of his own role in the domestic household, and progressive changes in his thinking about gender: he no longer endorsed the sexist notion that black male leadership was essential to black liberation.

It was again in the company of Fannie Lou Hamer, shortly before his death, that Malcolm made one of his most powerful declarations on the issue of gender. Calling Hamer "one of this country's foremost freedom fighters" at the Audubon Ballroom, Malcolm declared: "You don't have to be a man to fight for freedom. All you have to do is be an intelligent human being. And automatically, your intelligence makes you want freedom so badly that you'll do anything, by any means necessary, to get that freedom." Here Malcolm was clearly rethinking and challenging his own and others' privileging of the black male's role in resistance struggle. Another factor that caused Malcolm to rethink his attitudes towards women was the tremendous support black females extended to him after his break with the Nation, as well as his growing awareness that it was black women who were often the hardworking core of many black organizations, both radical and conservative.

Strategically, Malcolm had to build an autonomous constituency after his break with the Nation. It is not surprising that he had become more aware that women could be formidable advocates leading resistance struggle, and that he would need to rely on female comrades. Again, it's important to link Malcolm's

break with the patriarchal, hierarchical structure of Islam with a critical rethinking of the place of hierarchy in any social and political organization. During the last month of his life, he was quoted in the *New York Times* as saying: "I feel like a man who has been asleep somewhat and under someone else's control. I feel what I'm thinking and saying now is for myself. Before, it was for and by the guidance of Elijah Muhammad. Now I think with my own mind." Presumably, this self-critical moment helped him to critically interrogate thinking on gender. It is this rethinking Perry's biography refuses to acknowledge and critically interpret as an incredible political shift. Speaking with the same arrogant tone that informs much of the book, Perry writes of Malcolm's relationship with Shabazz:

> Malcolm's marriage was no more unhappy than those of other public figures who shun intimacy for the love of the crowd. Eventually, the marriage nearly broke up, ostensibly over the issue of money. But there were other issues, for Malcolm denied his wife the warmth and emotional support his mother and Ella (his older sister) had denied him. He controlled her the way they had controlled him. His male chauvinism was the predictable result of past tyranny.

This is a fine example of the way Perry attempts to stack the deck psychologically against Malcolm, using his sexist thinking and actions to define the man. Perry refuses to acknowledge those profound changes in Malcolm's thinking about gender, even his rethinking his relationships to family, because these changes disrupt Perry's critique. They suggest that while it may be accurate to say that Malcolm's sexist thinking about women in general and black women in particular was reinforced by his relationships to his mother and older sister, it is equally accurate to say that as he began to replace these dysfunctional kinship bonds with new ties with women, he began a kind of personal

self-recovery that enabled him to see women differently. Interaction with black women such as Fannie Lou Hamer and Shirley Graham Dubois, intelligent powerful leaders, made intense impressions on Malcolm X. Given that many of his misogynist viewpoints on women continually referred to the female body, to female sexuality, it's important to note that in an attempt to redress, Malcolm's later speeches emphasized black female intellectualism and intelligence. Hence, he could assert: "I am proud of the contribution women have made. I'm for giving them all the leeway possible. They've made a greater contribution than many men."

There is much documentation to support progressive changes in Malcolm's attitudes towards women; clearly he believed women should play a role in resistance struggle (one equal to men); he believed the contributions of females should be acknowledged; and he supported equal education for females. Yet there is little documentation providing any clue as to how he perceived these changes would affect gender roles in domestic life. And while we can speculate that Malcolm might have developed the kind of critical consciousness around gender that would have enabled him to listen and learn from black female advocates of feminist thought, that he might have become a spokesperson for the cause, a powerful ally, this must remain speculation—nothing more. Yet we should not minimize the significance of the transformation in his consciousness around the issue of gender late in his political career.

It would be a profound disservice to Malcolm's memory, his political legacy, for those who reclaim him as powerful teacher and mentor figure today to repress knowledge of these changes. Sexism, sexist oppression, and its most insidious expression—male domination—continue to undermine black liberation struggle, continue to undercut the positive potential in black family life, rendering dysfunctional familial relations that could enable recovery and resistance. Hence, more than ever

before, there needs to be mass education for critical consciousness that teaches folks about Malcolm's transformed thinking on gender. His move from a sexist, misogynist standpoint to one where he endorsed efforts at gender equality was so powerful. It can serve as an example for many men today, particularly black men. To remember Malcolm solely as a pimp and a batterer, as one who used and exploited women, is a distortion of who he was that is tantamount to an act of violation. Feminist thinkers cannot demand that men change, then refuse to extend full positive acknowledgment when men rethink sexism and alter their behavior accordingly.

Malcolm X would still be an important political thinker and activist whose life and work should be studied and learned from, even if he had never confronted and altered his sexist thinking. However, the point that has to be made again and again is that he did begin to critique and change that sexism, he did transform his consciousness.

When I hear Malcolm urging us to seize our freedom "by any means necessary," I do not think of a call to masculinist violence but rather of a call that urges us to think, to decolonize our minds, and strategize so that we can use various tools and weapons in our efforts at emancipation. I like to remember him speaking about our choosing to work for freedom "by any means necessary" in his response to the words of Fannie Lou Hamer. I like to evoke Malcolm's name and his words when writing to a black male lover about how we treat one another, using his evocation of redemptive love between black people, remembering that he told us:

> It is not necessary to change the white man's mind. We have to change our own mind ... We've got to change our own minds about each other. We have to see each other with new eyes. We have to see each other as brothers and sisters. We have to come together with warmth ...

The harmony Malcolm evokes here can only emerge in a context where renewed black liberation struggle has a feminist component, where the eradication of sexism is seen as essential to our struggle, to our efforts to build a beloved community, a space of harmony and connection where black women and men can face each other not as enemies but as comrades, our hearts rejoicing in a communion that is about shared struggle and mutual victory.

18

COLUMBUS

Gone but not forgotten

Late last night a strange white man came to my door. Walking towards him through the dark shadows of the corridor, I felt fear surface, uncertainty about whether I should open the door. After hesitating, I did. He was a messenger bringing a letter from a female colleague. As I took the letter from him, he told me that he was reading my book, *Black Looks*, that he liked it, but that he just wanted to say that there was just too much emphasis on "Oh," he insisted, "you know the phrase." I finished the sentence for him, "white supremacist capitalist patriarchy." After a moment's pause I said, "Well, it's good to know you are reading this book."

From the onset when I began to use the phrase "white supremacist capitalist patriarchy" to describe my understanding of the "new world order," folks reacted. I witnessed the myriad ways this phrase disturbed, angered, and provoked. The response

reinforced my awareness that it is very difficult for most Americans, irrespective of race, class, gender, sexual preference or political allegiance, to really accept that this society is white supremacist. Many white feminists were using the phrase "capitalist patriarchy" without questioning its appropriateness. Evidently it was easier for folks to see truth in referring to the economic system as capitalist and the institutionalized system of male gender domination as patriarchal than for them to consider the way white supremacy as a foundational ideology continually informs and shapes the direction of these two systems of domination. The nation's collective refusal to acknowledge institutionalized white supremacy is given deep and profound expression in the contemporary zeal to reclaim the myth of Christopher Columbus as patriotic icon.

Despite all the contemporary fuss, I do not believe that masses of Americans spend much time thinking about Columbus. Or at least we didn't until now. Embedded in the nation's insistence that its citizens celebrate Columbus's "discovery" of America is a hidden challenge, a call for the patriotic among us to reaffirm a national commitment to imperialism and white supremacy. This is why many of us feel it is politically necessary for all Americans who believe in a democratic vision of the "just and free society," one that precludes all support of imperialism and white supremacy, to "contest" this romanticization of Columbus, imperialism, capitalism, white supremacy, and patriarchy.

Columbus's legacy is an inheritance handed down through generations. It has provided the cultural capital that underlies and sustains modern-day white supremacist capitalist patriarchy. Those of us who oppose all forms of domination long ago debunked the Columbus myth and reclaimed histories that allow us a broader, more realistic vision of the Americas. Hence, we resist and oppose the national call to celebrate Columbus. What we celebrate is our subversion of this moment, the way many folks have made it a space for radical intervention. Indeed, the

invitation to celebrate Columbus was for some of us a compelling call to educate the nation for critical consciousness—to seize the moment to transform everyone's understanding of our nation's history. What we acknowledge is that this moment allows us a public space to mourn, an occasion to grieve for what this world was like before the coming of the white man and to recall and reclaim the cultural values of that world. What we acknowledge is the burgeoning spirit of resistance that will undoubtedly rock this nation so that the earth, the ground on which we stand and live, will be fundamentally changed—turned over as we turn back to a concern for the collective harmony and life of the planet.

Thinking about the Columbus legacy and the foundations of white supremacy in the United States, I am drawn most immediately to Ivan Van Sertima and to his ground-breaking book, *They Came Before Columbus.* Documenting the presence of Africans in this land before Columbus, his work calls us to rethink issues of origin and beginnings. Often the profound political implications of Van Sertima's work is ignored. Yet in a revolutionary way, this work calls us to recognize the existence in American history of a social reality where individuals met one another within the location of ethnic, national, and cultural difference and who did not make of that difference a site of imperialist/cultural domination. When I recall learning about Columbus from grade school on, what stands out is the way we were taught to believe that the will to dominate and conquer folks who are different from ourselves is natural, not culturally specific. We were taught that the Indians would have conquered and dominated white explorers if they could have but they were simply not strong or smart enough. Embedded in all these teachings was the assumption that it was the whiteness of these explorers in the "New World" that gave them greater power. The word "whiteness" was never used. The key word, the one that was synonymous with whiteness, was "civilization." Hence, we were made to understand at a young

age that whatever cruelties were done to the indigenous peoples of this country, the "Indians," was necessary to bring the great gift of civilization. Domination, it became clear in our young minds, was central to the project of civilization. And if civilization was good and necessary despite the costs, then that had to mean domination was equally good.

The idea that it was natural for people who were different to meet and struggle for power merged with the idea that it was natural for whites to travel around the world civilizing non-whites. Despite progressive interventions in education that call for a rethinking of the way history is taught and culturally remembered, there is still little focus on the presence of Africans in the "New World" before Columbus. As long as this fact of history is ignored, it is possible to name Columbus as an imperialist, a colonizer, while still holding on to the assumption that the will to conquer is innate, natural, and that it is ludicrous to imagine that people who are different nationally, culturally, could meet each other and not have conflict be the major point of connection. The assumption that domination is not only natural but central to the civilizing process is deeply rooted in our cultural mind-set. As a nation we have made little transformative progress to eradicate sexism and racism precisely because most citizens of the United States believe in their heart of hearts that it is natural for a group or an individual to dominate over others. Most folks do not believe that it is wrong to dominate, oppress, and exploit other people. Even though marginalized groups have greater access to civil rights in this society than in many societies in the world, our exercise of these rights has done little to change the overall cultural assumption that domination is essential to the progress of civilization, to the making of social order.

Despite so much evidence in daily life that suggests otherwise, masses of white Americans continue to believe that black people are genetically inferior—that it is natural for them to be dominated. And even though women have proved to be the

equals of men in every way, masses still believe that there can be no sustained social and family order if males do not dominate females, whether by means of benevolent or brutal patriarchies. Given this cultural mind-set, it is so crucial that progressives who seek to educate for critical consciousness remind our nation and its citizens that there are paradigms for the building of human community that do not privilege domination. And what better example do we have as a culture than the meeting of Africans and native peoples in the Americas? Studying this historical example we can learn much about the politics of solidarity. In the essay "Revolutionary Renegades" published in *Black Looks*, I emphasize the importance of ties between the Africans who came here before Columbus and Native American communities:

> The Africans who journeyed to the "New World" before Columbus recognized their common destiny with the Native peoples who gave them shelter and a place to rest. They did not come to command, to take over, to dominate, or to colonize. They were not eager to sever their ties with memory; they had not forgotten their ancestors. These African explorers returned home peaceably after a time of communion with Native Americans. Contrary to colonial white imperialist insistence that it was natural for groups who are different to engage in conflict and power struggle, the first meetings of Africans and Native Americans offer a counter-perspective, a vision of cross-cultural contact where reciprocity and recognition of the primacy of community are affirmed, where the will to conquer and dominate was not seen as the only way to confront the Other who is not ourselves.

Clearly the Africans and Native peoples who greeted them on these shores offered each other a way of meeting across difference that highlighted the notion of sharing resources, of exploring differences and discovering similarities. And even though there

may not remain a boundless number of documents that would affirm these bonds, we must call attention to them if we would dispel the cultural assumption that domination is natural.

Colonizing white imperialists documented the reality that the indigenous people they met did not greet them with the will to conquer, dominate, oppress, or destroy. In his journals and letters to Spanish patrons, Columbus described the gentle, peace-loving nature of Native Americans. In a letter to a Spanish patron, Columbus wrote (quoted in Howard Zinn's essay "Columbus, the Indians, and Human Progress"):

> They are very simple and honest and exceedingly liberal with all they have, none of them refusing anything he may possess when he is asked. They exhibit great love toward all others in preference to themselves.

Though he seemed in awe of the politics of community and personal relations that he witnessed among the indigenous people, Columbus did not empathize with or respect the new cultural values he was observing and allow himself to be transformed, born again with a new habit of being. Instead he saw these positive cultural values as weaknesses that made the indigenous people vulnerable, nations that could be easily conquered, exploited, and destroyed. This cultural arrogance was expressed in his journal when he boasted, "They would make fine servants. With fifty men we could subjugate them all and make them do whatever we want." At the core of the new cultural values Columbus observed was a subordination of materiality to collective welfare, the good of the community. From all accounts, there was no indigenous community formed on the basis of excluding outsiders so it was possible for those who were different—in appearance, nationality, and culture—to be embraced by the communal ethos.

It is the memory of this embrace that we must reinvoke as

we critically interrogate the past and rethink the meaning of the Columbus legacy. Fundamentally, we are called to choose between a memory that justifies and privileges domination, oppression, and exploitation and one that exalts and affirms reciprocity, community, and mutuality. Given the crisis the planet is facing—rampant destruction of nature, famine, threats of nuclear attack, ongoing patriarchal wars—and the way these tragedies are made manifest in our daily life and the lives of folks everywhere in the world, it can only be a cause for rejoicing that we can remember and reshape paradigms of human bonding that emphasize the increased capacity of folks to care for the earth and for one another. That memory can restore our faith and renew our hope.

Whether we are evoking memories of Columbus or the Africans who journeyed before him, the legacy they both represent, though different, is masculine. One semester, I began my course on African American women writers speaking about this journey. For the first time, I talked about the fact that initial contact between Africans and Native Americans was first and foremost a meeting between men. Later, Columbus arrives—also with men. While the African and Native American men who greeted one another did not embody the characteristics of an imperialist misogynistic masculine ideal, they shared with white colonizers a belief in gender systems that privilege maleness. This means that even though there were communities to be found in Africa and the Americas where women did have great privilege, they were always seen as fundamentally different from and in some ways always less than men. Zinn's essay emphasizes both "widespread rape of native women" by white colonizers as well as the degree to which the imperialist venture in the Americas was seen as a "masculine conquest." What contemporary speculative discussion do we have about the way indigenous men responded to the assaults on native women? Zinn emphasizes the way gendered metaphors were used to

celebrate the colonizers' victory. He quotes Samuel Eliot Morison's patriarchal romanticization of this conquest: "Never again may mortal men hope to recapture the amazement, the wonder, the delight of those October days in 1492, when the new world gracefully yielded her virginity to the conquering Castilians." Indigenous men had no relationship to the land, to the world of their ancestors, to the earth that would have allowed them to evoke metaphors of rape and violation. To imagine the earth as a woman to be taken over, consumed, dominated was a way of thinking about life peculiar to the colonizer. My point is not that Native Americans and Africans did not hold sexist values, but that they held them differently from white colonizers; that there were among these diverse men of color and communities of color limits to masculine power. It is a tragic consequence of colonization that contemporary men of color seek to affirm nationhood and male power in specific cultural contexts by asserting a masculinity informed by the very worst of the white patriarchal legacy.

In our cultural retelling of history we must connect the Columbus legacy with the institutionalization of patriarchy and the culture of sexist masculinity that upholds male domination of females in daily life. The cultural romanticization of Columbus's imperialist legacy includes a romanticization of rape. White colonizers who raped and physically brutalized native women yet who recorded these deeds as the perks of victory acted as though women of color were objects, not the subjects of history. If there was conflict, it was between men. Females were perceived as though they and their bodies existed apart from the struggle between males for land and territory. From that historical moment on, women of color have had to grapple with a legacy of stereotypes that suggest we are betrayers, all too willing to consent when the colonizer demands our bodies. Any critical interrogation of the Columbus legacy that does not call attention to the white supremacist patriarchal

mind-set that condoned the rape and brutalization of native females is only a partial analysis. For contemporary critics to condemn the imperialism of the white colonizer without critiquing patriarchy is a tactic that seeks to minimize the particular ways gender determines the specific forms oppression may take within a specific group. It subsumes the rape and exploitation of native women by placing such acts solely within the framework of military conquest, the spoils of war, a gesture which mystifies the way in which patriarchal thinking works both apart from, and in conjunction with, imperialism to support and affirm sexual violence against females—particularly women of color. Why is it many contemporary male thinkers, especially men of color, repudiate the imperialist legacy of Columbus but affirm dimensions of that legacy by their refusal to repudiate patriarchy?

Are contemporary people of color not wedding ourselves to the Columbus legacy when we construct a cultural politics of tribal or national identity that perpetuates the subordination of women? If contemporary notions of ethnic subcultural nationhood and identity condone and celebrate female subordination by males via the perpetuation of sexist thinking and behavior, then progressive demands for a rethinking of history will never be fundamentally linked with a politics of solidarity that fully repudiates domination. No transformative interventions can take place to end oppression and exploitation as long as we critique one form of domination and embrace another.

The Columbus legacy is clearly one that silences and eradicates the voices—the lives—of women of color. In part to repair the damage of this history, the way it has been taught to us, the way it has shaped how we live our lives, we must seize this moment of historical remembering to challenge patriarchy. No amount of progressive rethinking of history makes me want to call to mind the fate of native women during the imperialist conquest of the Americas. Or the extent to which their fate

determined the destiny of enslaved African Americans. There is only sorrow to be found in evoking the intensity of violence and brutalization that was part of the Western colonization of the minds and bodies of native women and men. We can, however, call that legacy to mind in a spirit of collective mourning, making our grief a catalyst for resistance. Naming our grief empowers it and us. Chickasaw writer Linda Hogan [in her essay "Columbus Debate" from the October 1992 issue of *Elle*] reminds us of the depth of this sorrow.

> No people could have imagined anything as terrible as what happened here—such terrors, a genocide that is ongoing, the beginning of a grief we still feel. What has been done to the land has been done to the people; we are the same thing. And all of us are injured by the culture that separates us from the natural world and our inner lives, all of us are wounded by a system that grew out of such genocide, destruction to the land and society.

Our indigenous comrades who struggle for freedom in South Africa remind us that "our struggle is also a struggle of memory against forgetting." To remember is to empower. Even though these memories hurt, we dare to name our grief and pain and the sorrow of our ancestors, and we defiantly declare that the struggle to end patriarchy must converge with the struggle to end Western imperialism. We remember the particular fate of indigenous women at the hands of white supremacist patriarchal colonizers; we remember to honor them in acts of resistance, to reclaim the sound of their protests and rage, the sound that no history books record.

In the past year, I have rejected all overtures to speak or write anything about Columbus. Again and again, I would hear myself saying, "I don't really ever think about Columbus." Critically interrogating this assertion, I unpacked the levels of untruth it

holds. It is not that simple—that I just do not think about Columbus. I want to forget him, to deny his importance, because those earliest childhood memories of learning about Columbus are tied to feelings of shame that "red and black" people (as I thought of us then) were victimized, degraded and exploited by these strange white discoverers. In truth, I can close my eyes and vividly call to mind those images of Columbus and his men sketched in history books. I can see the crazed and savage looks that were on the faces of indigenous men, just as I remember the drawings of sparsely clothed, shackled African slaves. I want to forget them even as they linger against my will in memory. Writing in a letter to a friend, Laguna novelist and poet Leslie Silko speaks about the place of images in the mind's eye, describing what it is like when we think we recall a specific event, as though we were really present, only to find out that our memory of that moment has been shaped by a photograph. Silko writes, "Strange to think that you heard something—that you heard someone describe a place or a scene when in fact you saw a picture of it, saw it with your own eyes." And I would add even stranger when those pictures linger in the imagination from generation to generation. When I recall the shame I felt seeing those images, of the Indian and the "great" white men, I recognize that there is also rage there. I was not only angry at these images, which did not feel right in my heart, I felt that being forced to look at them was like being forced to witness the symbolic reenactment of a colonizing ritual, a drama of white supremacy. The shame was feeling powerless to protest or intervene.

We are not powerless today. We do not choose to ignore or deny the significance of remembering Columbus because it continues to shape our destiny. By speaking, opposing the romanticization of our oppression and exploitation, we break the bonds with this colonizing past. We remember our ancestors, people of color—Native American and African, as well as

those individual Europeans who opposed genocide in word and deed. We remember them as those who opened their hearts, who bequeathed us a legacy of solidarity, reciprocity, and communion with spirits that we can reclaim and share with others. We call on their knowledge and wisdom, present through generations, to provide us with the necessary insight so that we can create transformative visions of community and nation that can sustain and affirm the preciousness of all life.

19

MOVING INTO AND
BEYOND FEMINISM

Just for the joy of it

Initially excited to be interviewed for a book that would high-light women and performance, I was pissed to learn that it would be called *Angry Women*. In our culture, women of all races and classes who step out on the edge, courageously resisting conventional norms for female behavior, are almost always portrayed as crazy, out of control, mad. This title was good for selling books. Representations of "mad" women excite even as they comfort. Set apart, captured in a circus of raging representations, women's serious cultural rebellion is mocked, belittled, trivialized. It is frustrating, maddening even, to live in a culture where female creativity and genius are almost always portrayed as inherently flawed, dangerous, problematic. Luckily, despite stereotyped packaging and the evocation of the image of "angry women," this portrayal is challenged and subverted by the resisting representations that appear in the book.

In this interview, I do not speak out in rage. The passion in my voice emerges from the playful tension between the multiple, diverse, and sometimes contradictory locations I inhabit. There is no unitary representation to be formed here, no fixed sense of what it is to be black, female, from a working-class Southern background. For years, I was afraid to engage in radical political thought or movement. I feared it would close down creativity, confine me in an unchanging standpoint. Moving past this fear and embracing struggles to end domination, I find myself constantly at odds with workers for freedom who invest in the notion of a unitary self—a fixed identity. I continually resist surrendering complexity to be accepted in groups where subjectivity is flattened out in the interest of harmony or a unitary political vision. Turned off by culture vultures who want me to talk "race only," "gender only," who want to confine and limit the scope of my voice, I am turned on by subjectivity that is formed in the embrace of all the quirky conflicting dimensions of our reality. I am turned on by identity that resists repression and closure. This interview was a site where I could transgress boundaries with no fear of policing—a space of radical openness on the margins, where identity that is fluid, multiple, always in process could speak and be heard.

Re/Search Publications: How did your childhood lead you to your present position: fighting political, racist and sexist oppression?

bell hooks: "Well, it's funny. I've been trying to assemble a collection of essays that are both autobiographical and critical about *death*. Because when I think about my childhood— the kind of early experiences (or what I think of as imprints) that have led me to be who I am today, they really revolve around the death of my father's mother, Sister Ray. In our work we use autobiographical experience from our childhood. I wrote this detective novel entitled *Sister Ray* (my grandmother's name is Rachel, and that's the name of the detective) and a childhood event I

really remember was my grandmother dying in the bed-room next to mine. My mother put all of us children to bed (allegedly "to take a nap") because she did not want us to know. So there was this incredible air of mystery about this, and I for one was not going to go to sleep . . .

I got to witness the men from the funeral home coming in with the stretcher, and—it's funny, but one of the things I deeply remember is the way they smelled—and to this day I have trouble with men who wear sweet colognes. But the most amazing thing was watching my mother closing my grandmother's eyes. Because I saw this and thought, "Wow—if this is death and it can be looked at and faced, then I can do anything I wanted to in life! Nothing is going to be more profound than this moment!" And I see this as a moment in time that shaped who I became . . . that allowed me to be the rebellious child I was—daring and risk-taking in the midst of my parents' attempts to control me.

R/SP: They thought they could control death by keeping it hidden—

bh: Absolutely. It's interesting to me that this intercession of death and the death of a foremother (the women who go before us) is tied to my development as an independent, autonomous woman. My father's mother lived alone: she was a powerful figure. And I talk a lot with other women about our experiences as women working to be artists—and in my own case, working not only as an artist but as a cultural critic/intellectual in a world that still isn't ready for us . . . that still hasn't adapted to who we are.

R/SP: We're all struggling to make these parts fit together into a whole. Your writing is not only philosophical and

theoretical but also informed by your personal life. One of the barriers we're trying to break down is that artificial separation between the so-called "objective" and the "subjective," the personal and the political.

bh: People have written to me about my book *Yearning: Race, Gender and Cultural Politics* saying, "It's such a heartbreaking book . . . it's so sad." I think that a lot of what's going on in my work is a kind of *theorizing through autobiography* or through storytelling. My work is almost a psychoanalytical project that also takes place in the realm of what one might call "performance"—a lot of my life has been a performance, in a way.

In an essay I wrote about Jennie Livingston's film *Paris is Burning*, which is about black drag balls in Harlem, I reminisced about myself cross-dressing years ago. I was thinking about this as a kind of reenactment of a past performance, but it's also a moment of autobiographical sharing that is a kind of *stepping* out:

There was a time in my life when I liked to dress up as a man and go out into the world. It was form of ritual, of play. It was also about power. To cross-dress as a woman in patriarchy meant, more so than now, to symbolically cross from the world of powerlessness to a world of privilege. It was the ultimate intimate voyeuristic gesture.

Searching old journals for passages documenting that time I found this paragraph: "She pleaded with him: Just once—well every now and then—I just want us to be boys together. I want to dress like you and go out and make the world look at us differently and make them wonder about us, make them stare and ask those silly questions like, 'Is he a woman dressed up like a man? Is he an older black gay man with his effeminate boy/girl/lover flaunting same-sex out in the open?' Don't worry. I'll

take it all very seriously, I won't let them laugh at you. I'll make it real 'Keep them guessing' . . . do it in such a way that they will never know *for sure*. Don't worry: when we come home I'll be a girl for you again. But for now, I want us to be boys together."

Then I wrote that "cross-dressing, appearing in drag, transsexualism, are all choices that emerge in a context where the notion of subjectivity is challenged . . . where identity is always perceived as capable of construction, invention, change."

I was thinking about this a lot, because today, even before we can have a contemporary feminist movement or a discourse on postmodernism, we have to consider "positionalities" that are shaking up the idea that any of us are inherently *anything*—that we *become* who we are. So a lot of my work views the confessional moment as a transformative moment—a moment of *performance* where you might step out of the fixed identity in which you were seen, and reveal other aspects of the self . . . as part of an overall project of *more fully becoming who you are.*

R/SP: This is very important. You write about how separatism or exclusionism really reinforces the older patriarchal hierarchy—therefore we need to analyze all the processes of separation operating within the black community, the women's community, etc. You're talking about reintegration with a whole new set of rules . . .

bh: . . . as well as different vision of *expansionism* (and not that *imperialist* expansionism that was about "Let's go out and annex more land and conquer some more people!") but about allowing the self to grow. I think of Sam Keen's popular book, *The Passionate Life: Stages of Loving,* which

declares that one wants to grow into a passionate human being, and that to some extent having fixed boundaries does not allow that kind of growth.

I really shudder when people tell me, "I only want to associate with (this little crowd)," because I think, "Well, what if what you really need in life is over there in another group? Or in another location?" It's interesting—the way in which one has to balance life—because you have to know when to let go and when to pull back. The answer is never just to completely "let go" or "transgress," but neither is it to always "contain yourself" or "repress." There's always some liminal (as opposed to subliminal) space in between which is harder to inhabit because it never feels as safe as moving from one extreme to another.

R/SP: There are lots of paradoxes to deal with; where are our lack of differences? In a Z magazine article you wrote about seeing your father beat up your mother—can you talk about that, and your feelings of murderous rage and terror mingled together?

bh: It's funny—when you reminded me of that I felt really "exposed." I know that my mother and father don't read Z and would probably never read it unless someone sent it to them, but they would be very devastated and hurt that I was exposing something about their private life to the public. And I would clarify that I talked about hitting and not beating her up. At the same time I deeply needed to express something. I was also frightened by the kind of "construction of difference" that makes it appear that there is some space of rage and anger that men inhabit, that is alien to us women. Even though we know that men's rage may take the form of murder (we certainly know that men murder women more than women murder men; that men commit most of the domestic violence in

our lives), it's easy to slip into imagining that those are "male" spaces, rather than ask the question, "What do we do as women with our rage?"

I've found that most children who have witnessed parental fighting (where a man has hurt or hit a woman) identify with the woman/victim when they retell the event(s). And I was struck that what I didn't want to retell was the fact that I didn't just identify with my mother as the person being hurt, but I identified with my father as the hurting person, and wanted to be able to really hurt him! My play daughter (who's an incest survivor) and I were talking about this recently . . .

R/SP: What do you mean by "play daughter"?

bh: When I was growing up, that was a term used in Southern black life for informal adoptions. Let's say you didn't have any children and your neighbor had eight kids. You might negotiate with her to adopt a child, who would then come live with you, but there would never be any kind of formal adoption—yet everybody would recognize her as your "play daughter." My community was unusual in that gay black men also were able to informally adopt children. And in this case there was a kinship structure in the community where people would go home and visit their folks if they wanted to, stay with them (or what have you), but they would also be able to stay with the person who was loving and parenting them.

 In my case I met this young woman, Tanya, years ago when I was giving a talk, and I felt that she really needed a mother. At the time I was really grappling with the question. "Do I want to have a child or not?" And I said, "Come on into my life: I need a child and you seem to need a mother!" And we've had a wonderful relationship; I've watched her become more fully who she's meant to

be in this world. From her talking about the experience of incest, a theory emerged: if you were in some traumatic moment where you felt a particular emotion, and then you repressed that emotion (let's say, for ten years), and didn't allow yourself to feel anything . . . then, when you open the door to those emotions you've closed off, you still have to work through that last emotion you were feeling. In other words, this is not like some other kind of emotional coming out—it's like: you've made that emotion incubate by locking it away, so when you reopen those doors, the emotion that first emerges is monstrous.

R/SP: Like facing "the belly of the beast"; facing incredible rage?

bh: Absolutely. I still think men have not fully named and grappled with the sorrows of boyhood in the way feminism gave us as women ways to name some of the tragedies of our "growhood" in sexist society. I think males are just beginning to develop a language to name some of the tragedies for them—to express what was denied them. If I imagine myself as a boy witnessing the grown father hitting the mother—well what "positionality" does the boy feel himself to be in? Clearly he doesn't think, "I'm going to grow up to be a woman who will be hit." So does he then have to fear: "I will grow up to be this person who hits—therefore I'd better live my life in such a way that I never grow up?" Like a lot of women, I feel that I've loved men who made that decision to never grow up "because then I'll become that monstrous Other." I think that's why so many men in our culture don't allow those doors to ever be opened: because there's something in the experience of boyhood they witnessed . . .

R/SP: . . . which is just too traumatic . . . Beyond merely

polarizing the men as "victimizers" and leaving it at that, we have to recognize that men are just as crippled as women. What's very liberating here is the whole notion of not identifying with victimization—that there could be an empowerment if you would just feel that rage, instead of merely shutting down and being victimized.

bh: In Toni Morrison's *The Bluest Eye* (one of my favorite novels), there's a moment when the little girl, a victim of rape/incest, says to another little girl whom she wants to be angry, "Anger is *better*—there is a *presence* in anger." I was always moved by that contrasting of victimization versus being victimized; it's important to maintain the kind of rage that allows you to *resist*.

R/PS: Yes. When I was a young girl I was petrified of horror films, particularly the psycho/slasher ones, and I'd even have dreams that they were "coming to get me." So I'd force myself to watch *Halloween*-type films where usually a male figure kills hundreds of women (or men, whatever). And I decided to try to identify with that male ... and it gave me such a sense of power. Of course, this is in the "safe" area of creative expression (film)—so it isn't like I'm going to go around killing people! But there was this incredible sense of empowerment when I realized I didn't have to identify with the victim.

bh: Certain feminist writings by lesbian women on S/M discuss what role-playing is in terms of power. A woman can take on ritualized role-playing in terms of *confronting a dragon*, and realize that in the *confrontation* of that dragon (through the role-playing), it no longer has power over you. I think it's been really hard for some feminists to "hear" that the ritualized role-playing in eroticism and sexuality can be *empowering* ... because there's such a

moralistic tendency to see it only as a disempowering reenactment of the patriarchy's sexual politics. Whereas in all forms of ritual and role-playing, if it is empowering and if one is truly only engaged in play acting, so to speak, there's the possibility of re-enacting the drama of something that terrifies you ... of working symbolically through it in a way that touches back on your real life, so that ultimately you are more empowered.

R/SP: I think that so many women really need to do this: confront those fears.

bh: In an essay on the construction of "whiteness" in the black imagination, I wrote about black people really being fearful of white people, and how it's really become a cliché or a "no-no" to talk about having that fear. I gave this paper recently at a university, and a young black man who was my host said that my paper really disturbed him—finally he had realized that he really *did* feel a certain fear of white people, without ever having thought about (or faced) that fact.

In our culture, black men are constructed as such a *threat*: they can pose on the street corner or on the street as people who are in power, in control. And the culture doesn't ever give black men a space where they can say: "Yes—*actually* I feel *scared* when I see white people coming toward me." When we think of an incident like Howard Beach, where a mob of whites killed a young black man who had "invaded" their neighborhood, we recognize that here were these black men who were not positioned in people's minds as being potentially afraid—that it might be *scary* for three black men to be in the space of dominating whiteness. Instead, all the fear was projected onto them as objects of threat, rather than as people who might inhabit a space of fear ...

There was a whole controversy around the fact that these men said that they wanted to use a telephone, and that they passed by a number of phones (which is what the opposition cited to prove that they weren't really being honest), and yet there's no suggestion that maybe they bypassed a number of phones because they were looking for a location in which they would feel greater safety. We have so little understanding about how black people fear white people in daily life . . .

Recently I was staying in New York. Sometimes I would get in the elevator and then see a white person approaching—so I'd try to hold the elevator . . . and most times they would brush me away! I would just be amazed at the idea that possibly they were afraid to go up in the elevator with me because I was black. And I thought about how afraid I am to go up in elevators with white people.

R/SP: Well, in a way blacks and other people of color become the disembodied shadows of the power structure; they symbolize the guilt the power structure can't acknowledge that is then projected on to them as fear.

bh: And I think it's really dangerous for us if we internalize those projections, because it means (and I think this has particularly been the case for black men) that we then shut off those areas of vulnerability in ourselves. It's a kind of defense to imitate those who have wounded you, because, to the degree that you become them, you imagine you are *safe*. (Or rather, to the degree that you become the way they *say* you should be, you imagine you are safe.) So I try to talk about the process of "assimilation" as a kind of mask, as an amulet almost whereby you feel, "I can ward off the evil of this by becoming it, or by appearing to be it." It's a kind of *camouflage*.

R/SP: Can you give us an example?

bh: When I enter a room where other black people are present, I might want to speak to another black person and acknowledge them—and that person might look away as if to say, "Don't think that just because we're black we have something in common." To some extent that person has decided to imitate the behavior of the larger white culture that says, "Color is not important . . . don't use *that* as a basis for bonding." And the fact is: the person may imagine that by adopting that behavior they're safer, they're more *part of the group* . . . when in fact we know that they're not necessarily safe, and that their safety might actually come from bonding with the other person of color.

I think the same can be said of women who enter spheres of power, and who feel, "It's important for me never to show bonding or allegiance to another woman, because that will show I'm weak." Whereas the irony is: we're more strengthened when we can show the self-love expressed through bonding with those who are like ourselves.

R/SP: It's always threatening to the male power structure when women get together and are friends.

bh: And I think right now we're at a historical moment when we all have to talk about "How can I be bonded with other black people in a way that is not constructed to be oppressive or exclusionary to other people?" I think that this can be viewed as a *magical moment*: "What does it mean to try to affirm someone, without excluding somebody else?"

I gave a talk at Barnard College in front of a large audience, and a black woman who came in late seemed

somewhat distressed. I wanted to reach out to her and say, "Hey, you're really welcome here, I'm glad to see you!" (And I always think, "How do you do that in such a way that you don't make other people feel that somehow her presence is more important than anybody else's?" Because it isn't—all the presences are important. So I always try to give off a real aura of warmth and welcome to everyone.) When she came in, I walked over and stuck out my hand to her and . . . I got this sweet letter from her saying that this action meant so much to her: "I was stunned by the spontaneous lovingness of the gesture you made toward me. It will take some time before I fully internalize the lessons of relatedness and sisterhood it showed me."

Part of what I try to express in my work is that racism, sexism, homophobia, and all these things really wound us in a profound way. Practically everybody acknowledges that incest is wounding to the victim, but people don't want to acknowledge that racism and sexism are wounding in ways that make it equally hard to function as a Self in everyday life. And . . . something like having a person reach out to you with warmth can just be healing . . .

R/SP: I think a lot of people need integrating philosophies now. Things are so alienated, fascistic, and polarized—it's very sad that we're all sort of "Displaced Others" . . . Everyone who really wants to change the world needs so much to be bonded together with our differences, instead of separated.

bh: That was one of the ideas I tried to express when I chose *Yearning* as a book title. At dinner last night when I looked around me across differences, I wondered, "What is uniting us?" All of us across our different experiences were

expressing this longing, this deep and profound yearning, to just have this domination *end*. And what I feel unites you and me is: we can locate in one another a similar yearning to be in a more *just* world. So I tried to evoke the idea that if we could come together in that site of desire and longing, it might be a potential place of community-building. Rather than thinking we would come together as "women" in an identity-based bonding we might be drawn together rather by a *commonality of feeling*. I think that's a real challenge for us now: to think about constructing community on different *bases*.

Eunice Lipton, a woman art historian, said, "What would it mean for us to look at biography not from the standpoint of people's accomplishments, but from what people *desired*." I thought, "Wow, what a different way to conceptualize life and the *value* of life." Again, this goes away from the imperialist model where you're thinking of life in terms of "who or what you have conquered?" toward: "what you have actualized *within* yourself?" So her question concerned: "What if biography were to tell about *desire*, not achievement—then how would we tell a woman's life?" I think that's really powerful.

R/SP: Our identities are so constructed that you hit a brick wall if you attempt to say what women "are," because one can always think of exceptions. All constructed identities such as "Black" or "Chicano" are sort of negative identities against the world of white WASP "ideals." For many women, what bonds us is: what is *against* us.

bh: Right, and that's not enough to build community upon— one has to build community on much deeper bases than "in reaction to." You heard about the Korean woman shopkeeper and the young black woman she murdered? In Los Angeles, this woman came into the store, took

some juice and put it in her backpack, then held out the money to pay for it and was shot to death by the shopkeeper (who claimed she was being attacked). But when the video was replayed, people could see clearly that she was not being attacked. And this can become the way relations between Korean/ Asian women and black women are projected. Those of us who have had very different kinds of relations (where we've learned about one another's cultures) haven't been vocal enough to propagate a representation that counters this—so that we see it for the individual moment of madness it is, rather than a representation of black/Asian relations.

When Vietnamese filmmaker and theorist Trinh T. Minh-ha and I come together in love and solidarity, it's usually in private spaces—in our houses, where we talk about what we share, the cultures we come from and ways they intersect. And one challenge I put forth is: it's no longer enough for us to do that—we need to also come out of those houses and name our solidarities publicly with one another.

I became fascinated by how a lot of the stereotypes for Asian women ("passive," "nonassertive," "quiet") are just the opposite of the stereotypes that plague black women ("aggressive," "loud," "mean"). It's like we exist in two radically different poles in the economy of racism. And it's those positionings that make it hard for Asian women and black women to come together . . . but I think we have to be more public in naming the ways that we dare to cross those boundaries and come together.

R/SP: Right. Wanda Coleman said that when she goes to a party and is the only black woman there, suddenly she has the burden of being the "representative of black culture,"

particularly with well-meaning "liberal" types, and that this was exhausting—she just wanted to have a *good time!*

bh: Right. You may think of race as just one facet of "who they are," but that facet doesn't mean they inherently know the "collectivity"! I went to a dinner party where a young white woman who seemed to be an admirer of my work wanted to sit next to me . . . but immediately she said, "I'm having problems with my black woman roommate, and I just wanted to know if you could tell me why she's behaving this way." I replied, "You know, if you wanted to know about Buddhism, would you grab the first Buddhist priest you met and say, 'Really tell me all about it in the space of a half hour'?"

I think that often when it comes to race or meaning *across* difference, people just lose their rational capacity to know how to approach something—I think a lot of white people give up their *power of knowing.* As soon as I said that to this young woman, she knew she should learn more about black culture and black history herself—not think she should go to some other black person to solve this problem. I asked her, "Why would I understand this situation better than you, when you're in it?" But on her part there was this whole sense of: "As a white woman, I couldn't possibly understand what a black woman is going through," when in fact (as Vietnamese Buddhist monk Thich Nhat Hanh says) understanding comes through our capacity to empty out the self and identify with that person whom we normally make the Other. In other words, the moment we are willing to give up our own ego and draw in the being and presence of someone else, we're no longer "Other-ing" them, because we are saying there's no space they inhabit that cannot be a space we can connect with.

R/SP: These days relationships are so superficial, clichéd, and stereotyped . . . but if anyone really talks to somebody, after ten minutes one forgets or loses one's self in that other person's emotions.

bh: When people ask, "How do we deal with difference?" I always refer them back to what it means to fall in love, because most of us have had an experience of desire and loving. I often say to people, "What do you do when you meet somebody and are attracted to them? How do you go about making that communication? Why do you think that wanting to know someone who's 'racially' different doesn't have a similar procedure?" It's like if I saw you on the street and thought you were cute, and I happened to know someone who knew you, I might say to that person, "Oh wow, I think so-and-so's *cute*. What do you know about them?" I think that often the empowering strategies we use in the arena of love and friendship are immediately dropped when we come into the arena of *politicized difference*—when in fact some of those strategies are useful and *necessary*.

I mean, how many of us run up to somebody we are attracted to and say, breathlessly, "Tell me all about your-self right away." We usually try to *feel out* the situation. We don't want to alienate that person: we want to approach them in a manner that allows them to be open to us . . . giving to us. I think it's interesting that often when *difference* is there (like a racial difference or something), people *panic* and do crazy, bizarre things . . . or say crazy, stupid things.

R/SP: Within any politicized group that is formulating a platform for social change (claiming "gayness" or "polit-ical correctness"), well, what does that really mean? For example, if you're in ACT UP, you can have less in

common with a Republican gay than with a "straight" political anarchist.

bh: Absolutely. I said something similar about the film *Paris Is Burning*: even though the subject matter *appears* "radical," it doesn't necessarily *mean* it's radical. Just to portray marginalized black gay sub-culture is not necessarily to be giving a portrait of subversion and oppositional life. One has to question more deeply what authentic terms of opposition might mean for any of us in our lives.

R/SP: Particularly in this society which has appropriated all the forms of rebellion ... where you have Lee Atwater playing the blues.

bh: Absolutely. My friend Carol Gregory made a video of Lee Atwater which contrasts him talking about how much he loved black music, with examples of the political racism he generated. The separation was so intense ...

R/SP: He fomented the most flagrant racism.

bh: Yes. She said, "This is what's so tragic ... that he was not able to allow his fascination with black music to alter his perceptions of race." This also reminds us how easily we can appropriate and commodify an aspect of a people's culture without allowing any personal transformation to take place—I mean, he was not transformed by his involvement in black music! A lot of what's happening now with Madonna and black culture is also raising those kinds of questions.

R/SP: When I saw Lee Atwater with Chuck Berry, there was such an implied colonialism—a certain "slumming" quality as he was "playing the blues" with these black musicians. You felt that the power structure had not been breached whatsoever.

bh: And yet, when I read recently of his death from a brain tumor, I kept wondering to what extent his inhabiting the *schizophrenic positionality* had affected his physiological well-being.

R/SP: When he found out he had brain cancer, apparently he had a genuine realization that he was going to die, and tried to apologize to all the people he had hurt.

bh: One of the myths of racism in this society and patriarchy is: "Those who oppress, do not suffer in any way." Yet, if we just look closely, we see that this—the most materially luxurious country on the planet—is beset by all forms of disease and ill health. This in itself is such an *interrogation* of the price people have had to pay for what has been taken in conquest.

R/SP: And people are so profoundly lonely. I saw this commercial that struck me like a brick, about a hospital outreach program for alcoholism, drug abuse or addiction in general. It cited this statistic: "One out of four people will have a mental breakdown." I thought: "What a claim for this society!"

bh: And of course we never know about black people or people of color who are breaking down (in some way or another) every day, because the political forces we contend with in everyday life are so grave that they render us helpless. There's no way even to chart those breaking-downs, those dysfunctionalities, those moments when people just feel like—as black woman law professor Patricia Williams wrote in an essay, "There are days where I *just don't know* ... I look at myself in a shop window and I think, 'Is this crazed human being *me?*' I don't know who I am." And she talks about how all the effort it takes—the forces involved in just *dealing* with

sexism and racism and all those things—can just destroy our sense of grounding.

R/SP: You were talking about black women professors and hair loss.

bh: It's interesting that while a lot of professional black women in this society have achieved a great deal, a major factor undermining that achievement is stress. One of the things about stress as a response to racism, homophobia, sexism . . . is that it's not something you can chart. I think about a black woman in a high-powered job who may be losing her hair—she may start wearing scarves or hats and nobody sees that—nobody registers the crisis she may be in. But it may be made visible by all kinds of psychological breakdowns that are happening to her.

R/SP: In the nuclear family structure, dysfunction is intrinsic. women in the 40s and 50s were always having "nervous breakdowns"—that was part of the "culture."

bh: In her film, Privilege, Yvonne Rainer shows how the white medical establishment dealt with menopause and how women were constructed as hysterical, sick, breaking-down human beings. She also ties that to how we look at race and difference.

R/SP: As a response to this society, which is so unhealthy, anyone with any sensitivity at all has to embody some form of madness.

bh: Absolutely, and I've written a lot about the necessity for black people to decolonize our minds. One of the things that happens when you decolonize your mind is that it becomes hard to function in the society, because you're no longer behaving in ways people feel comfort-able with. For example, white people are often much

more comfortable with a black person who doesn't ask any direct questions, who acts like they don't know anything—who appears *dumb*—in the same way that men are often more comfortable with a woman who doesn't appear to have knowledge, strength, power, or what have you—who assumes a positionality of, "Oh, I don't know what I'm doing." And when that person becomes empowered, it can totally freak out the people that they're with, and around, and work for.

On the other hand, when you begin to move out of the dysfunctionality (as we know from our movements of recovery) . . . when you begin to change toward health in a dysfunctional setting, it becomes almost impossible to remain in that setting . . . yet here we are in a whole dysfunctional society with *nowhere to go!* So I feel that we have to create what Thich Nhat Hanh calls "communities of resistance"—so that there are places where we can recover, and return to ourselves more fully.

R/SP: Can you explain this more?

bh: Well, he's created this village in France called Plum Village. It's a place where different people go and grow things, and live a "mindful" life together. Sometimes I get really distressed by the extent to which we, in the United States, have moved away from the idea of *communities*—of people trying to have *different* world views and value systems. In the 60s there was a lot of focus on such communities, but that sort of died out, and a refocus on the nuclear family emerged.

In fact, the whole focus on "yuppiedom" was really like a public announcement: "If you want to be cool, you'll return to the patriarchal nuclear family!" And we know that small alternative communities of people still exist, but they don't get a lot of attention. If I think about

the communities that have gotten a lot of attention from the mass media (such as Rajneesh town in Oregon), it was always *negative* . . . never attention on shared worship, shared eating of vegetables (and not being meateaters), or being peace-loving—*that's* not the attention it got. But whenever something goes wrong . . .

R/SP: . . . the media are right there to report it. However, many "alternative" societies in the 60s brought their same dualistic oppressional thinking to their would-be "paradise"—they just inverted it a little, but it became just as oppressive.

bh: Even then, though, the question becomes: "Do you give up on making the beloved community . . . or do you realize that you must make it a different way?" Because I feel what happened was: a lot of people took the failures of the 60s as a sign that, "See—you cannot really *make* an alternative space." Whereas I'm convinced that you can . . . if, as you say, you have changed your consciousness and your actions *prior* to trying to create that space.

I think that when we enter those new spaces with the same old negative baggage, then of course we don't produce something new and different in those spaces! It's like—I remember going to this town and working with a number of other black women. I said to them. "We should buy a building together. Why should we all be paying rent to some nasty white landlord?" And they all looked at me and said weird shit like, "Why would we *want* to live in the same space? What about *privacy*?" They raised all these negative issues and I realized, "These people would rather be victimized than think about taking some agency or control over their lives." And all the values that were being raised (such as "privacy" or "individualism") were really myths—I mean, what privacy do

we really have? I didn't feel I had any privacy in my little building where my landlady watched my comings and goings like a hawk. I didn't feel I had any autonomous existence there. Because this wasn't a *helpful* watching—it wasn't like someone who cared about me was watching me, wanting my life to be richer and fuller, you know?

R/SP: Right. "Privacy" in this country is usually just a euphemism for extreme loneliness, alienation, and fragmentation.

bh: And privacy becomes a way of saying, "I don't want to have to attend to something outside of myself." So it really becomes a screen for a profound *narcissism*. And people "privilege" this narcissism as though it represents the "good life." A lot of people will say to me, "How can you live in this small town of 8,000? It would just drive me nuts for people to *know* me and to run into people." And I say, "Well, you know, if you live your life in the open . . ."

I love that pulp book by M. Scott Peck, *The Road Less Traveled*. He has an incredible fun section on *lying*, where he says that if you are dedicated to truth and you live your life without shame, then you don't really have to care whether your neighbors can see what you're doing . . . I feel I don't really care if people can see how I live, because I *believe* in how I live, I believe that there is beauty, and joy, and much that is worthy of being *witnessed* in how I live. And I consider it a sign of trouble and confusion when I start needing "privacy" or to hide.

I think about how privacy is so connected to a politics of *domination*. I think that's why there's such an emphasis in my work on the *confessional*, because I know that in a way we're never going to end the forms of domination if we're not willing to challenge the notion of *public* and *private* . . . if we're not willing to break down the walls that

say, "There should always be this separation between domestic space/intimate space and the world outside." Because, in fact, why shouldn't we have intimacy in the world outside as well?

R/SP: I really believe in the idea that people break down the power structure through the confessional ... that just telling the truth in a society that's based on lies, is a radical act.

bh: Yes—a culture of lies.

R/SP: And truth is also liberatory. The very thing one lies about is usually something one is *ashamed* about. And this shame basically enslaves people to the status quo. For example, in the 50s blacks were trying to be white; they were actually ashamed of their blackness, whereas *racism* should have been the thing to be ashamed of. Or, take a woman who is ashamed of being sexually active and feels "used."

bh: Also, I think that only in a truly supportive environment can we know the real meaning of privacy or "aloneness." Because the real meaning is not about secrets or clandestine activity: I think that "real" (I'm struggling with the word "real") or "authentic" privacy has to do with being capable of being alone with one's self. And one of the sadnesses of a culture of lies and domination is *so many people cannot be alone with themselves*. They always need the TV, the phone, the stereo—*something* . . . because to be alone with the self is to possibly have to see all the stuff we spend so much of our time trying not to face.

R/SP: Right. It's the things we don't want to face that enslave us. So it's very liberatory to say, "Well, this is who I am." There's something very cathartic and transformative in accepting all the victimizations we've gone through.

Somebody described their incest as a "wall of shame." It's incredibly liberatory to "come out" of the closet of shame.

bh: That's why I like that book *Shame: The Power of Caring*, by Gershen Kaufman, because one of the things the author says is: There's no experience that we cannot heal . . . there is no space where we cannot be reconciled . . . but we can never be reconciled as long as we exist in the realm of denial, because denial is always about *insanity*. And sanity is so tied to our capacity to face reality.

I remember when I was really struggling around my own issues with men and with my father. One day I called up my mother (I think I was 22) and was crying, "Daddy didn't love me!" Usually my mother would say, "Of course he loved you: he did this and that . . ." But this time, after an hour of tortuous conversation, she suddenly said, "You're *right*—he *didn't* love you, and I never understood why." And that moment of her acknowledging the truth of what I had experienced was such a moment of relief! The moment she affirmed the reality of what had taken place, I was *released*, because somehow what we all know in our wounded childhood experiences (what the Swiss psychoanalyst Alice Miller tried to teach us) is: it's the act of *living the fiction* that produces the torturous angst and the anguish . . . the feeling that you're mind-fucked. I was watching Hitchcock's *Spellbound* again and I love it when that moment of truth—breaking through denial and reentering one's true reality—becomes the hopeful moment, the promise: when we can know ourselves and not live this life of running in flight from reality.

R/SP: When you were talking about being raised in the black community, I was reminded of Philippe Ariès' *Centuries of Childhood*.

bh: One of my favorite books in the world.

R/SP: In the Middle Ages, children weren't raised in a nuclear family, but in a healthier extended family.

bh: Something I think a lot about is the question of destiny. It seems that this technological society tries to wipe out cultures who believe in forces of destiny . . . who believe there are forces moving in our lives beyond ourselves. Because such beliefs suggest that one could never be confined to the realm of one's skin, or one's nuclear family, or one's biological sexuality (or what have you), because one has so much awareness that there are forces beyond at work upon us in the universe. And I think that part of what man's technological society tries to do is to deny and crush our knowing of that, so that we lose ourselves so easily.

I think that ironically, despite all its flaws, religion was one of those places that expanded our existence. The very fact that in the Christian religion Jesus made miracles, well, kids growing up in the Christian Church may learn all this other reactionary dogma, but they'll also learn something of an appreciation for mystery and magic. I was talking to an Indian Hindu woman friend whose son is fascinated with Christianity, and I said, "Yeah, those stories fascinated me, too!" He's into David and Goliath, Moses parting the Red Sea . . . Not only are those stories fascinating, but they also keep you in touch with the idea that there are forces at work on our lives beyond our world of "reason" and the intellect. So this turning away from religion (in black culture from traditional black religion) has also meant a turning away from a realm of the sacred—a realm of mystery—that has been deeply helpful to us as a people.

This is not to say that one only finds a sense of the

sacred in traditional Christian faiths, because I find this in the realm of spirituality and in the realm of occult thinking as well. It just seems to be a very tragic loss when we assimilate the values of a technocratic culture that does not acknowledge those high forms of mystery or even try to make sense of them.

Part of what people like Fritjof Capra (author of The Tao of Physics) are doing is reminding us that a true technological world has respect for mystery. I think they're trying to reclaim the aspect of physics and science that in a sense was suppressed by the forces, the mentality, that would only dominate and conquer.

R/SP: "New science" seems almost to be confirming older occult postulations. The newest physics, astronomy, or "super string" theories sound so much like cabalistic notions.

bh: Absolutely! Historically, when we study the lives of someone like Madame Curie, we discover that in fact it isn't just logical scientific methodology that allows her to make her "grand discovery," but the work of the imagination. And with Einstein, we see the role of mystery in the discovery of things as opposed to this notion that everything can be worked out in a logical paradigm.

R/SP: Some writers like Evelyn Fox Keller (Reflections on Gender and Science) and Donna Haraway discuss how the philosophy of science has been informed by a patriarchal colonialist mentality, and how that's being reformulated by different perspectives like feminism ... I wanted to talk more about black community.

bh: One of the more important things I want to say is it wasn't just that I grew up in a black community, but that I grew up in a caring black community—again, we don't

want to get stuck in false essentialisms . . . I don't want to suggest that something magical took place there *because* everyone was black—it took place because of *what we did together* as black people.

I was in Claremont, California with a black cultural critic from England. Every day we would take walks, and be the only people on the street. I felt like we were in the *Twilight Zone*, because there were all these grand houses with lovely porches, but we never saw any people. And I was reminded of growing up in a small town of black people, Hopkinsville, Kentucky, on the black side of town where if you went walking you would always be able to greet people on their porches and talk with them and spread messages. Some elderly person might say, "When you get to so-and-so's house, tell them I need a cup of sugar!" There was this whole sense of being connected through that experience of journeying, of taking a walk.

But where I live now, when I walk to my friend's house I won't see people out. Even though this is a small town and everyone has these grand porches, people will not be outside—the whole bourgeois notion of "privacy" means they don't want to be seen—and they particularly don't want to have to talk to strangers. Yet at least we have more communication around issues of "race" and "difference" than in most Midwestern towns, because of the Underground Railroad having gone through here, and the old black community that still exists in Oberlin, Ohio. Nevertheless, a lot of people who come here to college from New York City or other cities just think it's horrifying to be seen daily by the same people.

R/SP: Yet if you walk through a lot of ethnic, Jewish, Hispanic, or black neighborhoods in New York, usually the older

people still take their chairs and sit out on the street with their coolers—that's their living room. They talk to people, and it's really quite wonderful and relaxed.

bh: I struggle a great deal with the phone, because I think the telephone is *very dangerous* to our lives in that it gives us such an illusory sense that we are *connecting*. I always think about those telephone commercials ("reach out and touch someone!") and that becomes such a false reality—even in my own life I have to remind myself that talking to someone on the phone is *not* the same as having a conversation where you see them and smell them.

I think that the phone has really helped people become more privatized in that it gives them an illusion of connection which denies looking at someone. Telephone commercials can be "great" because they actually let us see that person on the other end—see how they respond and give of this warmth that is never really conveyed just through the phone, so that we're not just having a diminished experience of the nonperson you don't really see on the other end. And it's hard to always remember this—because we're seduced. I love Baudrillard's book *Seduction*, because he talks a lot about the way we're seduced by *technologies of alienation*. We know that all technologies are not alienating, so I think it's good to have a phrase like "technologies of alienation" so that we can distinguish between those ways of transmitting knowledge, information, etc. and other ways of knowing that are more fully meaningful to us.

R/SP: Don't you think that in our addictive culture, these seductions set up addictions which can never be satisfied? The telephone gives this impossible promise of connections; its "900" numbers promise a simulation of friendship and community (like a long-distance nightclub) which

can never be fulfilled. An incredible sense of longing and desire is evoked.

bh: Absolutely. When I spoke at a conference on the "War on Drugs, "I tried to talk about how a culture of domination is necessarily a culture of addiction, because you in fact take away from people their sense of agency. And what restores to people that sense of power and capacity? Well, working in an auto factory in America right now gives few workers a sense of empowerment. So how do you give them an illusory sense of empowerment? We could go to any major plant in America and look at what people do. And a lot of what people do when they get off work is drink. Many of the forms of "community" (set up to counteract the forces of alienation on the job) are tied to addiction. Because the fact is it's simply not gratifying to work fuckin' hard ten hours a day for low wages and not really be able to get the thing you need materially in life.

In fact, if people weren't seduced by certain forms of addiction, they might rebel! They might be depressed, they might start saying, "Why should any of us work ten hours a day? Why shouldn't we share jobs and work four hours a day and be able to spend more quality time for ourselves and our families? Why shouldn't workers who don't know how to read be able to go to a job where you spend four hours working and another four hours looking at movies and having critical discussions?" I don't know of any industry that has tried to implement those kinds of self-actualization moments in the experience of workers engaged in industrial work in this society.

R/SP: What do you think are the underlying mechanisms of the "Drug War"?

bh: I think the mechanisms of the Drug War have so much
 to do with the mechanisms of capitalism and money-
 making. Also, many people have shown the ways in which
 our state and our government are linked to the bringing
 in of masses of drugs to pacify people—starting with
 drugs like aspirin which make people feel like "you
 shouldn't have any pain in your life" and that "pain
 means you're not living a successful life." And I think this
 is particularly hard to take. Black people and the black
 community have really been hurt by buying into the
 notion that "If I'm in pain, I must be a *miserable* person,"
 rather than, "*Pain can be a fruitful place of transformation.*"

 I think that early on, in the black communities I grew
 up in, there was a sense of redemptive suffering. And it's
 really problematic for us to lose that sense. James Baldwin
 wrote in *The Fire Next Time* that "If you can't suffer, you
 can never really grow up—because there's no real change
 you go through." Back to M. Scott Peck who tells us that
 "All change is a moment of loss." And usually at a
 moment of loss we feel some degree of sorrow, grief—
 pain, even. And if people don't have the apparatus by
 which they can bear that pain, there can only be this
 attempt to avoid it—and that's where the place of so
 much addiction and substance abuse is in our life. It's in
 the place of "let me not feel it" or "let me take this drug
 so that I can go through it without having to really feel
 what I might have had to feel here." Or, "I can feel it . . .
 but I'll have no memory of it."

R/SP: And ultimately we go back to the whole issue of anger: to
 "not feel it so I won't erupt with the kind of anger that
 pain has caused."

bh: I think that's it precisely. What I see as the promise is:
 those of us who are willing to break down or *go through* the

walls of denial to build a bridge between illusion and reality so that we can come back to our selves and live more fully in the world.

R/SP: What do you write?

bh: I started out writing plays and poetry, but then felt I'd received this "message from the spirits," that I really needed to do feminist work which would challenge the universalized category of "woman." Years ago certain ideas were prevalent in the feminist movement, such as "Women would be liberated if they worked." And I was thinking, "Gee, every black woman I've ever known *has* worked (outside the home), but this hasn't necessarily meant *liberation*." Obviously, this started me posing questions: "*What* women are we talking about when we talk about 'women'?"

So I began doing feminist theory challenging the prevailing construction of womanhood in the feminist movement. I wrote *Ain't I a Woman: Black Women and Feminism*, which initially met with tremendous resistance and hostility because it was going against the whole feminist idea that "Women share a common plight." I was saying that, in fact, women don't share a common plight solely because we're women—that our experiences are very, very different. Of course, *now* that's become such an accepted notion, but twelve years ago people were really pissed.

I remember people being enraged because the book challenged the whole construction of white woman as victim, or white woman as the symbol of the most oppressed ... or *woman* as the symbol of the most oppressed. Because I was saying, "Wait a minute. What about *class* differences between women? What about racial differences that in fact make some women more powerful

than others?" So that's how I started out. I continued to do my plays and my poetry, but my feminist theory and writings became better known.

R/SP: And you're also a professor?

bh: Yeah, although I'm on a leave of absence. It's funny, lately I've been thinking a lot, because I'm having this life crisis right now and I'm just trying to pause for a moment—I call this a "pausitive life crisis" . . . I'm taking this time to focus more on creative work and on questions of performance. I have a desire to write little mini-plays and performances, dramas that can be acted out in people's living rooms.

I'm really into the *deinstitutionalization* of learning and of experience. The more I've been in the academy, the more I think about Foucault's *Discipline and Punish: The Birth of the Prison* and the whole idea of how institutions work. People have this fantasy (as I did when I was young) of colleges being liberatory institutions, when in fact they're so much like every other institution in our culture in terms of *repression* and *containment*—so that now I feel like I'm trying to break out. And I've noticed the similarity between the language I've been using, and the language of people who are imprisoned, especially with regard to that sense of what one has to recover after a period of confinement.

R/SP: I like your idea that theory *can* be liberating, but that so often it's encased in a language *so* elitist as to be inaccessible. In the lecture I saw, the ideas you presented seemed so understandable. Plus, it seemed you brought your heart and soul to the "lecture" format.

bh: That's where I think *performance* is useful. In traditional black culture, if you get up in front of an audience, you

should be performing, you should be capable of moving people, something should take place—there should be some total *experience*. If you got up in front of an audience and were just passively reading something, well, what's the point?

R/SP: Right. Why not listen to a tape recording?

bh: There has to be this total engagement, an engagement that also suggests dialogue and reciprocity between the performer and the audience that is hopefully responding. I think about theory; I use words like "deconstruction." Once someone asked me, "Don't you think that these words are alienating and cold?" and I said, "You know, I expect to see these words in rap in the next few years!"

In my book, *Yearning*, I talk about going home to the South and telling my family that I'm a *Minimalist* ... explaining to them what the significance of Minimalism is to me (in terms of space, objects, needs and what have you). Because meanings can be shared—people can take different language and jargon *across* class and across experiences—but there has to be an intermediary *process* whereby you take the time to give them a sense of what the meaning of a term is. You've got to be able to express that complicated meaning in language that is plainer or translatable. This doesn't mean that people can't grasp more complex jargon and utilize it—I think that's what books like *Marx for Beginners* had in mind: if you give people a basic outline or sense, then you are giving them a tool with which they can go back to the primary text (which is more "difficult") and feel more at home with that.

R/SP: Do you feel that you as a black woman are changing things in the academy?

bh: Black women change the process only to the degree that we are in revolt against the prevailing process. However, the vast majority of black women in *academe* are *not* in revolt—they seem to be as conservative as the other conservatizing forces there! Why? Because marginalized groups in institutions feel so vulnerable. I've been rereading Simon Watney's *Policing Desire*, and thinking a lot about how I often feel more policed by other black women who say to me: "How can you be out there on the edge? How can you *do* certain things, like be wild, be inappropriate? You're making it harder for the rest of us (who are trying to show that we *can* be 'up to snuff') to be 'in' with the mainstream."

R/SP: So it's like an assault from both sides. You were talking about the "internalization of the oppressor" in the minds of the colonized.

bh: Simon Watney was talking about marginalized communities who will protest certain forms of domination (like the notion of "exclusion/inclusion" whereby they are excluded) but then invent their *own* little group wherein the same practices determine who is allowed into their "community." We see that happening now with the recent return to a black cultural nationalism where a new, well-educated, cool, chic, avant-garde group of black people (who perhaps five years ago had lots of white friends or mixed friends) now say, "I really want to associate *only* with black people" or "black people and people of color."

 I'm very much into the work of Thich Nhat Hanh; I consider him to be one of my primary teachers and have been reading him for years. He talks a lot about the idea of resistance to the construction of false frontiers—the idea that *you* make or construct someone as an enemy

who you have to oppose, but who in fact may have more in common with you than you realize. However, in this society it's easier for us to build our sense of "community" around sameness, so we can't imagine a gay rights movement where eighty percent of the people might be nongay!

I was working from Martin Luther King's idea of the "beloved community" and asking, "Under what terms do we establish 'community'?" How do we conceptualize a 'beloved community'? King's idea was of a group of people who have overcome their racism, whereas I think more of communities of people who are not just interested in racism, but in the whole question of domination.

I think it's more important to ask, "What does it mean to inhabit a space without a culture of domination defining how you live your life?" In Thich Nhat Hanh's book The Raft Is Not the Shore (1975) he says that "resistance at heart must mean more than resistance against war. It must mean resistance against all things that are like war." And then he talks about living in modern society . . . how the way we live threatens our integrity of being, and how people who feel threatened then construct false frontiers: "I can only care about you if you're like me. I can only show compassion toward you if something in your experience relates to something I've experienced."

We see an expression of this in Richard Rorty's book Contingency, Irony and Solidarity, where he argues that white people in America can be in solidarity with young black youth if they stop seeing them as "young black youth" and look at them as Americans, and declare, "No American should have to live this way." So it's a whole notion of "If you can find yourself in the Other in such a way as to wipe out the Otherness, then you can be in harmony."

But a "grander" idea is "Why do we have to wipe out the Otherness in order to experience a notion of *Oneness*? I'm sort of a freak on the left in that I'm really dedicated to a spiritual practice in my everyday life, yet I'm also interested in transgressive expressions of desire.

R/SP: Like what?

bh: *"Like what?* she says! Well, for example, I just had this fling with a 22-year-old black male. A lot of people felt, "This is politically incorrect. This person isn't political; he's even got a white girlfriend. How can you be non-monogamous in the age of AIDS?" Likewise, if you say you have a spiritual practice, people immediately think you're plugged into a total good/bad way of reading reality.

R/SP: Or that you can't have a wild sex life . . . You're older and he's younger, so you're breaking an "age" taboo?

bh: Actually, less the taboo of age than the taboo of being involved with somebody who isn't involved with my work, who doesn't talk, and who's not politically correct.

R/SP: Almost as if *you* could be the exploiter?

bh: No! Rather, "You're letting us down. How could you be involved with a sexist terrorist?!" Because from jump I wasn't trying to pretend that this guy was a wonderful person—I said he was a "terrorist"—referring to people who are into "gaslighting," that great old term we should never have abandoned: men who seduce a woman, and just when you think you're in heaven, they suddenly abandon you. The syndrome of seduce and abandon, seduce and betray. This theme really was popular in Hitchcock movies.

I like that term "gaslighting"; I want to recover it. It makes me think of emotional minefields, of someone

you might actually have this ecstatic experience with, someone who inspires in you feelings of belonging and homecoming, you're walking along and suddenly you get blown up! Some part of you falls away, and you real-ize that all along this has been part of the other person's agenda: to give you a sense of belonging and closeness, then disrupt it in some powerful way. Which is what I think sexual terrorism does . . .

In a more general sense, in this country I always relate terrorism to the idea of *sugar-coated fascism*: where people really think they are free, but all of a sudden discover that if you cross certain boundaries (for example, decide you don't want to go fight in that Gulf War), suddenly you find you can be blown up—some part of you can be cut off, shot down, taken away . . .

I think about the soldiers that people were spitting on—the ones who *don't* want to happily get on planes and go kill some Iraqis . . . just how quickly their whole experience of "America" was altered in the space of, say, even a day. If you juxtapose the notion of "Choice/ Freedom of Will" (that mythic projection) against the reality of what it means to say, "Well, I really would like to exercise my freedom in this *democracy* and say that I don't really support this war, and I don't want to go to it!" then WHAM! You find out there really was no such free-dom, that you really *had* signed up to be an agent of White supremacy and White Western Imperialism globally—and that you get punished quickly if you choose against that!

R/SP: This really was a white supremacist war, yet the way it was presented on TV sidestepped that reality.

bh: It's funny, because I was just talking with a friend about *Dances with Wolves*. We were disturbed because so many

"progressive" people had been seeing this film, crying, and saying what a wonderful film it is. And while it is one of the best Hollywood representations of Native Americans, the fact remains that the overall package is completely pro-war, completely conservative.

I was interested in this, and my book *Black Looks: Race and Representation* has an essay that examines the whole history of Africans coming to the so-called "New World," and the kind of bonds that developed between Africans and different nations. All of a sudden we began to think of Native American Indians as lightskinned people with straight hair, whose cultures have nothing to do with African American (or any African) culture . . . when in fact, in the 1800s and early 1900s, there was still lots of communication—a lot of black people joined Native American nations legally. You could declare yourself a citizen of a particular nation.

R/SP: Do you have any thoughts regarding the presentation of people of color in mass media?

bh: I think one of the dilemmas in film or performance for people of color is it's not enough for us just to create cultural products in reaction to prevailing archetypes—we must try to create the *absences* in Hollywood cinema. For example, we think a Spike Lee film is "good" because it has different images from what we've seen before. But we need more than merely "positive" images—we need *challenging* images. When people say to me, "Well, don't you think that at least Spike Lee's telling it like it is?" I say, "You know, the function of art is to do more than tell it like it is—it's to imagine what is *possible*."

R/SP: To tell what *could be*.

bh: Yes. And I think that for all people of color in this culture

(because our minds have been so colonized) it's very hard for us to move out of that location of *reacting*. Even if I say, "I'm going to create a drama where Asian women's sexuality is portrayed differently than the racist norm," I'm still working within that sense of, "We only respond to the existing representation." Whereas actually, we need some wholesale reenvisioning that's outside the realm of the merely reactionary!

I'm fascinated by the appearance of transgression in an art form that in fact is no transgression at all. A lot of films *appear* to be creating a change, but the narrative is always so "sewn up" by an ending which returns us to the status quo—so there's been no change at all. The underlying message ends up being completely conservative.

R/SP: Can you think of any examples in mass media that work in a positive way?

bh: We haven't seen enough. Black heterosexuality in cinema and television is always basic, funky, and sexist, like in *Mo' Better Blues* by Spike Lee where nothing different takes place—even though we know that people's real lives can have far more complex constructions. For example, nobody says, "Let's have different arrangements—I don't think I want to be monogamous. Let's reorganize this." A location where one *can* imagine possible different constructions is performance art. We think of Whoopi Goldberg's early performances when she took on many different identities, such as the "bag lady" she gave voice to.

There was a point in my life when I needed a therapist. I was involved in this horrible, bittersweet life with a black male artist/intellectual. There was no one I could go to and say, "This is what's happening to me, and I have no apparatus for understanding it." So I *invented* this figure:

this therapist, this healer, and I could get up and do an improvisational performance on this persona. I realized you could invent something you need.

I was just reading a quotation from Monique Wittig's *Les Guérillères*: "There was a time when you were not a slave," which evokes the idea of *remembering who you were*. I was thinking about being in that emotionally abusive, bittersweet relationship, and was trying to remember when I was *not* in the matrix like that. But coming from a family where I had been routinely tortured and emotionally persecuted, it was hard for me to even imagine a space where I wasn't involved with people who seduce and betray—who make you feel loved one minute, and then pull the rug out from under you the next—so you're always spinning, uncertain how to respond. The point is: performance art, in the ritual of inventing a character who could not only speak through me but also for me, was an important *location of recovery* for me.

R/SP: As far as the position of women or people of color goes, it seems that the deception levels are getting worse. The illusions are so much tighter, and the grip of control.

bh: There's an incredible quote by Martin Luther King in his last essay, "A Testament of Hope." He says that the black revolution is not just a revolution for black people, but in fact is exposing certain systematic flaws in society: *racism, militarism*, and *materialism*. And while there are a lot of progressive people on the Left who oppose militarism, many do not oppose *materialism*.

One thing we can learn from Thich Nhat Hanh, who lived through the Vietnam War, is how much this culture is so profoundly materialistic . . . people think they need *so* much. When I teach a course on Third World Literature, I spend the first few weeks trying to get people to unlearn

thinking with a First World mind-set, which means when you watch a show like "Dynasty" and see all this material opulence, you measure your own life by that. You might say, Oh God, I don't have anything—I only have an old car and an old stereo, but just *look* at this opulence!" Whereas if we think about the rest of the world ... I remember myself as a naive teenager going to Germany and finding out that everyone *didn't* have a stereo!

When we think *globally*, we're able not only to see how much we have (compared to others), but also to think about what goes into the production of what we have. I tell my students, "In the first two weeks, in order to not think with a First World context—if you eat a steak, you have to take out your pen and paper and write down what goes into producing that steak." Thus you have a sense of being part of a world community, and not just part of a First World context that in fact would have you deny your positionality as an individual in a *world community*. It's not enough to just think of yourself in terms of the United States.

Even friends on the "Left" would rather not discuss the Gulf War in terms of *challenging materialism*; using so much of the world's resources, exploiting so much of the world's resources. Because then we might begin discussing what it would mean to change our way of life ... to realize that being against war also means changing our way of life. In his Nobel Prize speech the Dalai Lama said: "How can we expect people who are hungry to be concerned about the absence of war?" He also said that peace has to mean more than just the absence of war—it has to be about reconstructing society so that people can learn how to be fully self-actualized human beings, fully alive.

R/SP: Possessions become substitutes, covering up for a loss of meaning and connection (you *are* what you own). The things I love most don't cost that much—yet have special meaning for *me*, such as gifts that link me to certain people or objects that remind me of a certain time period. Whereas Western industrial society promotes items whose original function has been forgotten: a car isn't just a box on wheels that gets you around—it's the expensive commodity you buy to "communicate" status.

bh: I think our materialism is often totally disconnected from the idea that aesthetics are *crucial* to our ability to live humanely in the world, to be able to recognize and know beauty, to be able to be lifted up by it, to be able to *choose* the objects in your surroundings . . . I've always been interested in Buddhist room arrangement: how do we place something in our house so that we can be made more fully human by glancing at it, or by interacting with it? And there's *so little* of that in our culture.

For example, for some time I'd wanted this expensive coffee-table book on Amish quilts. And I was really sad when I got it and discovered it was just about the *Esprit* collection! On the one hand, we're made to feel "grateful" that these wealthy people are buying these quilts and making them "available" to the public. But no one talks about how yuppie consumers have turned quilts into something that totally abandons the homes of the people who had them as historical or family legacies—all in the interest of *money*. There's nothing that tells us, "Well, this is how we acquired this quilt." There's nothing about the process of acquisition in the context of capitalism, nothing about that whole *process of collecting* and what it implies . . .

R/SP: . . . which takes it out of the community. In certain

American Indian tribes, spirituality and a profound community sense would be deeply integrated into the making of objects whose function was also necessary for the survival of the tribe . . . I grew up in New England where old ladies used to have sewing bees which gathered women together and provided a valuable sense of community. And then suddenly for this community craft to get shunted off into a *collector* status, you've just alienated and *consumed* that spiritual, cultural reservoir.

bh: I know that when I have the money to buy a thing, I struggle a lot with the question of the meaning of that thing in my life. Do I want to possess something just because I have the money to buy it? What would be the way that I or *Esprit* (or any group of people) could own a collection of something, and not be participating in this process of cultural alienation? *Esprit* seems to think that hanging the quilts in their offices is a way of *sharing*.

I was trying to analyze why I felt violated when I got this book entitled *The Amish Quilt*—thinking I'm going to learn something about Amish quilts, only to realize that what I'm really learning about is this *Esprit* collection of Amish quilts. This brings in the question of *repackaging*, as well as the question of this fantasization of Amish life that's taking place in the United States. I think it's not untied to White Supremacy, because if we think about the Shakers or Mennonites or other groups who have welcomed people who are nonwhite into their midst, we find that one of the groups which has stayed more solidly *white* has been the Amish. And when white people are looking at them with a kind of nostalgia and evoking this ideal of "the Amish way of life"—whether we see them being grossly exploited (as in the movie *Witness*) or in the many books that have been published recently . . .

There's a new book by a white woman who went to live among the Amish; it describes the peace and serenity she found. I think we *all* have something to learn from the Amish way of life, their habits of being and thought . . . but it's interesting that this particular group which is most *white* is the one that gets fetishized.

R/SP: How can exploitation in general be prevented?

bh: I always think that whenever there's the possibility for exploitation, what intervenes is *recognition of the Other*. Recognition allows a certain kind of negotiation that seems to disrupt the possibility of domination. If a person makes a unilateral decision that does not account for *me*, then I feel exploited by that decision because my needs haven't been considered. But if that person is willing to pause, then at that moment of pause there is an opportunity for *mutual recognition* (what I call the "subject-to-subject" encounter, as opposed to "subject-to-object"). This doesn't necessarily mean the person will change what they intended to do, but it means that (at least temporarily) I am not rendered an *object* by their carrying forth with their objective.

To have a nondominating context, one has to have a lived practice of interaction. And this practice has to be *conscious*, rather than some sentimental notion that "you and I were born into the world with the 'will to do good towards one another.'" In reality, this nonexploitative way to be with one another has to be *practiced*; resistance to the possibility of domination has to be *learned*.

This also means that one has to cultivate the capacity to *wait*. I think about a culture of domination as being very tied to notions of efficiency—everything running smoothly. I mean, it's so much easier if you tell me, "I'm leaving!" rather than "I desire to leave and not come

back—how does that desire impact on you?" and I reply, "Is there a space within which I can have a response?" All this takes more time than the kind of fascism that says, "This is what I'm doing—fuck you!"

I often think, What does "resistance" mean (our resistance against war, sexism, homophobia, etc.) if we're not fully committed to changing our way of life? Because so much of how we *are* is informed by a culture of domination. So how do we become liberated within the culture of domination if our lived practice, every moment of the day, is not saying "No!" to it in some way or another? And that means we have to *pause, reflect, reconsider*, create a whole *movement* . . . and that is not what the machinery of capitalism in daily life is about. It's about "Let's do it all swiftly—quickly!"

I hope that what's happening now for many people is that a lot of the *denial* is being cut away, because denial is always about *insanity*. So we know that the less we engage in denial, the more we are able to recover our *selves*. *Hope* lies in the possibility of a resistance that's based on being able to face our reality *as it is*.

R/SP: And yet I see the denial getting more and more fierce, building up.

bh: There's one way you can look at this: it's like having a sickness in your body that gets more and more fierce as it is passing on to *wellness*. We don't have to view that period of intense sickness as an invitation to despair, but as a sign of potential *transformation* in the very depths of whatever pain it is we are experiencing.

20

LOVE AS THE PRACTICE OF FREEDOM

In this society, there is no powerful discourse on love emerging either from politically progressive radicals or from the Left. The absence of a sustained focus on love in progressive circles arises from a collective failure to acknowledge the needs of the spirit and an overdetermined emphasis on material concerns. Without love, our efforts to liberate ourselves and our world community from oppression and exploitation are doomed. As long as we refuse to address fully the place of love in struggles for liberation we will not be able to create a culture of conversion where there is a mass turning away from an ethic of domination.

Without an ethic of love shaping the direction of our political vision and our radical aspirations, we are often seduced, in one way or the other, into continued allegiance to systems of domination—imperialism, sexism, racism, classism. It has always puzzled me that women and men who spend a lifetime working to resist and oppose one form of domination can be systematically supporting another. I have been puzzled by powerful visionary

black male leaders who can speak and act passionately in resistance to racial domination and accept and embrace sexist domination of women, by feminist white women who work daily to eradicate sexism but who have major blind spots when it comes to acknowledging and resisting racism and white supremacist domination of the planet. Critically examining these blind spots, I conclude that many of us are motivated to move against domination solely when we feel our self-interest directly threatened. Often, then, the longing is not for a collective transformation of society, an end to politics of dominations, but rather simply for an end to what we feel is hurting us. This is why we desperately need an ethic of love to intervene in our self-centered longing for change. Fundamentally, if we are only committed to an improvement in that politic of domination that we feel leads directly to our individual exploitation or oppression, we not only remain attached to the status quo but act in complicity with it, nurturing and maintaining those very systems of domination. Until we are all able to accept the interlocking, interdependent nature of systems of domination and recognize specific ways each system is maintained, we will continue to act in ways that undermine our individual quest for freedom and collective liberation struggle.

The ability to acknowledge blind spots can emerge only as we expand our concern about politics of domination and our capacity to care about the oppression and exploitation of others. A love ethic makes this expansion possible. Civil rights movement transformed society in the United States because it was fundamentally rooted in a love ethic. No leader has emphasized this ethic more than Martin Luther King, Jr. He had the prophetic insight to recognize that a revolution built on any other foundation would fail. Again and again, King testified that he had "decided to love" because he believed deeply that if we are "seeking the highest good" we "find it through love" because this is "the key that unlocks the door to the meaning of ultimate

reality." And the point of being in touch with a transcendent reality is that we struggle for justice, all the while realizing that we are always more than our race, class, or sex. When I look back at the civil rights movement which was in many ways limited because it was a reformist effort, I see that it had the power to move masses of people to act in the interest of racial justice—and because it was profoundly rooted in a love ethic.

The sixties Black Power movement shifted away from that love ethic. The emphasis was now more on power. And it is not surprising that the sexism that had always undermined the black liberation struggle intensified, that a misogynist approach to women became central as the equation of freedom with patriarchal manhood became a norm among black political leaders, almost all of whom were male. Indeed, the new militancy of masculinist black power equated love with weakness, announcing that the quintessential expression of freedom would be the willingness to coerce, do violence, terrorize, indeed utilize the weapons of domination. This was the crudest embodiment of Malcolm X's bold credo "by any means necessary."

On the positive side, Black Power movement shifted the focus of black liberation struggle from reform to revolution. This was an important political development, bringing with it a stronger anti-imperialist, global perspective. However, masculinist sexist biases in leadership led to the suppression of the love ethic. Hence progress was made even as something valuable was lost. While King had focused on loving our enemies, Malcolm called us back to ourselves, acknowledging that taking care of blackness was our central responsibility. Even though King talked about the importance of black self-love, he talked more about loving our enemies. Ultimately, neither he nor Malcolm lived long enough to fully integrate the love ethic into a vision of political decolonization that would provide a blueprint for the eradication of black self-hatred.

Black folks entering the realm of racially integrated, American

life because of the success of civil rights and black power movement suddenly found we were grappling with an intensification of internalized racism. The deaths of these important leaders (as well as liberal white leaders who were major allies in the struggle for racial equality) ushered in tremendous feelings of hopelessness, powerlessness, and despair. Wounded in that space where we would know love, black people collectively experienced intense pain and anguish about our future. The absence of public spaces where that pain could be articulated, expressed, shared meant that it was held in—festering, suppressing the possibility that this collective grief would be reconciled in community even as ways to move beyond it and continue resistance struggle would be envisioned. Feeling as though "the world had really come to an end," in the sense that a hope had died that racial justice would become the norm, a life-threatening despair took hold in black life. We will never know to what extent the black masculinist focus on hardness and toughness served as a barrier preventing sustained public acknowledgment of the enormous grief and pain in black life. In *World as Lover, World as Self*, Joanna Macy emphasizes in her chapter on "Despair Work" that

> the refusal to feel takes a heavy toll. Not only is there an impoverishment of our emotional and sensory life . . . but this psychic numbing also impedes our capacity to process and respond to information. The energy expended in pushing down despair is diverted from more creative uses, depleting the resilience and imagination needed for fresh visions and strategies.

If black folks are to move forward in our struggle for liberation, we must confront the legacy of this unreconciled grief, for it has been the breeding ground for profound nihilistic despair. We must collectively return to a radical political vision of social change rooted in a love ethic and seek once again to convert masses of people, black and nonblack.

A culture of domination is anti-love. It requires violence to sustain itself. To choose love is to go against the prevailing values of the culture. Many people feel unable to love either themselves or others because they do not know what love is. Contemporary songs like Tina Turner's "What's Love Got To Do With It" advocate a system of exchange around desire, mirroring the economics of capitalism: the idea that love is important is mocked. In his essay "Love and Need: Is Love a Package or a Message?" Thomas Merton argues that we are taught within the framework of competitive consumer capitalism to see love as a business deal: "This concept of love assumes that the machinery of buying and selling of needs is what makes everything run. It regards life as a market and love as a variation on free enterprise." Though many folks recognize and critique the commercialization of love, they see no alternative. Not knowing how to love or even what love is, many people feel emotionally lost; others search for definitions, for ways to sustain a love ethic in a culture that negates human value and valorizes materialism.

The sales of books focusing on recovery, books that seek to teach folks ways to improve self-esteem, self-love, and our ability to be intimate in relationships, affirm that there is public awareness of a lack in most people's lives. M. Scott Peck's self-help book The Road Less Traveled is enormously popular because it addresses that lack.

Peck offers a working definition for love that is useful for those of us who would like to make a love ethic the core of all human interaction. He defines love as "the will to extend one's self for the purpose of nurturing one's own or another's spiritual growth." Commenting on prevailing cultural attitudes about love, Peck writes:

> Everyone in our culture desires to some extent to be loving, yet many are in fact not loving. I therefore conclude that the desire to love is not itself love. Love is as love does. Love is an act of

will—namely both an intention and an action. Will also implies choice. We do not have to love. We choose to love.

His words echo Martin Luther King's declaration, "I have decided to love," which also emphasizes choice. King believed that love is "ultimately the only answer" to the problems facing this nation and the entire planet. I share that belief and the conviction that it is in choosing love, and beginning with love as the ethical foundation for politics, that we are best positioned to transform society in ways that enhance the collective good.

It is truly amazing that King had the courage to speak as much as he did about the transformative power of love in a culture where such talk is often seen as merely sentimental. In progressive political circles, to speak of love is to guarantee that one will be dismissed or considered naive. But outside those circles there are many people who openly acknowledge that they are consumed by feelings of self-hatred, who feel worthless, who want a way out. Often they are too trapped by paralyzing despair to be able to engage effectively in any movement for social change. However, if the leaders of such movements refuse to address the anguish and pain of their lives, they will never be motivated to consider personal and political recovery. Any political movement that can effectively address these needs of the spirit in the context of liberation struggle will succeed.

In the past, most folks both learned about and tended the needs of the spirit in the context of religious experience. The institutionalization and commercialization of the church has undermined the power of religious community to transform souls, to intervene politically. Commenting on the collective sense of spiritual loss in modern society, Cornel West asserts:

> There is a pervasive impoverishment of the spirit in American society, and especially among Black people. Historically, there have been cultural forces and traditions, like the church, that

held cold-heartedness and mean-spiritedness at bay. However, today's impoverishment of the spirit means that this coldness and meanness is becoming more and more pervasive. The church kept these forces at bay by promoting a sense of respect for others, a sense of solidarity, a sense of meaning and value which would usher in the strength to battle against evil.

Life-sustaining political communities can provide a similar space for the renewal of the spirit. That can happen only if we address the needs of the spirit in progressive political theory and practice.

Often when Cornel West and I speak with large groups of black folks about the impoverishment of spirit in black life, the lovelessness, sharing that we can collectively recover ourselves in love, the response is overwhelming. Folks want to know how to begin the practice of loving. For me that is where education for critical consciousness has to enter. When I look at my life, searching it for a blueprint that aided me in the process of decolonization, of personal and political self-recovery, I know that it was learning the truth about how systems of domination operate that helped, learning to look both inward and outward with a critical eye. Awareness is central to the process of love as the practice of freedom. Whenever those of us who are members of exploited and oppressed groups dare to critically interrogate our locations, the identities and allegiances that inform how we live our lives, we begin the process of decolonization. If we discover in ourselves self-hatred, low self-esteem, or internalized white supremacist thinking and we face it, we can begin to heal. Acknowledging the truth of our reality, both individual and collective, is a necessary stage for personal and political growth. This is usually the most painful stage in the process of learning to love—the one many of us seek to avoid. Again, once we choose love, we instinctively possess the inner resources to confront that pain. Moving through the pain to the other

side we find the joy, the freedom of spirit that a love ethic brings.

Choosing love we also choose to live in community, and that means that we do not have to change by ourselves. We can count on critical affirmation and dialogue with comrades walking a similar path. African American theologian Howard Thurman believed that we best learn love as the practice of freedom in the context of community. Commenting on this aspect of his work in the essay "Spirituality out on The Deep," Luther Smith reminds us that Thurman felt the United States was given to diverse groups of people by the universal life force as a location for the building of community. Paraphrasing Thurman, he writes: "Truth becomes true in community. The social order hungers for a center (i.e. spirit, soul) that gives it identity, power, and purpose. America, and all cultural entities, are in search of a soul." Working within community, whether it be sharing a project with another person, or with a larger group, we are able to experience joy in struggle. That joy needs to be documented. For if we only focus on the pain, the difficulties which are surely real in any process of transformation, we only show a partial picture.

A love ethic emphasizes the importance of service to others. Within the value system of the United States any task or job that is related to "service" is devalued. Service strengthens our capacity to know compassion and deepens our insight. To serve another I cannot see them as an object, I must see their subject-hood. Sharing the teaching of Shambala warriors, Buddhist Joanna Macy writes that we need weapons of compassion and insight.

> You have to have compassion because it gives you the juice, the power, the passion to move. When you open to the pain of the world you move, you act. But that weapon is not enough. It can burn you out, so you need the other—you need insight into the

radical interdependence of all phenomena. With that wisdom
you know that it is not a battle between good guys and bad
guys, but that the line between good and evil runs through the
landscape of every human heart. With insight into our pro-
found interrelatedness, you know that actions undertaken with
pure intent have repercussions throughout the web of life,
beyond what you can measure or discern.

Macy shares that compassion and insight can "sustain us as
agents of wholesome change" for they are "gifts for us to claim
now in the healing of our world." In part, we learn to love by
giving service. This is again a dimension of what Peck means
when he speaks of extending ourselves for another.

The civil rights movement had the power to transform soci-
ety because the individuals who struggle alone and in com-
munity for freedom and justice wanted these gifts to be for all,
not just the suffering and the oppressed. Visionary black leaders
such as Septima Clark, Fannie Lou Hamer, Martin Luther King,
Jr., and Howard Thurman warned again isolationism. They
encouraged black people to look beyond our own circumstances
and assume responsibility for the planet. This call for com-
munion with a world beyond the self, the tribe, the race, the
nation, was a constant invitation for personal expansion and
growth. When masses of black folks starting thinking solely in
terms of "us and them," internalizing the value system of white
supremacist capitalist patriarchy, blind spots developed, the cap-
acity for empathy needed for the building of community was
diminished. To heal our wounded body politic we must reaffirm
our commitment to a vision of what King referred to in the
essay "Facing the Challenge of a New Age" as a genuine com-
mitment to "freedom and justice for all." My heart is uplifted
when I read King's essay; I am reminded where true liberation
leads us. It leads us beyond resistance to transformation. King
tells us that "the end is reconciliation, the end is redemption,

the end is the creation of the beloved community." The moment we choose to love we begin to move against domination, against oppression. The moment we choose to love we begin to move towards freedom, to act in ways that liberate ourselves and others. That action is the testimony of love as the practice of freedom.

INDEX

Routledge Classics
Get inside a great mind

Stigmata: Escaping Texts
Hélène Cixous

'Hélène Cixous is in my eyes, today, the greatest writer in the French language . . . *Stigmata* is henceforth a classic . . . One of her most recent masterpieces.'
Jacques Derrida

Hélène Cixous is hailed as one of the most formidable writers and thinkers of our time and is celebrated for her brilliant contributions to contemporary culture. Questions of the self and the other, autobiographies of writing, sexual difference, literary theory, post-colonial theory, death and life are explored here, woven into a stunning narrative. Displaying a remarkable virtuosity, the work of Cixous is exciting, powerful, moving, and dangerous.

0–415–34545–6
978–0–415–34545–3

The Location of Culture
Homi Bhabha

'Homi Bhabha is one of that small group occupying the front rank of literary and cultural theoretical thought.'
Toni Morrison

Terry Eagleton once wrote in *The Guardian*, 'Few post-colonial writers can rival Homi Bhabha in his exhilarated sense of alternative possibilities'. In *The Location of Culture*, Bhabha uses concepts such as mimicry, interstice, hybridity, and liminality to argue that cultural production is always most productive where it is most ambivalent. Speaking in a voice that combines intellectual ease with the belief that theory itself can contribute to practical political change, Bhabha has become one of the leading post-colonial theorists of this era.

0–415–33639–2
978–0–415–33639–0

For these and other classic titles from Routledge, visit
www.routledge.com/classics

Routledge Classics
Get inside a great mind

The Political Unconscious
Narrative as a socially symbolic act
Fredric Jameson

'Fredric Jameson is generally considered to be one of the foremost contemporary English-language Marxist literary and cultural critics.'
Douglas Kellner

In this ground-breaking and influential study Fredric Jameson explores the complex place and function of literature within culture. At the time Jameson was actually writing the book, in the mid- to late seventies, there was a major reaction against deconstruction and post-structuralism. As one of the most significant literary theorists of the time, Jameson found himself in the unenviable position of wanting to defend his intellectual past yet keep an eye on the future. With this book he carried it off beautifully.

Hb: 0–415–28750–2 Hb: 978–0–415–28750–0
Pb: 0–415–28751–0 Pb: 978–0–415–28751–7

The Use and Abuse of History
Or how the past is taught to children
Marc Ferro

'Marc Ferro is remarkable in writing history enjoyed both by scholars and by people curious about the world in which they live and its past.'
Natalie Zemon Davis

This is a book for anyone interested in history, what it is and where it comes from. Engaging and challenging, *The Use and Abuse of History* examines the different narratives that constitute the histories of countries around the world and what these narratives tell us about the societies which created them – how much is history distorted in order to condition the minds of those who are taught it? A pioneer in its field that has become a key text of contemporary historiography, this is a book that poses fundamental and disturbing questions about the use and abuse of history.

0–415–28592–5
978–0–415–28592–6

For these and other classic titles from Routledge, visit
www.routledge.com/classics